PLUG IN with onOne SOFTWARE

A Photographer's Guide to Vision and Creative Expression

Nicole S. Young

Peachpit
Press

Plug In with onOne Software:
A Photographer's Guide to Vision and Creative Expression
Nicole S. Young

Peachpit Press
www.peachpit.com

To report errors, please send a note to errata@peachpit.com
Peachpit Press is a division of Pearson Education.

Copyright © 2013 by Peachpit Press

Project Editor: Valerie Witte
Production Editor: David Van Ness
Developmental Editor: Linda Laflamme
Copyeditor: Linda Laflamme
Proofreader: Liz Welch
Composition: WolfsonDesign
Indexer: Valerie Haynes Perry
Cover Photo: Nicole S. Young
Cover Design: Aren Straiger
Interior Design: Mimi Heft
Author Photo: dav.d daniels

ISBN-13: 978-0-321-86278-5
ISBN-10: 0-321-86278-3

9 8 7 6 5 4 3 2 1

Printed and bound in the United States of America

To Brian: Without you this book would have never been written. Thank you for your encouragement, for your inspiration, and for getting me out the door with my camera when I needed a break. I feel honored to have you in my life now and forever. I love you!

Acknowledgments

When I write a book it absorbs the majority of my time and energy, and this book, more so than any I've written thus far, was an exceptional challenge to complete. Even though I am and have been thoroughly familiar with the topic, writing a book on software before it's released is not an easy task and cannot be accomplished without the help of many individuals behind the scenes.

To my editors and production team over at Peachpit: Valerie Witte, Linda Laflamme, David Van Ness, Liz Welch, WolfsonDesign, Aren Straiger, Mimi Heft, and Valerie Haynes Perry. Thank you for your patience and dedication in putting this book together. The road was much bumpier than expected, but we pushed through and ended up with something I'm very proud of and excited to share with the world.

To the entire team at onOne Software: You have created an excellent product with Perfect Photo Suite 7 and should be *very* proud of it.

To Craig Keudell, onOne Software's President and Founder, for having the vision to put out a product for photographers and artists to help them create something beautiful.

A huge thanks Dan Harlacher, onOne's Senior Product Manager, for putting up with my prodding questions about the tiny bits and pieces of the software I needed verification on. It has been a busy time for all of us and I appreciate you taking the time out of your day to help me add so much value to the pages in this book.

To Amy Chan (Marketing), Rick LePage (Content), Brian Kraft (Sales), Kevin Bier (Engineering), Jonny Davenport (Prerelease Coordinator), and Patrick Smith (Customer Support) for not only being awesome, but also for helping out whenever I had any questions about the software. You guys are also pretty good for a laugh from time to time.

To the readers of this book, many of whom have been asking for a book about the Perfect Photo Suite for some time now. I hope that this book helps you in seeking the inspiration you desire, and also gives you the knowledge you need to speed up your "staring at pixels" time to give you more time creating beauty with your cameras.

And last, but definitely not least, to my husband, Brian Matiash. Thank you for being supportive during my rants and frustrations during the process, and also for your scrutinous tech editing of this book. You're the "preset of my life"… don't ever forget that. ;)

Contents

Foreword

Seeing *Plug In with onOne Software* come to fruition means a great deal to me, and being asked to write its foreword is icing on the cake. You see, the software that this book encapsulates, the company that created it, and the author who penned this book all mean a great deal to me. I've been a devoted user of the Perfect Photo Suite for many years, and I attribute much of my success as a photographer squarely to its tools.

As onOne Software's curriculum and education manager, I'll occasionally roam around the engineering, development, and QA sections at the office to peek at the engineers' displays. Usually, I am greeted to windows of code— lots of code. To see the magical and creative ways that you, the photographer, use the tools built on these thousands upon thousands of lines of code is nothing short of astounding. This book will help you get the most out of Perfect Photo Suite 7 so you can amaze me even more.

At its core, we built Perfect Photo Suite 7 to serve as an extension of your creativity. We wanted to provide you with a finely tuned instrument that can provide beautiful results in a scalable way, from the casual user who simply wants to apply a one-click effect to the power user who loves spending hours digging deep into the fiber of what makes this suite of tools so powerful. We all have our own sensibilities around style when it comes to post-processing and the Perfect Photo Suite was built to help each of you find, refine, and evolve what that means.

When you first launch Perfect Photo Suite 7, you're going to see the product of so many months of labor. In its truest form, this was a labor of love for us at onOne. Every aspect of every module, from the fonts used to the order that the tools were laid out, was carefully discussed, debated, and even argued over. Nothing was deemed as trivial. But every decision was made with one overriding purpose in mind: to build the most powerful and inspiring collection of photo editing products for you, providing everything you need to realize your photographic vision.

To that end, *Plug In with onOne Software* is a wonderful complement to the Perfect Photo Suite. You might say it's the *perfect* complement. With Nicole Young as the book's author, you will be treated to some of the best educational material out there. If there is one skill that Nicole excels at, it is sharing her knowledge in a way that is clear, approachable, and easy to understand. She thrives on turning obscure topics like layer masks, blending options, and resize algorithms into material that is truly easy to grasp and, more importantly, to use. In these pages, you'll tour every single product and its tools and follow along through step-by-step examples of those tools in action. Every discussion is supported by beautiful imagery—*all* processed using Perfect Photo Suite 7. This book is one of the most comprehensive resources for using Perfect Photo Suite 7 to its fullest potential.

Nicole took such great care to make sure every corner of the Perfect Photo Suite was represented and explained in a familiar tone. From her frequent visits to the onOne Software office in Portland to her whimsical, ad hoc video chats with Senior Product Manager Dan Harlacher, Nicole made it her number one priority to thoroughly learn every feature, every tool, and every menu item that makes up Perfect Photo Suite 7. I'll be the first to admit to learning a number of new things about software during the tech-editing phase of this book. In turn, for all of her effort, Nicole was able to synthesize this material in a way that will truly engage you and make you excited to run out the door, grab some new photos, and launch them in the Perfect Photo Suite as soon as you get home.

I hope you enjoy the inspiring words and imagery that Nicole shares in the coming pages. It is my sincerest wish that her efforts serve as inspiration for you as you learn all about the power of Perfect Photo Suite 7.

Never stop shooting. Never stop sharing.

Brian Matiash
Curriculum and Education Manager
onOne Software

Introduction

Post-processing can, at times, feel like a necessary evil. We photographers tend to enjoy the *photography* side of things and dread staring at pixels in front of a glowing computer monitor to create the final image. I definitely put myself into that category; I don't hate post-processing, I just prefer to spend my time doing something else.

In writing *Plug In with onOne Software*, however, I had to dig deep into every crevice of Perfect Photo Suite 7 to discover its potential, and during that process I learned so much more than I expected. And then a surprising thing happened: I began to *enjoy* editing my photos with my newfound knowledge. Now, I'm often *excited* to import images into my computer because I look forward to seeing what I can do with them in the Perfect Photo Suite 7. The editing process has become my playground. My hope is that the Perfect Photo Suite, along with this book, will encourage you to enjoy the process of experimenting with your photos, too.

Not only will you learn more about the software, you may discover new ways to edit your photos. While writing, I uncovered a few that had never occurred to me. When working on Chapter 3, "Perfect Mask," for example, I quickly realized how easy it was to mask a subject out of a scene and swap in a new backdrop, and it has inspired me to create more composite images. And, with the introduction of the brand-new product, Perfect B&W, I now have an easily accessible and simple-to-use tool to convert images into gorgeous black and white photographs. In-between the pages of writing each chapter I found ways to breathe new life into old photographs I had nearly forgotten about. I don't believe that we can use software and plug-ins as a quick fix to create a beautiful work of art from a crappy photograph, but we can use the software for a boost of inspiration and fuel the fire of our creative minds.

This book is not intended to be read from cover to conclusion; rather, it was made for you to jump around and learn about the specific areas you need help with the most. In Chapter 1, "Getting Started," I spell out some of the best practices for using the software, such as setting up your computer and preparing your files, and from there I dive straight into each specific product in Perfect Photo Suite 7. The chapters are laid out in the same order you'll find the products in the software, and to make things easy, you'll always know which product you're reading about just by looking at the top of the page. Chapters 2 through 7 each have a "step by step" section at the end to demonstrate how to process one or more images in that product; and you can learn how to enlarge, sharpen, and get your images ready for printing in Chapter 8, "Perfect Resize." Chapter 9, "Perfect Integration," brings the workflow together by showing how to process images in more than one product in the Perfect Photo Suite. You'll learn not only what the features can do, but also how you can combine them for spectacular results.

So, whether you're new to the onOne Software products or you've been using them for several years, you're bound to learn a thing or two in *Plug In with onOne Software*. My goal was to create an intensive book covering as many features of the Perfect Photo Suite 7 that I could fit inside of each of these pages. I hope that in reading this book you get as excited and inspired about photography as I did while writing it.

NOTE

No book ever seems to have enough room to fit all the useful information about a product, so I was selective about what I included in each chapter. Because I just had to share a little more information that might come in handy, however, I've provided a bonus for you online. As an added value for you, I wrote an appendix, "Keyboard Shortcuts," which covers the keyboard shortcuts you can use as you are working in the software. To access it, log in to or join Peachpit.com (it's free), then enter the book's ISBN. After you register the book, a link to the bonus content will be listed on your Account page under Registered Products.

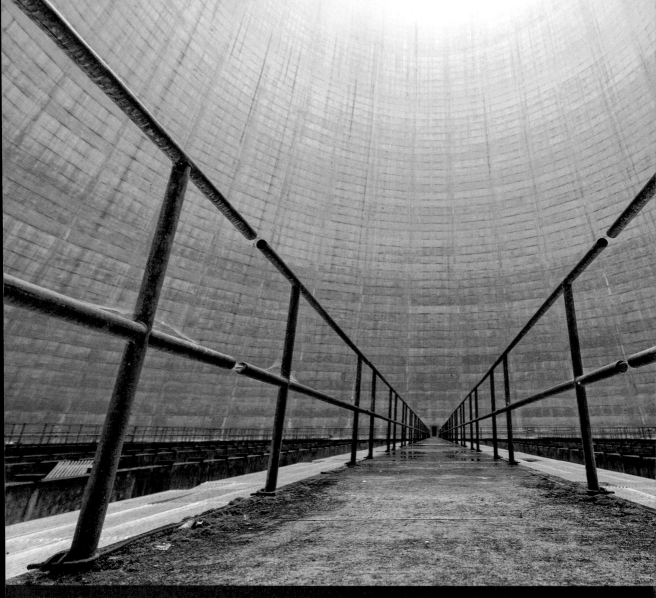

Nuclear Symmetry, 2012; inside a cooling tower in Elma, Washington.

Canon 5D Mark III, TS-E 17mm f/4L lens, 1/15 sec at f/5.6, ISO 400
Processed using Perfect Effects 4

GETTING STARTED

Before you can dive into Perfect Photo Suite 7, you need to load the software and prep your computer to process your photos. This chapter is all about getting set up and ready to go to ensure that you have the best experience possible. Not only will your post-processing time be better spent, if you spend a little extra time now the software will simply be that much easier to use as well. So, let's get started!

Installation and Setup

In this section you'll find information on installation, plug-ins, and setting preferences, as well as some guidance on color settings and calibration.

Installing the Software

Installing Perfect Photo Suite 7 is very simple, because the provided installer guides you through the process (**FIGURE 1.1**). All you need to do to get started is to double-click the installer icon from the DVD or from the file you downloaded, and then follow the on-screen instructions.

FIGURE 1.1 The Perfect Photo Suite 7 installer walks you through the installation process on your computer.

Before you click, however, you should take note of a few things. First of all, your copy of the Perfect Photo Suite will include both a Mac and a PC version of the suite. This means that you can install your software on a Mac, a PC, or both. You can also have the software installed on up to two different computers at any given time (either on two Macs, two PCs, or one of each).

One nice advantage to Perfect Photo Suite 7 is that you can keep all of your legacy releases on your computer and install this latest edition alongside the previous versions. If you created presets in previous versions, those presets will transfer to the new software automatically. If you prefer to declutter when installing, you also have the option of removing all of your old onOne files at the time of installation (**FIGURE 1.2**). If you plan on removing and erasing your previous versions, however, create backups of all of your presets to make sure they don't disappear as well.

HOT TIP

A detailed list of minimum system requirements for using Perfect Photo Suite 7 are listed on the onOne Software website at ononesoftware.com. Be aware, however, that the PC version of Perfect Photo Suite 7 is not compatible with Windows XP; you must have Windows Vista, Windows 7, or any of the more recent releases of the Windows operating system.

FIGURE 1.2 Perfect Photo Suite 7 gives you the option of removing older versions of the software during the installation process by checking the appropriate boxes in the Custom Install window. If you have no previous versions currently installed, you can skip that step as shown here.

After the software installs, a few pop-ups appear on your screen. One of them asks if you would like to view an introductory video on Perfect Photo Suite 7; click OK and your browser will open, taking you to the onOne Software website (**FIGURE 1.3**). Here you can view videos about the suite and individual products to get you off to a great start. Also, as you open individual products you'll notice an overlay with instructions on how to use each pane. Just click anywhere in the window to step through the introductions, and you'll then be able to get started using the software.

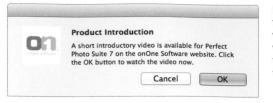

FIGURE 1.3 Click the OK button to enter the onOne Software website and view an introductory video on the suite. Click Cancel to close the window and continue the installation process.

NOTE

Uninstalling the software is very simple: For Mac users, go to the Perfect Photo Suite 7 folder, open the Documents folder, then double-click the Remove Perfect Photo Suite 7 icon to initiate the uninstall process. For PC users, access the Control Panel from the Start menu and use the Add or Remove Programs option to uninstall the Perfect Photo Suite.

Installing Plug-ins

NOTE

For more information on using the plug-ins inside of your host software, see the section titled "Opening an Image in the Perfect Photo Suite."

When Perfect Photo Suite 7 installs, you'll also have plug-in files installed into any host applications you may have on your computer (such as Adobe Lightroom or Photoshop). In other words, you really don't need to do anything —the installation process will do this for you. You'll even have a window pop up informing you that the plug-in files were added (**FIGURE 1.4**).

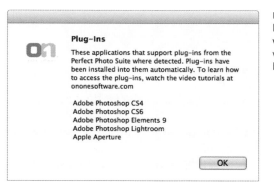

FIGURE 1.4 After you install Perfect Photo Suite 7, a window will pop up informing you of which applications plug-in files have been installed.

Setting the Preferences

When using the Perfect Photo Suite, you may want to consider adjusting the Preferences settings to suit your individual needs as a photographer. You can access the Preferences by choosing Perfect Photo Suite > Preferences on a Mac or Edit > Preferences on a PC. The sections that follow describe some of these settings as well as some recommended modifications.

Working Color Space

Located under the General section of the Preferences, Working Color Space determines the color space of your software (for more specific information, see the "Color Settings and Calibration" section). If your images already have an embedded color profile, then this setting will not necessarily matter; however, if you are opening an image that is untagged (no color profile) or are creating a brand-new file from within Perfect Layers, then the document will pull its color profile from the Working Color Space setting. A good, general setting for this that I recommend (and the one I use) is Adobe RGB.

NOTE

Be sure not to confuse the Working Color Space with the color profile of an image. To learn more, please turn to the "Color Settings and Calibration" section.

Lightroom Plug-ins

If you use Lightroom then you'll probably want to take a look at this tab in the Preferences window. The most important setting to pay attention to is File Type (**FIGURE 1.5**). Here are each of the options under this setting and how they affect your workflow:

HOT TIP

For more information on editing files from Lightroom, please turn to the "Working from Lightroom" section further along in this chapter.

FIGURE 1.5 The Lightroom Plug-Ins preferences allow you to select the file type, color space, bit depth, and resolution of images edited from Lightroom.

- **PSD (Supports Layers, Default):** As it states in the name, this is the default setting. If you want to retain the layers you create inside of the Perfect Photo Suite, then I *highly* encourage that you use this setting. The way it works is that when you edit a photo from Lightroom in the Perfect Photo Suite, it will save the file as a PSD file, regardless of the file type you set in Lightroom.

- **Same as Source (PSD for RAW):** When you use this option, the file type of your Lightroom images will remain the same after you edit and apply your changes in the Perfect Photo Suite. If you're editing from PSD or RAW files then the layers will remain intact. If you're working from a JPEG or TIFF file, however, then the layers created will be automatically flattened after you save and close the file in the Perfect Photo Suite.

- **TIFF or JPEG (No Layers):** Each of these settings will either save your images as a TIFF file or a JPEG file. The downside to this is that no layers will remain in your documents after you save and close. If maintaining the layers in your documents is not important to your workflow, then this is a possible choice for you. If you do want to retain your layers, however, then I do not recommend using this setting.

Performance

You may want to consider adjusting the Performance sliders to increase the performance of the Perfect Photo Suite on your computer (**FIGURE 1.6**). All machines are different and have different hardware, graphics cards, and RAM, so here are some guidelines for making changes to this section of the Preferences:

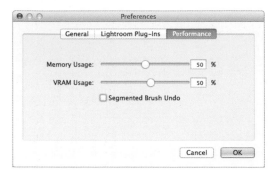

FIGURE 1.6 The Performance preferences settings allow you to customize the memory and VRAM usage for your computer.

HOT TIP

To find out how much RAM and VRAM you have on your Mac, choose Apple > About This Mac. PC users can go to the Start menu, right-click Computer, and then click Properties.

- **Memory Usage:** This setting is directly associated with how much RAM (Random Access Memory) you have installed in your computer. If you have the minimum RAM required for the software (4GB) then you'll want to keep this setting as it is (at around 50%). If you have a considerable amount of RAM (8GB or more), however, then you can push this slider much higher, possibly up to its maximum of 80%. The higher this slider is set, the more memory you are allocating toward the use of the Perfect Photo Suite, which improves both the speed and performance of the software. You may need to play around with the Memory Usage setting after working with the software to find the "sweet spot" for your specific machine.

- **VRAM Usage:** The VRAM (Video RAM) is the amount of RAM on your video card. If you have a powerful video card, such as 1GB or more, then you can push this slider up pretty high. With a 300MB or less video card, you may want to consider leaving this slider set to 50% or only slightly increasing it. Again, the more VRAM you can route to the Perfect Photo Suite, the faster it will run.

- **Segmented Brush Undo:** By default this setting is off, which means when you undo a brush stroke the Perfect Photo Suite will behave like any other program; the entirety of your brush stroke, from clicking in your document to the time you lift up the cursor, will be undone. If you click this check box, the undo process for brush strokes will undo only one segment at a time, which means you may have to use the Edit > Undo command several times to remove your entire brush stroke. The default setting is usually best, as it helps speed things up with the undo process (turning the feature on may slow things down a bit, however).

HOT TIP

The Perfect Photo Suite requires 4GB of RAM to function properly, but 8GB or more is recommended and will give you a faster working experience.

Color Settings and Calibration

As a photographer I'm very particular about the colors and tones in my images, but all my careful work is wasted if the color and tones I see on my computer appear differently in print or on other computers, tablets, or phones. The best way to ensure that others see what you see while you work is to calibrate your computer monitor.

Now, onOne Software doesn't calibrate your monitor for you, so you'll need to use a third-party product, such as ColorMunki (X-Rite Inc., http://colormunki.com) or Spyder (Datacolor, http://spyder.datacolor.com), but the results are worth the effort. I highly recommend using a hardware calibration device; a calibrated monitor will guarantee that you are seeing the true colors and tones of your images. Without a calibrated monitor you run the risk of your images having a strange color tint to them or being severely over-processed. I won't get into the specifics of setting up the calibration of your monitor, but you should be able to find more information online and with either of the above-mentioned calibration companies.

A few more aspects of color when working on the computer are the *color profile* and *working color space profile*. The difference between the two is that the Color Profile is the color profile of your *photo*, which tells other types of software and programs how to read the color in your image. The working color space, on the other hand, is the color profile for the *software* you're working in and will determine how much color data you have available in the software. Although it's likely that you have several profile options on your machine, there are three commonly used profiles:

- **sRGB:** The sRGB color space has the least amount of color data of the three color profiles listed here. It's not a good idea to edit your images in this color space, but it is commonly used as an embedded color profile to save final copies of images for uses such as printing, viewing on the computer or tablet (such as a portfolio on an iPad, for example), or posting online.

- **Adobe RGB:** The AdobeRGB color space is a very common space used for many professional photographers, and it's a much better compromise over sRGB. I personally use this space very often, both for my image files and for my working space. This color space is best for those who use 8-bit files or work with JPEGs, but will work with 16-bit files as well.

- **ProPhoto RGB:** ProPhoto RGB has the largest color gamut and you are less likely to introduce any odd color artifacting or banding into your images. It's an ideal choice if you work exclusively with 16-bit files.

NOTE

The basic differences between 8-bit and 16-bit files are that you are working with fewer colors in 8-bit and more colors with 16-bit. This can mean that when making edits you are less likely to "destroy" the pixels and create unwanted blooming and banding. To get the best quality possible in your images, I recommend working with 16-bit files as often as possible when using TIFF or PSD inside of the Perfect Photo Suite (JPEG files support 8-bit only).

Preparing Your Files

The products inside the Perfect Photo Suite allow you to work with four basic file types supported (JPEG, PSD, PNG, and TIFF), along with a very long list of RAW files (for a current list of supported RAW file types, see www.ononesoftware.com/support). Understanding the strengths and weaknesses of each type and how you can work with them in the software will help you achieve the results you're after. Here is an overview of each of the file types you can use within the Perfect Photo Suite:

- **JPEG:** A JPEG file (.jpg) is an 8-bit compressed image and has much less embedded image data than other file types. This leaves it susceptible to unwanted artifacting, pixilation, and color changes (blooming) in your images. It's not the best choice to start with a JPEG file when editing your images in any type of photo processing software, including the Perfect Photo Suite.

- **PSD:** A Photoshop Document (.psd) is an uncompressed file, and you will typically be working on PSD files as a result of editing a processed photo pulled from a host application (Adobe Lightroom, Apple Aperture, and so on). These files can be either 8 bit or 16 bit, and will give you better overall results in your image when making changes. You can also save PSD files with their layers intact, which means that you can open previously created PSD files from either the Perfect Photo Suite or other programs, such as Photoshop. Certain Photoshop layer types, however, cannot be read inside of the suite, including Smart Objects, type layers, adjustment layers, styles and effects, alpha channels, unsupported masks, and layer groups.

- **PNG:** A PNG file (Portable Network Graphics, .png) employs lossless compression on your image, which means editing the photo will not damage the pixels. It's also a file type commonly used on the Internet, especially when the image has transparency. You can edit and save PNG files from within Perfect Photo Suite 7.

- **TIFF:** A TIFF file (.tif) is similar to a PSD in that it is a higher quality file type and will work with color and tones much better than a JPEG. Any layers in your original TIFF file will not be retained inside the Perfect Photo Suite, however. The software will automatically create a one-layered composite image and then save it as a PSD.

- **RAW:** You can work on RAW images straight out of your camera in this software. (The Perfect Photo Suite does not provide a nondestructive workflow with RAW images, however, so use a dedicated RAW processor, such as Lightroom or Adobe Camera Raw, before editing your file in onOne Software.) The exact file type will vary depending on your camera brand (for example, Canon cameras use .cr2 and Nikons use .nef). For an updated list on the current RAW files supported in the Perfect Photo Suite, see www.ononesoftware.com/support.

NOTE

The Perfect Photo Suite's native file type is PSD, so whenever you are working on a file type other than PSD (JPEG, TIFF, or RAW), then the software automatically will save your image as a copy of the original and save it as a PSD, unless you choose File > Save As and select a different file type.

Tools, Groups, and Panes

While each individual product in the Perfect Photo Suite has its own unique tools and processes, some common elements span the workspaces of several products. Understanding these elements will help you understand how to navigate, organize, and control your work within each product.

Arranging the Workspace

The ability to customize your software can be extremely helpful to your creative flow. Personally, I'm very particular about how my workspace is set up for the various Perfect Photo Suite products. The sections that follow will give you some ideas for customizing your own space to work just for you.

Working with Groups

Within most products, on the left and right of your window you'll see vertical groups that contain a file browser, Library, or Effects and My Presets tabs on the left and adjustment panes on the right. If you don't want to view them, you can use a few methods to hide them. First, pressing the Tab key makes both groups disappear, giving you a full-window preview of your image. To bring them back, just press the Tab key again.

You can also hide individual groups by either clicking on the vertical bar separating the group and the Preview window (**FIGURE 1.7**) or by using the keyboard shortcuts **Cmd+left/right arrow** or **Ctrl+left/right arrow** (PC) to hide the left or right groups respectively.

FIGURE 1.7 You can hide the groups on the right or left by clicking on the arrows in-between the group and the Preview window.

Preview Modes

By default the Preview window will show you the finished view of the image you are editing. For example, by default, you will see the fully edited version in Perfect Effects (After view mode), a composite image in Perfect Layers (All Layers view mode), and so on. You will know which view mode you are seeing by looking at the mask view mode selector on the bottom left of your Preview window.

HOT TIP

In many of the products in the Perfect Photo Suite you'll see a Preview checkbox at the bottom of the window. You can toggle this button on and off to see a before and after of your edited image. A much quicker way to access the preview, however, is to use the keyboard shortcut **Cmd+P** or **Ctrl+P** (PC).

If you want to change this view, you can do so by clicking the black text in the Mask View mode selector and selecting a different view. Or, if you prefer to view them in a split-view mode or side by side with a before and after image, click the A icon on the bottom to toggle the different view modes (**FIGURE 1.8**). This is a great way of seeing your changes and comparing them to your original image.

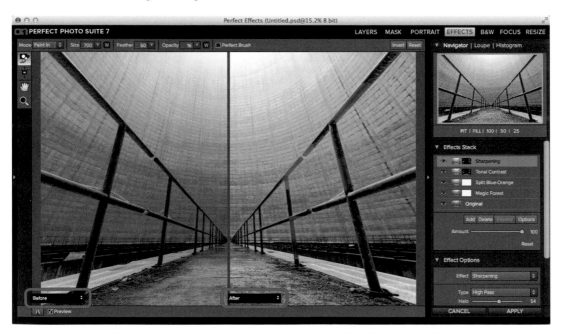

FIGURE 1.8 I toggled the preview mode to show a split before-and-after view of my image while processing it inside of Perfect Effects.

Working with Tools

The tools of the Perfect Photo Suite are what give you a large amount of customization inside of each product. While the tools change between each product, there are a few things that remain the same throughout the suite: the tool-well and Tool Options bar.

The Tool-well

The tool-well, located on the far-left side of the Preview window, is where you will access all of the tools for each product. These tools vary from product to product, with the exception of the Hand and Zoom tools, which are constants across the suite. The Hand tool (keyboard shortcut **H**) allows you to move your image in the Preview window to access different areas when zoomed in. When you're inside any other tool, you can access the Hand tool quickly by pressing and holding the Space Bar. The Zoom tool (keyboard shortcut **Z**) allows you to zoom in to your image. You can also draw a box with the Zoom tool to specify a certain area of zoom (**FIGURE 1.9**).

FIGURE 1.9 You can use the Zoom tool to draw a specific area to magnify.

Tool Options Bar

The Tool Options bar is located at the top of the screen and will change depending on which tool you are currently using (**FIGURE 1.10**). This bar allows you a lot of control over the images, as you may not want to use a certain tool in its default settings. So don't forget to take a look at the initial settings in the Tool Options bar before getting started on your projects.

FIGURE 1.10 The Tool Options bar will change depending on which tool you have selected in the tool-well; in this example I have the Brush tool selected.

Also, one thing to note inside of the Tool Options bar is the occasional appearance of a small W icon, usually when you working with one of the many brush tools in the suite. This button is for those working with Wacom tablets to brush and paint in their images, and, when highlighted, it indicates that the brush size, opacity, and so on are pressure sensitive. Also, when you use this setting, whatever your slider is set to is the maximum value for the brush; for example, if I have the size set to 200 with Wacom pressure sensitivity activated, my brush size will vary between 0 and 200 while painting. And, you'll also see the readout change (with whatever pressure is applied on your table) in the Tool Options bar as you brush over your image. This is an extremely useful tool for those who value the pressure sensitivity options when using a Wacom tablet.

Navigator, Loupe, and Histogram

In the upper-right portion of your window are three panes: Navigator, Loupe, and Histogram. Each of these will appear in all of the products in the Perfect Photo Suite, with the exception of FocalPoint (which has the Navigator only).

Navigator

The Navigator pane gives you a thumbnail-sized preview of your image and also shows you where your zoom is, indicated by a small blue box (**FIGURE 1.11**). I like having this small view of my images, because oftentimes when I share a photo or preview it in a portfolio I'm going to first see the thumbnail view of the photo. If the thumbnail "pops" and catches my attention, then the larger version will very likely do the same as well.

FIGURE 1.11 When zoomed in, the small blue box in the Navigator pane will show you the location in your image you are looking at in the Preview window.

One great feature of the Navigator pane is the ability to quickly jump to a specific zoom in your image. These options are located at the bottom of the pane and include Fit (to scale the image so it fits inside of the Preview window), Fill (to scale whichever layer is active to fill the entire Preview window with your image), as well as zoom percentages of 100%, 50%, and 25%.

Loupe

The Loupe pane allows you to view a zoomed-in portion of your screen. Wherever your cursor is hovering over within the Preview window, you'll see that in the Loupe pane. You can change the amount of zoom you're previewing by using the slider at the bottom of the pane (**FIGURE 1.12**).

FIGURE 1.12 The Loupe pane will show you a zoomed-in preview wherever the cursor is hovering.

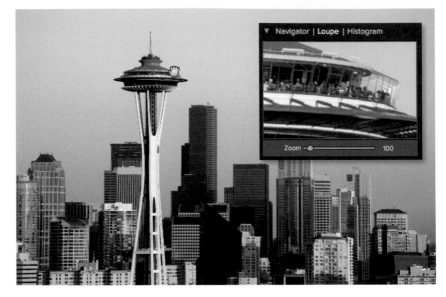

Histogram

The Histogram pane shows a graphical version of the balance of tones in your image and can help determine if an image is overexposed or underexposed, or if the colors are clipped (or bloomed). The dark areas are on the left, and the bright areas are on the far right, with shades of gray in between (**FIGURE 1.13**). As you make tonal changes in your image the histogram will shift to show how those changes have affected the overall tones in your photograph.

When adding effects to your images, check for "clipping" of the whites or blacks to make sure you're not removing any detail in those areas, especially the highlights. One indication of clipping is to look at the histogram to see if the graph is falling off to the right or left. Then, to locate the areas within your image, just press and hold the J key on your keyboard, and you'll see red and blue areas appear in the clipped areas your image (**FIGURE 1.14**). You can also view the clipping areas by clicking on the small triangles on the top right and left of the Histogram pane. Red means that area is pure white, and black

means that the area is pure black. You typically will want to avoid creating any large areas of either of those clipped tones with your adjustments, particularly the clipped whites.

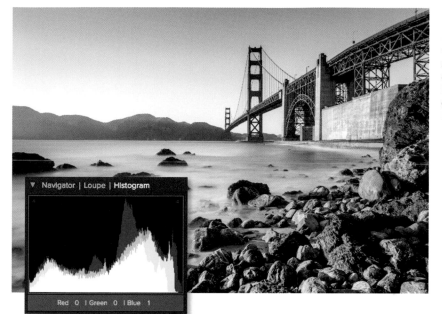

FIGURE 1.13 This image shows a well-balanced histogram, with no overexposed areas and only slight clipping of the blacks, indicated by the histogram falling off on the left side of the graph.

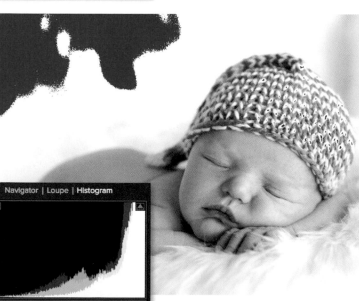

FIGURE 1.14 By holding the J key I was able to view the clipped whites in this image of a baby.

The Histogram pane also shows an RGB color readout at the bottom of the pane of whichever color the cursor is hovering over (**FIGURE 1.15**). This can be helpful when masking or doing any type of detail work in your photo.

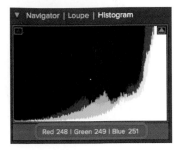

FIGURE 1.15 The RGB readout underneath the histogram shows you the RGB values of wherever your cursor is hovering in the image.

Opening an Image in the Perfect Photo Suite

Perfect Photo Suite 7 does an excellent job of seamlessly integrating into your current workflow. In this section you'll learn the different ways of working on files from Lightroom, Apple Aperture, and Photoshop, as well as directly from inside of Perfect Layers.

Working from Perfect Layers

NOTE

If you're working in Photoshop then you're already using a layer-based image editor, and so you will not be able to access Perfect Layers from inside of Photoshop. Instead you can go directly to the product you want to use; either choose File > Automate or use the onOne Extension panel.

One of the easiest ways to work in the Perfect Photo Suite is directly from inside Perfect Layers. This software is completely standalone, which means that it doesn't require the use of other host applications to make it work (in fact, nearly all of the images processed for this book were pulled directly from the Browser in Perfect Layers). For more detailed information on working inside of Perfect Layers, please see Chapter 2, "Perfect Layers."

What's great about Perfect Layers is that it allows you the ease of staying within the Perfect Photo Suite while also using other individual products in the suite. This way you can jump from either Lightroom or Aperture into Perfect Layers, jump in and out of the other products (such as Perfect Effects or FocalPoint) and also stay inside of the suite until your work is finished.

Working from Lightroom

There are two ways you can open a file from Lightroom into the Perfect Photo Suite. First, you can choose File > Plugin Extras and then select the product you would like to open your image in. You can access any of the products through this method, including Perfect Layers. Also, you can choose Photo > Edit In and then select your product (or right-click the image to access the same menu command; see **FIGURE 1.16** for an example). When using the Edit In method you will be unable to edit your photo in Perfect Layers or Perfect Mask; instead you will need to choose File > Plugin Extras to use those products.

HOT TIP

If you highlight more than one image in Lightroom, right-click the selection, choose Edit In, and then select one of the Perfect Photo Suite 7 products, you can quickly batch all of the photos selected. Just apply whichever settings you would like to the first image. After you click Apply, the Perfect Photo Suite will automatically batch process the remaining images with the same settings.

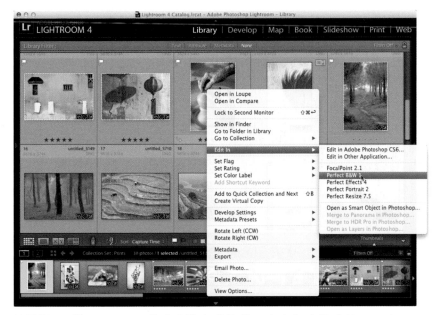

FIGURE 1.16 You can access Perfect Photo Suite 7 products by right-clicking your images inside of Lightroom.

NOTE

If you don't see the Perfect Photo Suite products appear under File > Plugin Extras then you'll need to add them manually. To do so, choose File > Plugin Manager and locate the plug-in files on your computer. You can find more information and instructions on the onOne Software support page at www.ononesoftware.com/support/1012.

If you choose the Edit In method you should be aware that the option you choose in the Edit Photo window will determine the file type of your saved image (**FIGURE 1.17**). Here are each of the settings in Lightroom and how they affect your images when working in the Perfect Photo Suite:

FIGURE 1.17 When editing non-RAW files from Lightroom you have options on how to process the file.

- **Edit A Copy With Lightroom Adjustments:** Choosing this option applies any of your changes made in Lightroom, opens the file into the Perfect Photo Suite, and saves your final image as a layered PSD file (or whichever file type you set in the Perfect Photo Suite preferences). If you prefer to work with and save layered documents, then this is the best option for you. This is also your only option when working from RAW files.

- **Edit A Copy:** This option edits a copy of the original file and saves the image in whichever file type the original file was saved. For example, if you use this setting to edit a PSD image in Perfect Effects, the software will be save your edits on a brand-new layer in a new file, which will show up next to your original image in Lightroom. If you use this setting with a JPEG or TIFF file, however, it will result in a new, flattened file (no layers) in either the JPEG or TIFF file format in Lightroom.

- **Edit Original:** This setting edits and saves all changes to the original file. Be cautious when using this option; I recommend it only if you are working from a PSD file and want to save your layers in the original file. Otherwise, if you edit and save from a JPEG or TIFF then your original file will be overwritten.

HOT TIP

If you want to open an image into the Perfect Photo Suite so that it launches directly into Perfect Layers without accessing any of the menu commands, just drag the image from either your file browser (Finder or Windows Explorer), Adobe Bridge, Lightroom, or even Aperture directly over to the onOne Software application icon on your computer. This will launch the Perfect Photo Suite and open your image directly inside of Perfect Layers.

Working from Aperture

To open an image from Aperture into the Perfect Photo Suite, choose Photos > Edit With Plug-in, and then select the product you would like to launch your image into. Alternatively, you can right-click the file and access the same menu command (**FIGURE 1.18**). After you save your edits and close out of the Perfect Photo Suite, the image will appear alongside the original as a layered PSD.

NOTE

Aperture allows you to save your files from the Perfect Photo Suite in the PSD file format only.

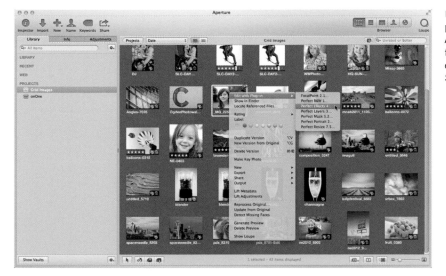

FIGURE 1.18 To process files from Aperture, right-click the files you would like to open in Perfect Photo Suite 7.

Working from Photoshop

If you use Photoshop and want to integrate the Perfect Photo Suite with your images, you can do so easily by using the onOne Extension panel (**FIGURE 1.19**). This panel installs automatically when you install the Perfect Photo Suite, and you can access it inside Photoshop by choosing Window > Extensions > onOne. From here you can launch any of the individual products from within the suite, and also apply any presets you have created or downloaded.

FIGURE 1.19 The onOne Extension panel allows you to quickly process images from Photoshop.

To use the onOne Extension panel, first make sure you have the layer you want to edit active in the Layers panel (**FIGURE 1.20**). Click the product you want to work in, and when you're ready to launch the product or apply a preset, just double-click the one you want to use (**FIGURE 1.21**). After applying your settings you will be brought back into Photoshop with the changes applied to that layer.

FIGURE 1.20 Before editing an image from Photoshop, make sure you have the layer selected you want to work on.

FIGURE 1.21 When you are ready to launch a product or apply a preset, double-click it inside the onOne Extension panel.

One of my *favorite* features of working with the Perfect Photo Suite inside Photoshop is its ability to function as a Smart Filter with Smart Objects (**FIGURE 1.22**). A Smart Object is a special layer inside of Photoshop in which the image's data is preserved; a Smart Filter is a filter you add to a Smart Object, which can be nondestructively re-edited and changed. For example, this would allow you to use FocalPoint to alter the depth of field in your image, but then go back and re-edit those Focus Bugs after you've already applied them. As long as you retain the Smart Object in your image, you can go back and edit the filters.

NOTE

Because Photoshop is already has a layered workflow, you are unable to launch Perfect Layers when working from inside of Photoshop.

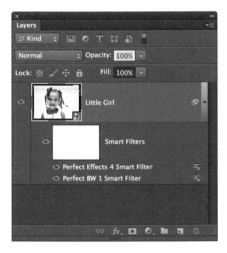

FIGURE 1.22 Smart Objects in Photoshop allow nondestructive editing of your files inside Perfect Photo Suite 7.

To edit with Smart Objects in Photoshop, first you'll need to create a Smart Object in Photoshop by selecting the layer you want to convert and then choosing Layer > Smart Objects > Convert To Smart Objects. Then, using the onOne Extension panel, launch the product you want to work on, make your changes, and click Apply. You'll then see a Smart Filters icon appear beneath your layer. You can also toggle the visibility of the filters with the eyeballs, and to re-edit the filter just double-click the one you want to work on in the Layers panel and that product will launch with the original edits still intact.

NOTE

Smart Object compatibility works only with Perfect Portrait, Perfect Effects, Perfect B&W, and FocalPoint.

Saving Images

By default, Perfect Layers saves your images as layered PSD files. By retaining the layers created in your document you can access it again in the future to make changes, and the PSD format will also allow you to open the file inside of Photoshop to do further manipulation and editing. If you prefer, however, you can also save your file as a different file type altogether.

> **NOTE**
>
> If you are working from a host application such as Lightroom or Aperture, then your file type will be determined by whatever your settings are in that software program.

To save your file as a PSD file inside of Perfect Layers, just choose File > Save. If it's the first time saving that document then a Save Image window will pop up and ask you where you want to save the file. You are also given the option of selecting the file type (PSD, PSB, TIFF, JPEG, or PNG). Type a new name for your document, select the location and file type, and then click Save. Now, as you continue working on your image you can continually save your progress by going to File > Save, or by using the keyboard shortcut **Cmd+S** or **Ctrl+S** (PC).

> **NOTE**
>
> A PSB file is an Adobe Large Document file for images larger than 4GB in size. A PNG file is a type of file that supports transparency and is a good choice when you want to save an image with transparency for the Web, for example.

If you would like to retain your saved layered PSD but also create a copy you can use in another environment, such as a JPEG to post online, then you'll want to use the File > Save As command. This then brings up the same Save Image window for you to select a new file type, name, and location for your file (**FIGURE 1.23**).

FIGURE 1.23 You can save additional file formats from your edited images in Perfect Layers by choosing File > Save As.

Working with Presets

One thing you'll probably want to do within many of the products is save and apply presets to your images, which you can do inside of Perfect Portrait, Perfect Effects, Perfect B&W, FocalPoint, and Perfect Resize. Presets are a great way to completely personalize your images and ensure that your own unique style is showing through. This section shows you some of the ways you can organize your presets inside of the Perfect Photo Suite.

Saving, Organizing, and Deleting

Saving a preset is relatively simple: After you've set everything up in whichever product you're working in, choose Preset > Save Preset. (The only exception to this is FocalPoint; please turn to Chapter 7 for more detailed information on saving presets inside of FocalPoint.) Each preset will be saved in the product in which it was created. If you would like to delete any of your presets, select the preset you want to delete from the My Presets tab, and then choose Preset > Delete Preset. A window will pop up asking if you're sure you want to delete it, and if so click Yes. If you click No, then the preset will remain intact.

If you would like to edit the information stored in the preset, choose Preset > Edit Preset Info. A window pops up allowing you to rename the preset and change any other data you added when you first created it (**FIGURE 1.24**).

FIGURE 1.24 To edit the details of an existing preset, choose Preset > Edit Preset Info.

You can also manually organize your preset files. Choose Preset > Show Presets Folder to open the folder on your computer where the preset files are stored. Here you can create new folders and reorganize them as you see fit (**FIGURE 1.25**).

FIGURE 1.25 You can access the presets folder on your computer by choosing Preset > Show Presets Folder.

HOT TIP

If you tend to create a lot of presets and use them often, I recommend that you keep a regular backup of your presets on an external hard drive or cloud service, such as Dropbox (https://www.dropbox.com) or Google Drive (https://drive.google.com). I store all of my presets in a folder in Dropbox; not only do I have a backup of the files in case something happens to them, but it also allows me to transfer them between computers.

Importing and Exporting

If you have presets you created in previous versions of the Perfect Photo Suite, or if you download presets from online, such as from the onOne Software Marketplace, then you'll want to get those into your new software, right? Or, maybe you want to save your current presets to install them on another computer, or share them with a friend. Here are the methods you can use to do both of these:

- **File > Import:** If you want to add presets to your My Presets tab from inside an individual product, choose Preset > Import Preset and navigate to the folder containing your presets. Highlight the ones you want to

import, then click the Open button. The Select Category For Imported Presets window will pop up; select your category from the drop-down (or create a new one) and click OK. Your new preset will appear in the My Presets tab on the left side of your screen.

- **Double-click to import:** A quick method to import one or more presets is to highlight and double-click them on your computer (you can also highlight them and choose File > Open to achieve the same result). The Perfect Photo Suite will recognize the files as preset files and automatically import them into your software. After you select a category, the suite adds the presets to the appropriate product automatically.

- **Import and export with drag and drop:** A more manual method of installing presets is to physically drag them from their saved location into the Preset folder. To do this, open the Preset folder by choosing Preset > Show Presets Folder, and then drag your preset into a folder in the Presets folder. Alternatively, you can copy presets from these folders and save them to other locations on your computer or a separate drive for backup or sharing.

NOTE

Make sure to close the product in the Perfect Photo Suite to which you are installing the presets when using this method or they will not install.

Batch Processing

When you want to apply one preset to a large group of images, batch processing is a great option for you. This can save you a lot of time and is a welcome feature in the Perfect Photo Suite. You can batch process from presets created in Perfect Portrait, Perfect Effects, Perfect B&W, FocalPoint, and Perfect Resize. Here's how to do this from Lightroom, Aperture, Photoshop, and Perfect Layers.

HOT TIP

When creating presets for batch processing with Perfect Portrait, it's best to create those that affect the skin only (not the eyes and mouth). For more information on Perfect Portrait, please see Chapter 4.

Lightroom

To batch process from Lightroom, follow these steps:

1. Make sure that you have an effect or a preset you want to apply to your images. This can be a preset from Perfect Portrait, Perfect Effects, Perfect B&W, FocalPoint, or Perfect Resize.

2. Highlight the images you want to batch process, and choose File > Export.

3. In the Export Files window, change the Export To setting to the product with the preset you want to use.

4. In the top section, select the appropriate choices from the Category and Preset drop-downs. Set your other settings as necessary for your project, and click Export (**FIGURE 1.26**).

FIGURE 1.26 The Lightroom Export window allows you to batch process several files through Perfect Photo Suite 7.

The Perfect Photo Suite will run through the process of adding the preset and saving the file.

Aperture

To batch process from Aperture, follow these steps:

1. Locate and highlight the images you want to batch process.

2. Choose Photos > Edit With Plug-in (or right-click one of the images to access the same menu command), and select the product you want to use to process your images (**FIGURE 1.27**).

 Aperture will prepare the images for editing, and then one of the photos will open up in the Perfect Photo Suite.

3. Make any changes you would like to that image, and then click Apply.

 After you click the Apply button, the Perfect Photo Suite will process all of the images you originally highlighted and save them back into Aperture (**FIGURE 1.28**).

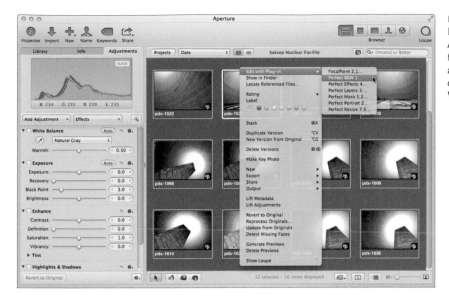

FIGURE 1.27 To batch process out of Aperture, highlight the files you want to use and either right-click or choose Photos > Edit With Plug-in.

FIGURE 1.28 After batch processing from Aperture the files will show up alongside your original images.

Photoshop

Batch processing from Photoshop is a little trickier, because you'll first need to create an action in order for it to work. Here's how:

1. Be sure that you have the Window > Actions panel open and one of the photos you want to batch opened inside of Photoshop.

2. Select a folder in the Actions panel (where you want to save the action), and click the Create New Action icon on the bottom of the panel. The New Action window will pop up; name the action, and click Record (**FIGURE 1.29**).

3. It's time to edit your photo with the Perfect Photo Suite: Access the products through File > Automate; then select the product you want to use (**FIGURE 1.30**).

FIGURE 1.29 To start recording your action, click the Create New Action icon on the bottom of the Actions panel and give your action a name, then click Record.

FIGURE 1.30 To record a step in an action from a Perfect Photo Suite product, you need to access it by choosing File > Automate.

4. Edit your image just as you would in any other situation (it's not necessary to use a preset for this method). When you're finished, click the Apply button on the bottom right.

5. Click the Stop icon on the bottom of the Actions panel (**FIGURE** 1.31), and then close this image without saving. You're now ready to batch process your images with this newly created action.

6. To batch this process to your images, open Adobe Bridge and locate the files you want to batch. Highlight the images, and choose Tools > Photoshop > Image Processor.

7. Once inside of the Image Processor window, select the location you want to save the files, the file type, and the action you created at the bottom of the window (**FIGURE** 1.32). Click the Run button.

Photoshop and onOne Software will process the images with your settings and save them to the new folder.

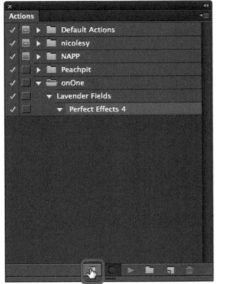

FIGURE 1.31 To stop recording your action, click the square icon on the bottom of the Actions panel.

FIGURE 1.32 The easiest way to batch images with an action is to use the Image Processor.

Perfect Layers

While you can batch process inside Perfect Layers, at this point you are only able to do batches from presets created in Perfect Resize. Other products will be integrated into the software on future releases. Until then, here's how to batch process images through Perfect Resize inside of Perfect Layers:

1. Make sure that the files you want to batch are grouped into a folder on your computer; then open Perfect Layers and choose File > Batch.

2. Under Source, click the Choose button and select the folder of images you want to batch.

3. Select the preset you want to use in the Perfect Resize section. You can just resize your images as well, without selecting a preset.

4. Select a destination folder, along with a file type and color profile, and you can rename the files as well (**FIGURE 1.33**). Click OK, and your images will be processed through Perfect Resize and saved to the new destination.

FIGURE 1.33 The Perfect Photo Suite allows you to batch images from Perfect Resize from inside of the suite.

Composite image created using layer masking inside of Perfect Layers.

Nikon D200, 14mm, 1/125 sec at f/5.6, ISO 100

PERFECT LAYERS

Perfect Layers, in all its simplicity, is a very powerful product in the Perfect Photo Suite lineup. It not only lets you make changes to individual layers within a document, it also allows photographers to use the Perfect Photo Suite as a standalone product—in other words, you don't need other host software to open up and use Perfect Layers.

The Perfect Layers Interface

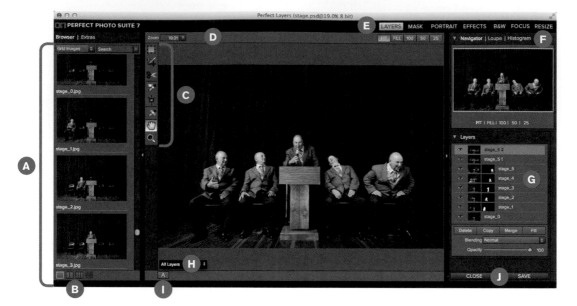

A Browser and Effects pane
B Browser modes
C Tool-well: Transform, Crop, Trim, Masking brush,
 Masking Bug, Retouch brush, Hand tool, Zoom tool
D Tool Options bar
E Module selector

F Navigator, Loupe, and Histogram
G Layers pane
H Mask View mode
I Preview mode
J Close and Save buttons

When to Use Perfect Layers

The whole point of having Perfect Layers is to provide a layered workflow
without having to jump in and out of Adobe Photoshop or a similar program.
In fact, many photographers these days do the majority of their image edit-
ing (if not all of it) in programs like Adobe Lightroom and Apple Aperture.
Unfortunately, those programs don't support layers in their workflows, but
Perfect Layers offers a solution. With it, you can add layers support to
Lightroom or Aperture, or you can open and edit images directly inside of the
Perfect Photo Suite as a standalone product.

Why use Perfect Layers? Here are some things you can do:

- **Swap heads:** When photographing a group of people, sometimes it's difficult to get everyone smiling and looking their best in one frame. With Perfect Layers you can easily mask faces and heads from one image into another.

- **Blend layers:** Perfect Layers offers several blending modes, along with an opacity setting to creatively blend your layers together.

- **Edit nondestructively:** When you work with layers, you can make changes to your image without destroying any of the pixels on the original image.

- **Create collages and custom album pages:** Perfect Layers lets you resize, mask, and stylize images. You can then place them on album-page templates or create your own pages.

- **Work from a PSD file:** You can open Photoshop .psd files within Perfect Layers with many of the layers intact.

Layers, Blending, and Masking

Before you dig too deep into Perfect Layers, you need to understand the fundamentals of layers, blending, and masking. Learning these techniques will vastly improve your efficiency when post-processing and will also open up endless creative possibilities.

What Are Layers?

Imagine you have a printed photo lying flat on a table (**FIGURE 2.1**). Now, set a piece of black construction paper on top of the print (**FIGURE 2.2**). You can't see the print anymore because it's covered up, but what if you cut a hole in the center of the black paper (**FIGURE 2.3**)? Voilà! The print is now showing through. Do you see where I'm going with this?

FIGURE 2.1 Start with your photograph—the base layer.

FIGURE 2.2 Add a layer above it.

FIGURE 2.3 Cut a hole and the layer acts like a mask so the image shows through.

Using layers in post-processing software is identical to adding physical layers of paper on top of one another, but with all the advantages and flexibility that technology adds (**FIGURE 2.4**). Layers allow you to create composite images or control the blending of adjustments and other layers to your images below. They also give you the *huge* advantage of nondestructive image editing, which means you can edit a photo, re-edit, fix changes, start over, or add on to existing edits without losing the original version. In other words, layers are an extremely powerful post-processing tool, and it's to your advantage to master and use them with your photographs.

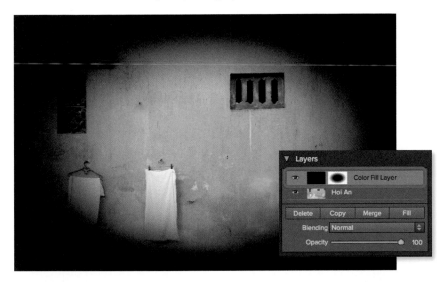

FIGURE 2.4 These two images show a software creation of a black layer over the photo, with a hole "cut out" of the middle using layer masking. The second image shows how you can blend those layers together using blending modes and opacity settings.

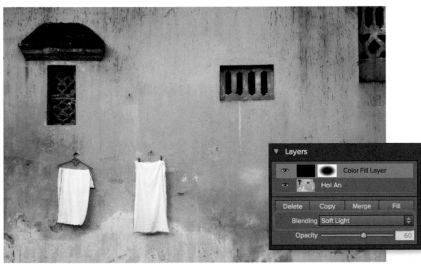

HOT TIP

The order of your layers in the Layers pane greatly determines how each layer appears in your final image. For example, the image on top will either cover up or blend in with the layers below it, depending on your settings. You can rearrange the layers in the Layers pane just by dragging them up and down (FIGURE 2.5).

FIGURE 2.5 The image on the left shows two layers in the wrong order, so to rearrange them I clicked on the top layer (cloud image) and dragged it down below the image of the church.

Layer Blending and Opacity

When you have two or more layers in your Layers pane, those layers will usually interact with each other in some way, and you can change their interaction by changing a layer's blending mode and Opacity. Both of these options are at the bottom of the Layers pane on the right side of the window.

Blending Modes

Perfect Layers offers 24 blending modes (**FIGURE 2.6**) you can use to stylize and alter the look of your images. Although some of the modes produce predictable results, it's often beneficial to scroll through the list while changing the mode to see how each changes your image's look. In fact, I highly encourage you to play with the blending modes to see what they do to your photographs—you just might discover something new along the way. Here's a quick preview of some of the most commonly used modes:

FIGURE 2.6 Because Perfect Layers offers the same 24 blending modes as Photoshop, you can easily swap projects between programs.

- **Lighten and Darken:** Not surprisingly, these two blending modes lighten and darken your image, respectively, while also working from the colors in the layer. If you select Lighten mode, then in the layers below, Perfect Layers will replace the colors that are darker than the blending color; all other colors remain unchanged. Because you're replacing dark colors with a lighter color, the resulting image appears lightened overall (**FIGURE 2.7**). If you select Darken mode, then Perfect Layers replaces the colors from the layers below that are lighter than the blending color. Because you're replacing light colors with a darker color, the effect is an overall darkening of the image (**FIGURE 2.8**).

- **Screen and Multiply:** At the very basic level, these modes also either lighten (Screen) or darken (Multiply) your image but don't *replace* colors the same way the Lighten and Darken blending modes do. They will, however, add a tint of the color you are blending in with your other layers (**FIGURES 2.9** and **2.10**). These modes are extremely useful if you want to quickly adjust the tones in an image from within Perfect Layers by blending in a copy of the original image with one of these blending modes (**FIGURES 2.11, 2.12,** and **2.13**).

FIGURE 2.7 The Lighten blending mode creates an interesting lightening effect to a red textured layer over an image of a flower.

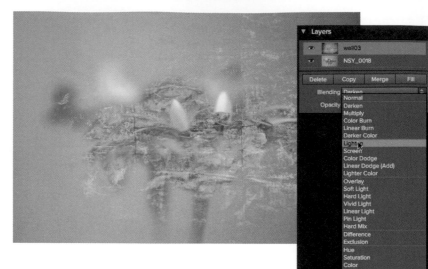

FIGURE 2.8 This is the same image as in Figure 2.7, but with the Darken blending mode applied.

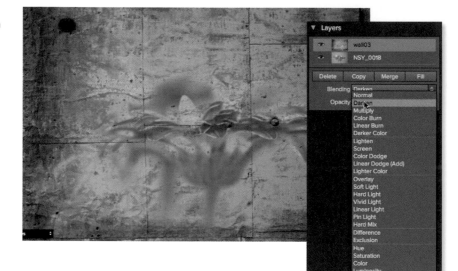

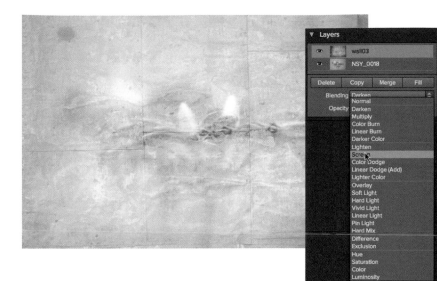

FIGURE 2.9 The Screen blending mode softly brightens the image.

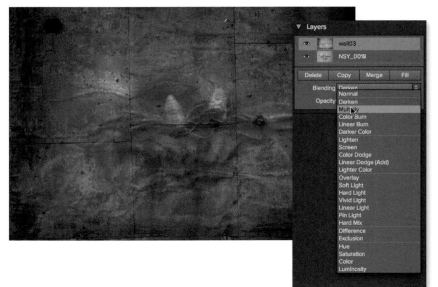

FIGURE 2.10 The Multiply blending mode adds a darkening effect to the image.

FIGURE 2.11 This figure shows a duplicated layer with the Normal (default) blending mode applied.

FIGURE 2.12 Changing the blending mode to Screen brightens the entire image.

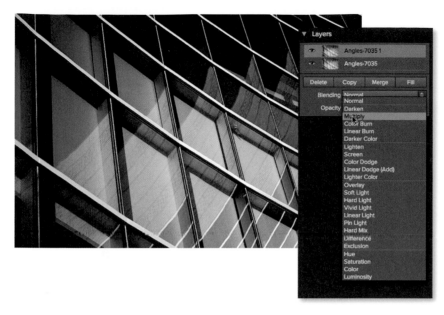

FIGURE 2.13 Changing the blending mode to Multiply darkens the entire image.

- **Overlay:** This blending mode adds contrast to your image by brightening the light areas and darkening the dark areas. More specifically, Overlay mode brightens anything lighter than 50% gray and darkens anything darker than 50% gray (**FIGURE 2.14**). If you use this blending mode with a layer that has color in it, then you'll also see some of that color transfer over to parts of your image.

- **Soft Light and Hard Light:** These two blending modes are similar to Overlay mode, but with different intensities. Soft Light adds a subtle contrast to the overall image and also adds a slight color tint if the blending layer differs from the layers below (**FIGURE 2.15**). Hard Light, on the other hand, is very much affected by the luminosity of the layer it's working with and affects the layers beneath accordingly (a lighter color brightens the image, whereas a darker color darkens the image). It's also more likely to blend the layer's colors in with the layers below very harshly (**FIGURE 2.16**).

- **Color:** Color mode *only* blends the colors of your blended layer with the layers below and does not affect the contrast or tones of your image. It's a good way to add a tint to a black-and-white photo, warm up an image, or cool it down (**FIGURE 2.17**).

FIGURE 2.14 The Overlay blending mode is a great choice for black and white textures; it blends the texture with the image and also adds contrast.

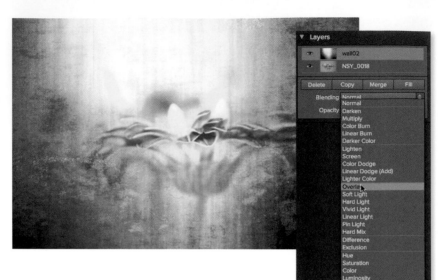

FIGURE 2.15 The Soft Light blending mode is a much softer version of the Overlay blending mode.

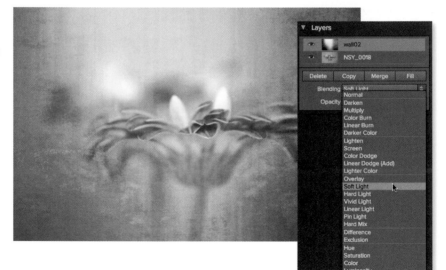

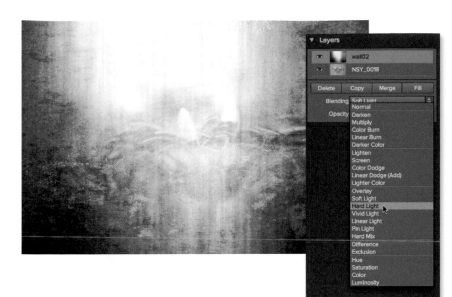

FIGURE 2.16 Using the Harsh Light blending mode is a harsher blend of both Overlay and Soft Light.

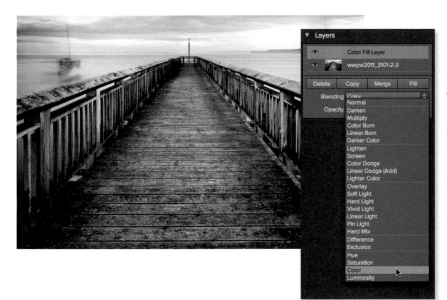

FIGURE 2.17 The Color blending mode is a good way to add a color cast to an image, as I did with this black-and-white photo. The soft brown layer blended with the Color blending mode gives the image a sepia look.

HOT TIP

To view changes from a blending mode, you need at least two layers in the Layers pane and you should apply the blending mode to one of the top layers. In other words, do not apply blending modes to your very bottom layer.

Opacity

Another way to blend your images together is by changing the layer's Opacity setting, which determines how much of the layer you can view and how much of the layers below will show through. The Opacity slider ranges from 1 to 100 percent, and by default most layers will be set to 100% (**FIGURES 2.18**, **2.19**, and **2.20**). You can change the setting by dragging the slider to the left, use a keyboard shortcut (number keys 0 through 9), or type the percentage in the field.

FIGURE 2.18 Set at 10% opacity, the blue Color Fill layer above the flower layer is very faint.

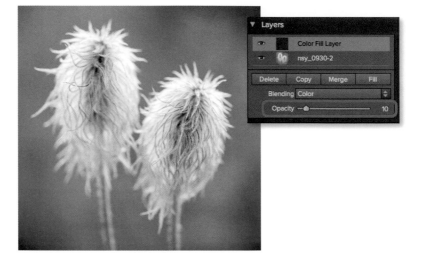

FIGURE 2.19 At a 50% Opacity setting the blue Color Fill layer is more apparent.

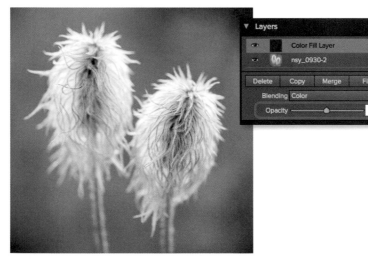

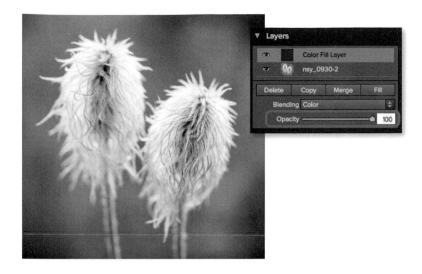

FIGURE 2.20
Increasing Opacity to
100% makes a dra-
matic difference.

HOT TIP

The quickest way to change a layer's opacity is by using keyboard shortcuts. Make sure
your layer is highlighted in the Layers pane, and press the appropriate number key; 1
changes the opacity to 10%, 2 to 20%, and so on. To set the opacity to 100%, press the
0 key.

Basic Masking

One of the biggest reasons people use layers is to do layer masking. *Masking*
is a process of hiding parts of a layer so that the layer below shows through
(**FIGURE 2.21**). This, like layers, opens up limitless possibilities with post-
processing. You can combine images, create realistic composites, and
selectively adjust specific parts of an area. The best part is that masks are
completely re-editable. Because you're not actually *deleting* any pixels, you
have the ability to bring them back and make changes down the road.

Black Conceals, White Reveals

The main, and most basic, masking concept to master is this: *Black conceals,
and white reveals*. When you apply a mask to a layer, the parts of the mask
that are white are visible and the parts of the mask that are black are hidden
(**FIGURE 2.22**). Also, any shade of gray hides the mask as well, just at a lower
opacity than 100% black. In the Perfect Photo Suite, when you set a brush
to Paint In the brush will paint with *white*. When you set a brush to Paint Out,
the brush will paint with *black*.

FIGURE 2.21 This is an example of masking inside of Perfect Layers. I masked the white background out of the skateboard image to reveal the clouds in the layer below.

FIGURE 2.22 In this grayscale preview of the mask the areas in black are hiding the layer (the white background behind the skateboarder), whereas the areas in white reveal that layer (the skateboarder). To access this type of preview choose View > Mask View Mode > Grayscale.

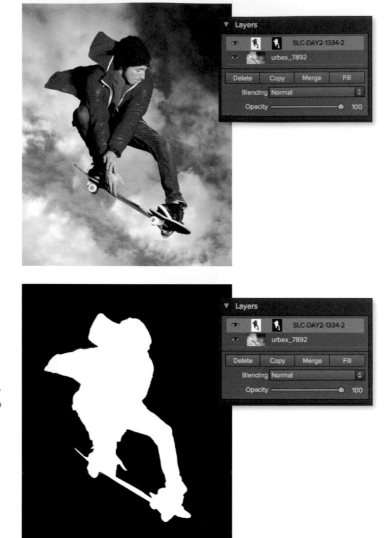

NOTE

There are some limitations with certain Photoshop layers and masks inside of Perfect Layers. Please see Chapter 1, "Getting Started," for more information.

The best part about using masks is that they are completely nondestructive. Because you can continually paint the mask in and out, you don't have to worry about erasing anything that you unintentionally mask out. Also, another great thing is that any mask you create inside of the Perfect Photo Suite with either Perfect Layers or Perfect Mask will translate to a layer mask in Photoshop (**FIGURE 2.23**). You can also open up .psd files with masks created inside of Photoshop and manipulate them inside of the Perfect Photo Suite as well.

FIGURE 2.23 This is the same image opened up in Photoshop CS6; notice how the layers and masking look identical to those inside of Perfect Layers.

The Mask

Now, you might be wondering where these masks actually *exist* in your image, and the answer is pretty simple: in the Layers pane. You won't see a mask until you start actually using a Masking brush or Masking Bug, in which you will be painting with black (or painting out) and then the mask will appear to the right of the image thumbnail (**FIGURE 2.24**).

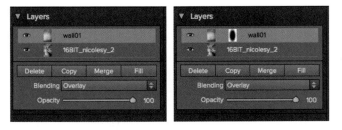

FIGURE 2.24 The Layers pane on the left shows a layer before masking was applied. The right pane shows the layer after masking was applied.

Using Perfect Layers

One of the great things about Perfect Layers is that it enables you to run Perfect Photo Suite entirely on its own without any external software to launch its programs. Because it provides a layered workflow, it also serves as

NOTE

To learn how to open your files into Perfect Layers from Lightroom or Aperture, please turn to Chapter 1.

NOTE

For information on compatibility with file types in Perfect Layers, please turn to Chapter 1.

a home base for your projects. Perfect Layers is not just a place to push your photos in and out to the other products; it also allows you to perform powerful edits and other major transformations.

Getting Started

When you open Perfect Photo Suite, Perfect Layers is the first module to appear. From within Perfect Layers you can perform masking, editing, cropping, transforming, and much more to your images, but first you have to get the images into the software. You can open images and start your projects when working from Perfect Layers, Adobe Lightroom, or Apple Aperture.

Opening Images Within Perfect Layers

On the left of your screen, look for the vertical pane labeled Browser | Extras. This is an easy way to access your files if you have images ready to go in a folder on your computer. From the Browser you can view your images in four ways: List view and three different column views that you can change by using the controls on the bottom left of your screen (**FIGURE 2.25**). To access a specific folder in this pane, go to File > Browse and navigate to the desired folder (**FIGURE 2.26**). If your folder has subfolders, the Browser lists them as drop-downs (**FIGURE 2.27**).

FIGURE 2.25 You can change the way Browser displays your images by clicking the icons on the bottom of the Browser pane.

FIGURE 2.26 To change the folder visible in the Browser pane, choose File > Browse.

FIGURE 2.27 Subfolders in the Browser folder appear as drop-down folders.

To open a file, double-click on the image in the Browser. The file will appear in the Preview window. (You can also highlight your image and choose File > Open Selected From Browser to get the same result.) To add more than one file at a time, just highlight the images in the Browser by holding the **Cmd** or **Ctrl** key (PC) while selecting your images and double-click one of them; Perfect Layers loads the images into one document as multiple layers (**FIGURE 2.28**).

If you want to add additional images as layers to your document, then double-click a file from the Browser or choose File > Add Layers From File. Perfect Layers will ask you if you want to add the selected image as a new layer or if you want to create a new image (**FIGURE 2.29**). To add it as a layer click Add; the new layer will appear in the Layers pane.

Another option in Perfect Layers is to create a brand-new blank file, which is a good option to use if you want to create a collage or composite from scratch (among other things). You can do this by choosing File > New in the menu bar, then entering your settings in the window that pops up (**FIGURE 2.30**).

NOTE

You can also open files by choosing File > Open in the menu bar and locating them on your computer.

HOT TIP

Perfect Layers has a selection of pre-installed backgrounds you can use with your images. You can access these from the Extras pane. Just click on the Backgrounds folder up at the top, browse through the selection, and then add the file as a new layer by double-clicking the image.

FIGURE 2.28 You can highlight multiple images in the Browser pane to open them at the same time.

FIGURE 2.29 Click Add to add your image as a new layer, or click New to create a new document from that file.

FIGURE 2.30 You can create a brand-new blank file by choosing File > New in the menu bar.

The Layers Pane

When you open an image into Perfect Layers, the most important pane is the Layers pane. Look for it on the right side of your window, just below the Navigator (**FIGURE 2.31**). From here you'll be able to change, remove, edit, and control the layers in your document. Perfect Layers is very powerful, and you may be surprised at the number of possibilities that exist just from stacking one image layer on top of another.

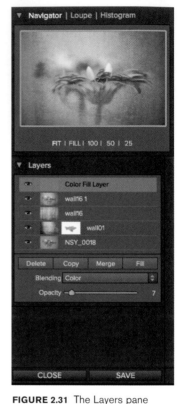

FIGURE 2.31 The Layers pane is your control center in Perfect Layers.

> **NOTE**
>
> If you're working on a .psd document created or edited inside of Photoshop, you may run into compatibility issues with certain types of layers. Although Perfect Layers can read and create .psd files, it is still limited in the kinds of layers it supports. If your document contains any of these unsupported layers, then Perfect Layers will prompt you to open your file as a merged composite. More information on .psd layer compatibility and limitations is in Chapter 1.

Layer Visibility

Next to each layer in the Layers pane, notice an eyeball icon (**FIGURE 2.32**). This icon indicates that the layer is visible.

To hide a layer, click the eyeball; the icon changes to a "closed eye" eyelid (**FIGURE 2.33**). You can also press and hold the **Opt** or **Alt** (PC) key while clicking the eyeball of a visible layer to show that layer while hiding all other layers. Toggling layers on and off is a great way to preview your image with different layers applied, such as when you are trying out different backgrounds and need to preview them quickly.

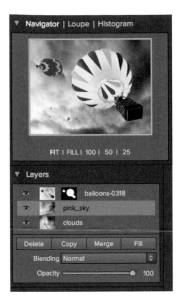

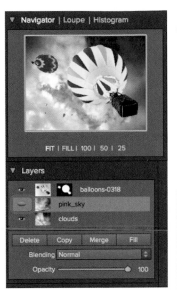

FIGURE 2.32 (left) This image of a hot air balloon has the sky replaced by pink puffy clouds, but there is also a layer below with a different type of sky.

FIGURE 2.33 (right) By clicking the eyeball icon of the pink clouds layer it hides it, revealing the layer below.

HOT TIP

Renaming your layers is a great way to stay organized. Double-click the layer's name in the Layers pane to highlight the text, then type in your new name and press **Return** or **Enter** (PC).

Copy and Delete

At times you may want to duplicate a layer (or layers) from the Layers pane. For example, maybe you want to add a subtle adjustment with a blending mode or copy the background layer to mask it with a layer edited in, say, Perfect Effects. To do this, just highlight the layer (or layers) you want to duplicate and click the Copy button in the Layers pane (**FIGURE 2.34**). You can also access this feature from the menu by choosing Layer > Duplicate, or by using the keyboard shortcut **Cmd+J** or **Ctrl+J** (PC). All methods create an exact duplicate of the selected layer, retaining its related information such as masking and blending modes.

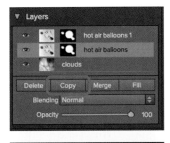

FIGURE 2.34 You can easily duplicate layers in the Layers pane by clicking the Copy button.

If you want to delete a layer, select it and click the Delete button in the Layers pane (**FIGURE 2.35**). Alternately, you can choose Layer > Delete or press the **Delete** or **Backspace** (PC) key. Just be sure that you're deleting something you no longer need. Once it's deleted then that layer is gone forever, and your only hope to retrieve it is by undoing the action using **Cmd+Z** or **Ctrl+Z** (PC).

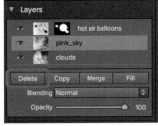

FIGURE 2.35 Use the Delete key to remove unwanted layers.

Merge, Copy, and Composite Layers

One thing to keep in mind when working with layers is that even though the Preview window displays the composite image, you probably pieced several layers together to create that composite. If you want to push the pieced-together image into one of the other products, such as Perfect Effects, you would need to make sure that you're working on an image with all of the edits and effects you've applied in Perfect Layers.

For example, let's say the topmost layer in the Layers pane is a texture layer with a blending mode applied to your image (**FIGURE 2.36**). If you were to click on that layer and then go into Perfect Effects you would only be editing the topmost layer of your image (the texture layer) when you probably intended to run Perfect Effects on the entire *composite* of your image, which includes all the layers, edits, and blending you applied in Perfect Layers (**FIGURE 2.37**).

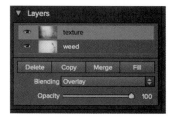

FIGURE 2.36 This is the Layers pane in Perfect Layers with the texture layer selected.

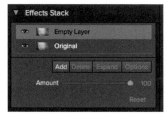

FIGURE 2.37 When moving from Perfect Layers to another application, be sure you first select the correct layer. Here Perfect Effects pulls the selected layer from Figure 2.39, meaning it will add effects to only the texture layer.

You can do this a few different ways, and all of them are listed under the Layer menu at the top of your screen:

- **Merge Layers:** This option merges, or combines, the selected layer with the layer below it (**FIGURE 2.38**). Selecting Layer > Merge Layers wipes out any blending modes you previously applied, however, so you may need to add them after the fact. Be certain that you have completed any and all edits to your image because you will lose the ability to make changes to the original layers once you merge them. This option is also a button in the Layers pane.

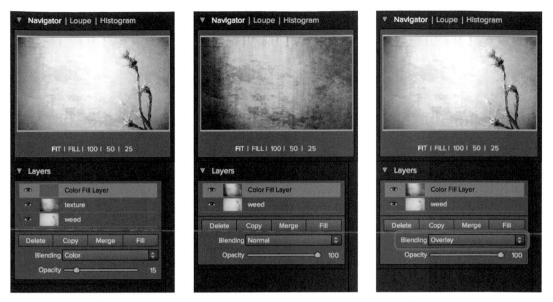

FIGURE 2.38 This sequence shows an image with three layers. The top layer is selected (left), the top two layers were merged by choosing Layer > Merge Layers (middle), and a blending mode was reapplied (right).

HOT TIP

If you make a mistake and merge your layers you can undo the command by pressing **Cmd+Z** or **Ctrl+Z** (PC) on your keyboard, or go to Edit > Undo. If you save and close your file, however, you will lose the ability to undo.

• **Merge All Layers:** This option combines all of the layers in the Layers pane into one single layer (**FIGURE 2.39**). Again, be certain you no longer need any of the original data in your layers before choosing this option, as you will be unable to make changes to the originals once you merge the layers them together.

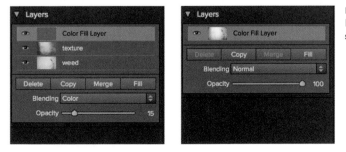

FIGURE 2.39 When you merge all layers together, all layers are smooshed into one combined layer.

- **New Stamped Layer:** Similar to Merge All Layers, this option combines the selected layer with all the layers below it and creates a brand-new, merged layer (**FIGURE 2.40**). The advantage of choosing Layer > New Stamped Layer is that you retain all of the original layers without losing any data. If you want to create a merged composite image of all of the layers in the Layers pane, make sure you select the topmost layer. If you prefer to work in a nondestructive environment, New Stamped Layer will be your best option.

FIGURE 2.40 Creating a new stamped layer allows you to retain the layer data below while having a merged layer on top.

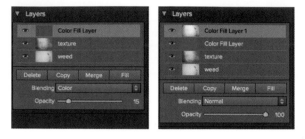

Color Fill Layers

Color fill layers are a great way to get creative and add simple effects to your images. To add a color fill layer, click the Fill button in the Layers pane. You can also use the menu bar: Choose Layer > New Color Fill Layer. In the Color Fill window, select a preset or customize the layer's look with the layer properties (**FIGURE 2.41**). At any time if you wish to make changes to the color fill layer, such as selecting a different color or preset, select the color fill layer and choose Layer > Edit Color Fill Layer.

FIGURE 2.41 I used the Tobacco preset with my Color Fill layer to give this image a warmer tone.

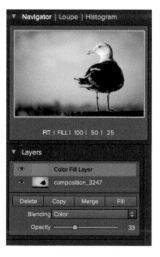

Masking Tools

Throughout several of the products in the Perfect Photo Suite you'll be able to mask your images in many different ways. Here inside of Perfect Layers you will find the most basic masking tools. You can create simple composites as well as make isolated adjustments to specific parts of an image. The great thing about masking in Perfect Layers is that it's compatible with both Perfect Mask and Photoshop; you can create masks in Perfect Layers and edit them in Perfect Mask or Photoshop, and vice versa.

The Masking Brush

The most basic brush in the Perfect Photo Suite, the Masking brush enables you to do simple masking to your layers. To use it, click on the Masking Brush icon in the tool-well and start painting over the area you want to change (**FIGURE 2.42**). Make sure you have the proper layer selected in the Layers pane before painting, however, or you may end up masking the wrong image.

FIGURE 2.42 You can find the Masking brush in the tool-well.

Here are some of the Masking brush settings you'll find in the Tool Options bar:

- **Paint In and Paint Out:** By default, the Masking brush is set to Paint Out, which means that you will be hiding the area you brush over (**FIGURE 2.43**). If you want to bring back an area you previously painted out, just click the button to toggle it to Paint In. Now, when you paint, you will be able to bring back an area you originally masked out.

FIGURE 2.43 Use the Paint Out mode to mask out the current layer; for this example I'm masking out a boring sky and replacing it with clouds.

- **Size:** The Size setting determines how large the Masking brush is and ranges from 0 to 2500. You can change this setting on the fly by pressing the left bracket key ([) to decrease brush size and the right bracket key (]) to increase the size.

- **Feather:** This setting determines how soft or harsh the edges of your brush will be when you paint. A larger number results in softer edges, and a smaller number results in harsher edges.

- **Opacity:** The Opacity setting refers to the percentage of the brush stroke that's visible when you paint. A low setting produces a very light, translucent brush stroke, whereas a high setting results in a much more opaque brush stroke. When you want to do subtle masking to a layer and build up a mask slowly, paint over and over at a low opacity.

- **Perfect Brush:** The Perfect Brush option is very useful and can aid in controlling the area you are brushing over. To activate the Perfect Brush, click the check box in the Tool Options bar. When you click in your image, the brush analyzes the color at its center (the crosshairs) and masks out *only* similar colors. If the crosshairs of the brush cross over into a new color, the Perfect Brush will start using that color as its guide and then mask out new similar colors. This is a great tool to quickly make selective adjustments to specific areas of your image (**FIGURE 2.44**).

FIGURE 2.44 Using the Perfect Brush option allows you to quickly paint around edges.

The Masking Bug

The Masking Bug is perfect for creating soft transitions of masking between one layer and another. It's called a bug because of its antennae, which enable you to change its settings (**FIGURE 2.45**). In addition, you can change many of these settings in the Tool Options bar. To add a Masking Bug to your layer, click on the Masking Bug icon in the tool-well and then click somewhere within your image. When you apply the Masking Bug to a layer it, by default, adds a rectangular-shaped mask that you can resize and edit to better fit your image's needs.

To move the Masking Bug around in your image, just drag the bug from its center. You'll see the changes (areas that are visible or hidden) as you move it around. You can also resize and rotate the bug by clicking and dragging on the small handlebars with solid-filled circles.

FIGURE 2.45 Here a round Masking Bug is applied over a texture layer.

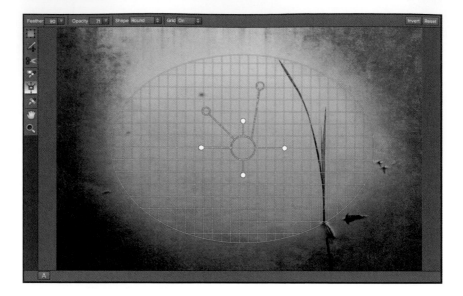

Here are some of the settings you can change with the Masking Bug:

- **Feather**: The Feather option refers to the softness (or hardness) of the bug's edge. For example, if you're using a round bug then the oval shape will be more defined when you set Feather to 0. Progressively higher values for Feather will produce a softer and softer edge (**FIGURES 2.46** and **2.47**).

FIGURE 2.46 (left) Masking Bug Feather is set to 0.

FIGURE 2.47 (right) Masking Bug Feather is set to 100.

- **Opacity**: The Opacity percentage determines how much of the mask is showing through and ranges from 0 to 100% (**FIGURES 2.48** and **2.49**). The setting's default is 100%, which means that the black areas of the mask are completely opaque. If you want to create a subtle adjustment with the Masking Bug, then you can do so easily by reducing the opacity.

FIGURE 2.48 (left) Masking Bug Opacity is set to 0.

FIGURE 2.49 (right) Masking Bug Opacity is set to 100.

- **Shape**: You can specify two bug shapes from the drop-down choices in the Tool Options bar: *Rectangle* and *Round*. A rectangle-shaped bug creates a rectangular area of masking that you can stretch from one end of your image all the way to the other (**FIGURE 2.50**). Rectangle bugs work great for creating a gradient of masking for skies and landscapes. The round bug creates a circular or oval area of masking that you use for creating circular-shaped adjustments or even vignettes (**FIGURE 2.51**).

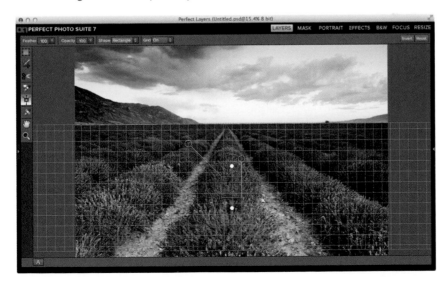

FIGURE 2.50 The rectangle-shaped bug works well for landscape images.

FIGURE 2.51 Use the round bug to create circular masks.

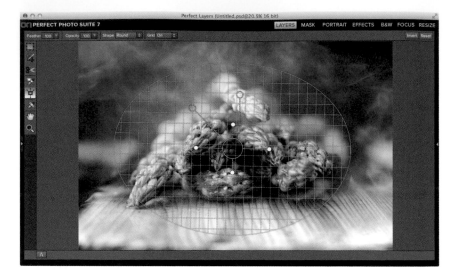

- **Grid**: When you move the bug or make changes using the antennae, the Masking Bug displays an overlay grid, which is helpful for resizing and placement. You can change the view settings of this grid by using the option in the Tool Options bar, or by choosing Mask > Masking Bug Grid Mode, then your preferred setting. *Auto* means the grid shows when you move or click on the bug but is hidden otherwise. *On* ensures the grid always appears, whereas *Off* means the grid is off at all times.

There are a few additional things to keep in mind when working with the Masking Bug. For example, once you apply your Masking Bug and move to another tool, you can no longer make changes or edit the bug. Although you can edit your mask with the Masking brush, you can't reactivate the bug to make overall changes. Also, you can apply only one Masking Bug to a layer at a time. If you were to click the same mask with the Masking Bug after previously applying a Masking Bug, then the tool will remove your previous bug and start over with a new one. Also, make sure that you don't apply bugs to layers with existing masks or the new bug will overwrite them. If you want to make edits to your mask after applying a Masking Bug, you're better off just using the Masking brush. If the outline of the Masking Bug is interfering with viewing your image, you can reduce its opacity by choosing Masking > Masking Bug Tool Opacity and setting a lower percentage. A lower opacity will make it easier to see your image below while still being able to view the Masking Bug (**FIGURE 2.52**).

FIGURE 2.52 You can reduce the opacity of the actual bug itself— this shows the Masking Bug tool opacity set to 20%.

Additional Masking Features

You may find an occasional mask just doesn't go as planned. Maybe you need to invert your mask or even start again from scratch. Or, perhaps you just need to view the *actual* mask instead of the composite image. Here are some ways to do each of these (and more):

- **Invert Mask:** At times when you are working with a mask, or possibly a tool like the Masking Bug, the mask is reversed: The areas you want to show are hidden and those you want hidden are visible. The solution is to invert the mask so that the black areas are white and the white areas are black (**FIGURES 2.53** and **2.54**). To do this choose Mask > Invert Mask in the menu.

- **Reset Mask:** When you want to start your mask from scratch or completely remove it, choose Masking > Reset Mask in the menu.

- **Copy and Paste Mask:** Perfect Layers makes it possible for you to copy and paste your mask from one layer to another easily. All you need to do is highlight the layer with the mask you want to copy, choose Mask > Copy Mask, then highlight the layer you want to copy the mask to and choose Mask > Paste Mask. The mask will now appear in the both layers (**FIGURE 2.55**).

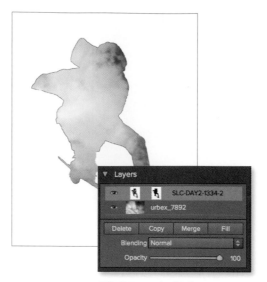

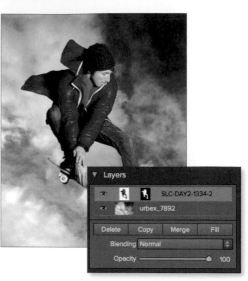

FIGURE 2.53 In this image the mask is reversed; my intention is to have the white background hidden and the skateboarder visible.

FIGURE 2.54 By choosing Mask > Invert Mask I inverted the mask so that the correct parts of the image are hidden and visible.

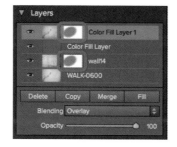

FIGURE 2.55 I was able to copy the mask from one layer and paste it to another by choosing Mask > Copy Mask and Mask > Paste Mask from the menu bar.

- **Show Mask:** When you want to view the actual mask, choose View > Mask View Mode and pick how you would like the mask to appear: All Layers, Red, White, Dark, or Grayscale. You can also use the black box to change the settings, located on the bottom-left of the Preview window (**FIGURE 2.56**).

FIGURE 2.56 Perfect Layers offers five Mask View modes (from left): All Layers, Red, White, Dark, and Grayscale.

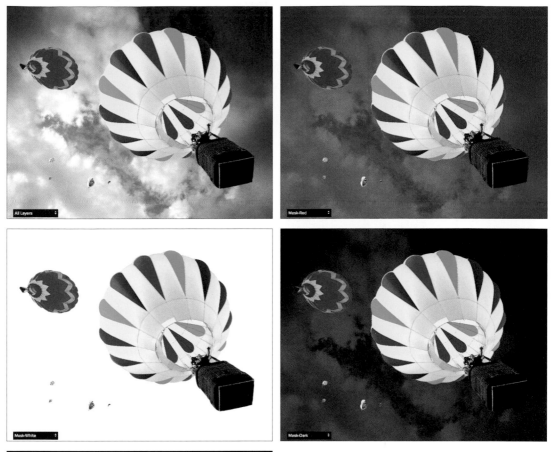

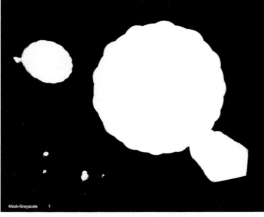

Transforming Your Document

Not only does Perfect Layers allow you to position your images in the Layers pane, it also allows you to transform those layers within the document, as well as change the size of the document itself. Here are the different ways you can make changes to both the image and canvas size in Perfect Layers.

The Transform Tool

FIGURE 2.57 You can find the Transform tool at the top of the tool-well.

When you want to rotate, resize, or move your layer within the document, you need the Transform tool. It's usually best to do only minor enlarging of your layers; otherwise you risk introducing artifacts and softening the image. Downsizing your images to smaller than their original size, however, is safer and will keep them looking their best.

To get started, click on the Transform tool in the tool-well (**FIGURE 2.57**). If you want to move the layer, just click anywhere in the layer and drag it to wherever you like. When you have the layer positioned where you want it, click the Apply button in the Tool Options bar. Click the Cancel button instead, and the layer will revert to where it originated.

To resize a layer, just hover over the one of the black points along its edges until a small arrow appears next to the cursor (▶↑), then click and drag to change the layer's size. If you want to keep your changes proportional, hold the Shift key as you resize. If you want the image to remain centered in the document, hold the **Option** or **Alt** (PC) key while dragging. To stay proportional *and* centered, hold both keys while dragging. When you're finished with your transformation, click the Apply button to finalize your resize.

To rotate your image, hover over the edge of the layer until the cursor changes into a circular icon (↻), then drag the layer in the direction you want to rotate it. Again, click the Apply button in the pop-up to finalize your rotation.

FIGURE 2.58 The Transform Tool Options bar is located at the top of the screen.

Width	4500	Height	3000	Scale	100	Rotation	0	Cancel	Apply	FILL

The Tool Options bar offers some additional ways to resize and transform your layer, especially if you want to have a bit more control over the process (**FIGURE 2.58**). Here is what each of these settings does:

- **Width and Height:** You can use these settings to enter the specific width and height of your layer. To change these settings, just double-click in the boxes and type the desired values; the default unit is pixels. You

can also use the up and down arrow keys to increase or decrease each setting incrementally. The Width and Height settings are also a handy way to reference the actual size of your layers.

- **Scale:** Specified as a percentage, the Scale setting changes the size of the layer. You can change the setting by using the slider, typing the number in the field, or clicking in the box and using the up and down arrow keys to change the setting incrementally. When you need to slightly increase or decrease the layer size, Scale is a good option to use.

- **Rotation:** The Rotation setting, listed in degrees, is for rotating the image. It's a useful alternative to the click-and-drag option when you need to do only minor adjustments to the layer, such as leveling the horizon in a landscape photo. To change the setting, you can drag the slider, enter a number in the field, or press the up and down arrow keys.

- **Cancel and Apply buttons:** These buttons respectively cancel and apply the changes you've made with the Transform tool. You can also use the Esc key (to cancel) or Return key (to apply changes).

- **Rotate and Flip buttons:** If you need to quickly rotate your layer by 90 degrees, the Rotate and Flip buttons are your quickest options. Clicking the Rotate button immediately rotates your image. To flip your image horizontally, click the Left/Right button on the Tool Options bar. To flip vertically, click the Up/Down button.

- **Fill:** If your image is too large or small and you want it to fit to the canvas size, click the Fill button to automatically resize it to fit the document. This usually works best when an image is too large for the document and you need to size it down.

The Crop Tool

The Crop tool will crop your entire document and all its layers. To get started, click the Crop tool in the tool-well. Next, click within the document and drag the crop out manually. You can gauge the size of your crop with the crop box that appears or check the crop's exact pixel size by looking at the Width and Height boxes on the Tool Options bar. You can also enter specific dimensions for your crop (in pixels) in the Width and Height fields, or you can move the box with your cursor or nudge the crop left, right, up, or down with the arrow keys.

If you want a good starting point, try the Fit To Layer or Fit To Canvas option on the top right of the Tool Options bar. When you click Fit To Layer, the crop box appears within the boundaries of the image in the layer you

HOT TIP

Be warned that all of the resize features are destructive edits, meaning that you cannot fully recover the original image after you apply the change (such as resizing, for example). Your only hope is to use the Undo command under Edit > Undo, or by using the keyboard shortcut Cmd+Z or Ctrl+Z (PC).

NOTE

The Fill button will distort your image if the proportions are not identical to your canvas size.

selected (**FIGURE 2.59**). You'll notice this more if your layer is smaller than the canvas size. If you click the Fit To Canvas button, the crop box will appear over your entire document (**FIGURE 2.60**). Fit To Canvas is a good option to use when you want to keep the crop proportional to the original canvas size; just hold the Shift key while cropping to maintain the proportion of the crop box.

FIGURE 2.59 Fit To Layer will fit the crop margins to the layer you have selected in your document.

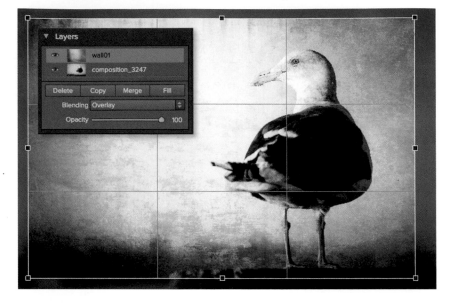

FIGURE 2.60 Fit To Canvas will fit the crop margins to the entire size of your canvas.

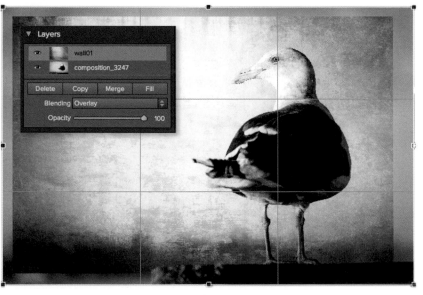

After you crop your image, all pixels outside of the crop box will be discarded. Make sure you will no longer need these pixels for resizing or moving. If you want to have more flexibility, be sure to use the Adjust Canvas Size option further along in this chapter.

The Trim Tool

If you want to maintain the current canvas size but need to trim down one layer, turn to the Trim tool. Trim is especially useful when you are creating a collage or album design and want only part of the layer to be visible. To trim a layer, click on the Trim tool in the tool-well, drag the trim box over the area you want to trim, then click the Apply button (**FIGURES 2.61** and **2.62**). That layer will be trimmed down to the size of the box you drew with your cursor. You can also enter your dimensions (in pixels) in the Width and Height boxes in the Tool Options bar, as well as use the arrow keys to increase or decrease the amounts. You can also use the number keys to nudge the trim box left, right, up, or down.

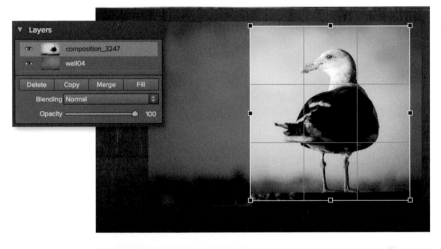

FIGURE 2.61 Select an area of a layer with the Trim tool to trim it down.

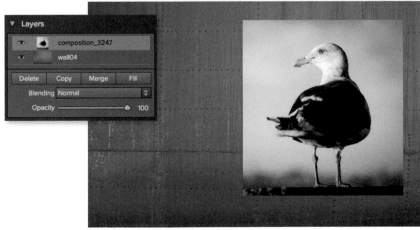

FIGURE 2.62 After you apply the trim, Perfect Layers trims down only the selected layer, leaving the rest of your image intact.

Adjusting the Canvas Size

What if you want only a portion of your image visible, but you still need to maintain the "excess" image data? Try resizing the canvas in Perfect Layers. With this option you won't see any of the image beyond the boundaries of the canvas, but those areas are still there (unlike when you choose Crop) and can still be edited and manipulated.

To adjust the canvas size, choose Edit > Adjust Canvas Size to access the Canvas Size window (**FIGURE 2.63**). The top part of this window shows you the current canvas size, and the bottom part enables you to change the size of your document. You can enter dimensions in the Width and Height fields, as well as select the units you want to use for the resize (inches, centimeters, or pixels). If you want to lock the proportions of your current canvas, make sure that the Lock Proportions box is checked at the bottom of the window.

FIGURE 2.63 Choose Edit > Adjust Canvas Size to access the Canvas Size window.

Finally, the Set To drop-down menu inside the Canvas Size window offers some resizing shortcuts. The three options you can choose are:

- **Current Layer:** Choose Current Layer to automatically set the new canvas size to the size of the selected layer. This is a good way to reduce the size of the canvas so that it fits to a smaller layer in your document.

- **All Layers:** Choose All Layers to set the new size to that of the largest layer on the canvas. This option is useful when you add a layer that is larger than the current canvas size and need to make it visible without transforming it.

- **Custom:** Use Custom when you want to select your own custom canvas size. Also, any time you enter specific values in the Width and Height fields the Set To setting automatically changes to Custom.

The Retouch Brush

The Retouch brush is a good tool to use when you have small areas you need to clean up in your image, such as dust spots or unwanted specks (**FIGURE 2.64**). To use it, just select the Retouch brush from the tool-well, then click or drag the cursor over the area you want to fix. Because this is a destructive edit (you permanently change the pixels on the layer you are retouching), be safe and copy the layer you want to retouch in the Layers pane first.

FIGURE 2.64 Select the Retouch brush and brush over an area to make dust spots and other specks disappear.

You can use three settings with this tool:

- **Size:** Ranging from 0 to 100, the Size setting determines how large the Retouch brush is. You can also change this setting on the fly by pressing the left bracket key ([) to decrease the size of the brush, and the right bracket key (]) to increase the size.

- **Feather:** This setting determines how soft or harsh the edges of your brush will be when you paint. Larger numbers result in softer edges, and smaller numbers produce harsher edges. It's usually a good idea to keep the Feather setting high so the brush edges are soft; that way you don't make noticeable edits with harsh transitions.

- **Opacity:** The Opacity setting specifies the percentage of the brush you use to paint. A low percentage produces a very light, translucent brush stroke, and a high percentage results in a much more opaque brush stroke. Most of the time you'll want Opacity at 100%, but if you need to do subtle changes then try setting this to a lower number.

Doing a Head-Swap

When photographing groups of people you probably won't always get everyone smiling and looking at the camera at the same time. So, by taking more than one image of the group you have a good chance of capturing everyone smiling at some point and then you can use masking to piece all of the faces together. In this image of my nephews and nieces I was hoping to get them all looking at the camera at the same time. I knew that probably wouldn't happen, so I created a few different photos. Then, using the Masking brush I was able to do a quick head-swap of my niece to get them all looking at me at once.

Step 1

I started off by locating the images in the Browser pane. Then, I held down the **Cmd** key while highlighting both images. Next I double-clicked one of the images to open them up as two individual layers in one document.

Step 2

In the top layer, my niece (the third one to the right) is looking right at me, but in the other photo she's looking away. So I used this photo to mask in only her face to the image below. The first thing I did was invert the mask by choosing Mask > Invert Mask, which then hid that layer and revealed the layer below.

Step 3

The last step was to use the Masking brush. In the Tool Options bar, I made sure it was set to Paint In, then I set Size to 150 and Feather to 53. Finally, I painted over her face. The resulting image has all of my nieces and nephews looking into the camera!

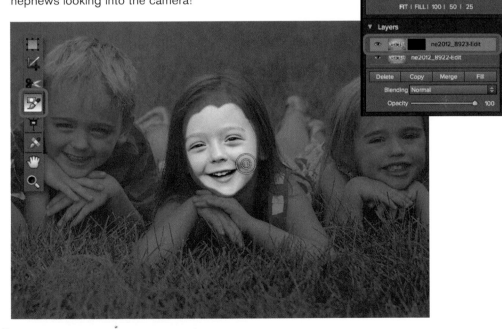

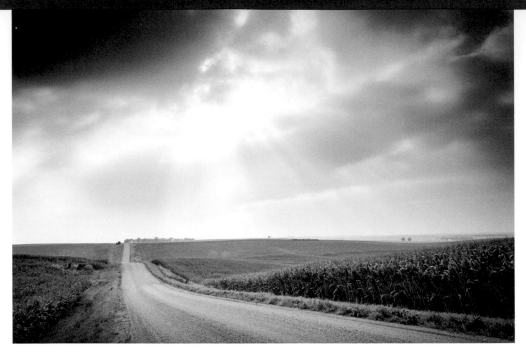

Exposure Blending with a Landscape Photograph

Photographing landscapes on a sunny afternoon means that you're probably going to have a very bright sky, especially when the sun is actually in your frame. That was the case with this image I photographed in Nebraska where the sun was much brighter than the fields. To capture everything at a proper exposure I needed to create two exposures and then blend the two together using a Masking Bug in Perfect Layers.

Step 1

I started off by locating the two images in the Browser pane. Then, I held down the **Cmd** key and highlighted both images. Next I double-clicked one of the images to open them up as two individual layers in one document.

Step 2

I wanted to use the sky image from the top layer and blend it into the land image on the bottom layer, so I decided to use a rectangular-shaped Masking Bug. I clicked on the Masking Bug tool and clicked in my image. Then I rotated the bug so it was over the image horizontally and moved it to the bottom of the window, keeping all other default Masking Bug settings intact. This covered up the dark foreground from the top layer and revealed the properly exposed foreground from the bottom layer.

Step 3

I wanted to add some contrast and color pop to the image, so I created a merged composite of the layers (by choosing Layer > New Stamped Layer) and then changed the blending mode of the new layer to Overlay. This added too much brightness to the sky, so I used the Masking brush to mask out those hot-spots. I set Feather to 100 and Opacity to 55, then I painted over the bright areas in the sky. The result is an image with a balanced exposure and a little bit of added color and contrast.

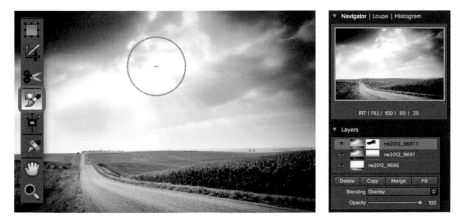

77

Creative Compositing

Layers and masking are so powerful. They allow you to create amazing composites and beautiful works of art. You can also set up interesting compositions with repeating elements, like with this photograph of one man on a stage. The key is to use a tripod so that your background element remains static, and then you move your subject and mask it all together with Perfect Layers.

Step 1

I started by selecting my six images in the Browser pane, and then chose File > Open Selected from Browser. Perfect Layers opened the images opened and added them as the individual layers in the Layers pane.

Step 2

My goal was to add the man into every chair on the stage using masking, and the very bottom layer was my "base" layer where I needed to mask the man into each seat. So, to get to that as a starting point, I hid all of the layers except for the bottom layer by **Opt-clicking** (**Alt-clicking**, PC) the eyeball next to the layer titled stage_0.

Step 3

Next I made the layer directly above it (stage_1) visible by clicking the eyeball, clicked the layer to activate it, and then went to Mask > Invert Mask. This hid the layer so I could start painting only in the areas that I wanted to reveal. So, using the Masking Brush set to Paint In, a brush Size of 250, Feather of 25 and at 100% Opacity, I painted over the far left chair to reveal the man from the layer stage_1. Notice the mask icon in the Layers pane; it shows white where the man is revealed in the image, and black where the layer is hidden.

Step 4

I repeated the previous step for each additional layer, painting over the corresponding area each time to reveal the man in that layer, until I was finished masking all of the areas in. For some of the layers, the light was a little different and the curtain had been moved, so there was an outline around the man.

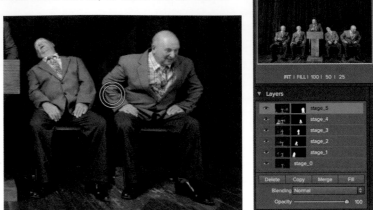

Step 5

To remove the bright outline so that only the man was masked in to the scene, I selected the Brush from the tool-well and used the Perfect Brush option in the Tool Options bar. I clicked on the Perfect Brush check box, switched the mask to Paint Out, and then kept the center of the brush over the curtain and floor to only affect those areas. I also switched over to the mask preview mode by clicking **Ctrl+M**.

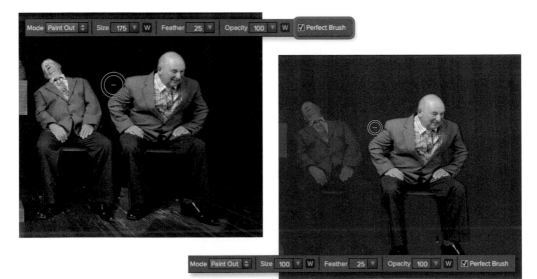

Step 6

As a final touch, I did some simple stylization of the image using blending modes. With the top layer was active, I chose Layer > New Stamped Layer to create a merged composite of the image. Then I changed the blending mode to Hard Light and reduced the Opacity to 50% to add some contrast to the photo. I created another merged layer (Layer > New Stamped Layer) and used the Retouch brush to clean up a few of the specks on the floor and podium.

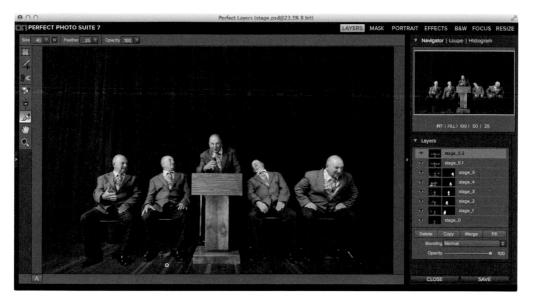

Seagull in Seattle; a composite image using two different photographs.

Canon 5D Mark II, 70-200mm lens, 1/2000 sec at f/4, ISO 100

Background: Canon 5D Mark III, 70-200mm lens, 1/20 sec at f/16, ISO 100. Processed using FocalPoint to add blur.

PERFECT MASK

I'll be honest, replacing backgrounds and compositing is not one of my favorite tasks. I'm a photographer, I love the creative process, but making selections and precision masks just feels like work. That's why I love Perfect Mask: It takes a lot of the work out of the process. This product is more than just a simple masking brush to paint your mask in and out; it includes specific tools to help you turn your images into beautiful composites in a matter of minutes.

The Perfect Mask Interface

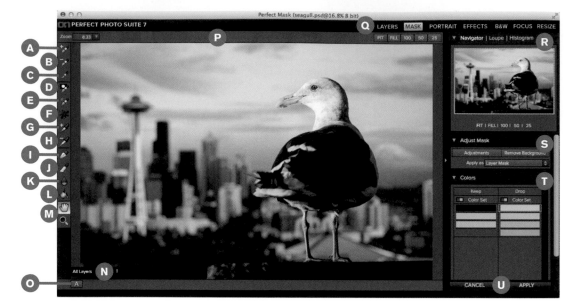

A Keep brush	I Pen tool	Q Module selector
B Drop brush	J Chisel tool	R Navigator, Loupe,
C Refine brush	K Blur tool	and Histogram
D Brush tool	L Paint Bucket	S Adjust Mask pane
E Magic brush	M Hand and Zoom tools	T Colors pane
F Color Spill brush	N Mask View mode	U Cancel and Apply buttons
G Keep Color eyedropper	O Preview mode	
H Drop Color eyedropper	P Tool Options bar	

When to Use Perfect Mask

Have you ever photographed a beautiful landscape scene with a gorgeous view but there wasn't a cloud in the sky? Or maybe you photographed someone in a studio and wanted to place him in a different scene after the fact. Perfect Mask allows you to do all of that and more! Here are just a few reasons to consider using Perfect Mask:

- **Replacing a sky:** This is probably one of the more popular uses for Perfect Mask. We cannot control nature, but we can fix it. If you find yourself in a situation where the scenery is beautiful but the clouds in the

sky are either nonexistent or just boring, then you can easily replace that sky with a different one.

- **Composite work:** Perfect Mask is a great way to remove and replace an existing background, studio backdrop, or scene. You might even find yourself reinventing and compositing old photographs with your new-found knowledge of this software.

- **Removing solid backgrounds:** Perfect Mask allows you to remove and replace a simple backdrop, such as a solid white background or green screen, very quickly.

- **Masking difficult subjects:** The tools in Perfect Mask are created specifically for tough subjects, such as flyaway hair and trees. You can even mask out photos with transparency, like water droplets, glass, or sheer material. Once you start using it, you'll find Perfect Mask to be a huge timesaver and be amazed at how well this product works with challenging subjects.

Using Perfect Mask

If you're new to masking, or even just new to Perfect Mask, this product may seem a bit daunting at first. Don't worry; it's relatively simple to use. The entire Perfect Photo Suite was created for photographers, by photographers. Once you start playing with the tools and features, you'll soon realize how intuitive and easy this product is to work with. You may also find yourself getting so excited about the software that you start searching through your photos to see how many good images could be transformed into great ones just by adding or replacing the background.

Getting Started

When you plan to mask an image, you probably have a visual idea of what you want to do with it. Typically, you'll need at least two images: the main image you want to mask and a replacement background photo. Your first step is to layer these images into a single document as a starting place for your work. You can do this several ways, including from directly within the Perfect Photo Suite using Perfect Layers, as well as from Adobe Photoshop, Adobe Lightroom, and Apple Aperture. Using whichever method you choose, open

> **NOTE**
>
> While this entire chapter is all about masking in Perfect Mask, the basics of masking are covered in Chapter 2, "Perfect Layers." Be sure to head on over there before getting too far into this chapter if you need a quick refresher.

your images as layers and select the image you want to mask (**FIGURE** 3.1).
Once you have your images ready to go, make certain to have the layer
you want to work on selected in the Layers pane, and then head on over to
Perfect Mask and start creating your mask!

FIGURE 3.1 Before
launching Perfect
Mask, make sure that
the layer you want to
work on is selected
in the Layers pane. In
this example I want to
remove the white back-
ground and replace
it with a blue sky, so
I selected the top
layer before launching
Perfect Mask.

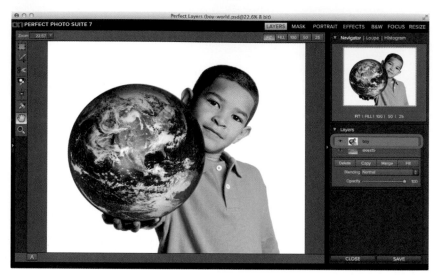

NOTE

For more informa-
tion on opening
your image into
the Perfect Mask
interface, please see
Chapter 1, "Getting
Started."

Working with Brushes

HOT TIP

It's usually a good
idea to reset your
settings before start-
ing on a new image.
Choose Edit > Reset
All to reset the set-
tings in the Tool
Options bar at the
top, as well as delete
all of the Color Sets
in the Colors pane.

At the very basic level, masking is just painting with white, black, and shades
of gray to reveal or hide parts of an image. With Perfect Mask you'll use
brushes for the majority of your work. The software does most of the heavy
lifting for you but needs a small amount of human intervention to refine and
beautify your mask.

Throughout Perfect Mask some settings are common among the brushes,
while many brushes also have a few unique settings as well. You can find
all these at the top of your screen in the Tool Options bar or use keyboard
shortcuts, which can speed things up while you're working. Here are some
of the common settings to be aware of when working with the brush tools:

- **Size:** This setting changes the overall size of your brush. You can also use the left bracket key ([) to decrease the brush size and the right bracket key (]) to increase it.

- **Feather:** The feather of a brush determines softness of your brush edges. The larger the number, the softer the edge; likewise, a very low setting produces a very harsh and sharp edge. To decrease the feather, use the shortcut Shift+[, and to increase the feather use the shortcut Shift+].

- **Opacity:** This setting determines how opaque or transparent your brush is. A low number makes the brush stroke very transparent, which allows you to subtly change specific areas of your mask. A high number means the brush is opaque and much more solid.

HOT TIP

If you make a mistake, don't like the results, or need to redo your brush stroke at a different setting, choose Edit > Undo from the menu bar. You can also change your mind again by choosing Edit > Redo from the same menu drop-down.

Brush Tool

The most basic of Perfect Mask's brushes, the Brush tool is very similar to the Masking Brush inside of Perfect Layers, so you're probably already familiar with it. In its default form it doesn't support color or edge detection; it's just a simple brush (**FIGURE 3.2**). This is a good tool to use when you need to paint out areas of your background or paint in spots that were unintentionally masked out.

Keep and Drop Brushes

When want to remove a large amount of solid color from an image, the Keep and Drop are great brushes to use. To get started, select the Drop brush and paint a short stroke across the area you want to remove. Perfect Mask will analyze the colors and remove the entire background, based on the areas of color you painted over (**FIGURES 3.3** and **3.4**). If the brush removed an area you want to keep, then switch over to the Keep brush and paint over the area you want to bring back. These brushes can be used for both large and small areas of a photo.

FIGURE 3.2 The Brush tool is the simplest masking tool inside of Perfect Mask.

FIGURE 3.3 To use the Drop brush, drag over the background area you want to remove to sample colors. Perfect Mask then anaylzes those color segments and removes similar colors.

FIGURE 3.4 This is the result of using the Drop brush in Figure 3.3.

These brushes also have a few additional settings in the Tool Options bar with which you can tailor your masking:

• **Refine:** This setting determines how jagged or soft the edges are after you apply the brush. The lower the number, the more jagged your edges, and the higher the number, the softer the edges.

• **Segment:** One word you'll see used frequently throughout Perfect Mask is "segments." In fact, a Progress window to do just that is the first thing

that pops up when you launch the software (**FIGURE 3.5**). Segments are groupings of color that Perfect Mask uses to complete certain functions, such as removing areas of color with the Drop brush. Here the Segment setting refers to the segment size. The lower the number, the smaller the segment size and the more groupings color you will have in your image. A higher value means a larger segment size and fewer groupings of colors. You can preview the segments in your image at any time by changing the mask view mode to Segments (**FIGURE 3.6**).

FIGURE 3.5 When you launch Perfect Mask, the software will analyze the colors and group them into segments.

FIGURE 3.6 This is a zoomed-in view of the color segments. You can access this view mode by choosing Mask > Show Mask > Segments.

HOT TIP

If, after using the Drop brush, you find you're having problems with small dots of color still remaining in areas of your mask, such as the sky, try increasing the Segment setting to a larger size. This will group more similar colors together and eliminate the small-dot areas that the Drop or Keep brush is having problems finding.

- **Tolerance:** This setting determines how similar in color different segments need to be before they are grouped together and treated as one segment. High values mean that the Drop brush is more likely to pick up color segments outside of the background color. Try keeping this setting on the low side; the default setting of 10 is usually a good place to start.

- **Auto Expand:** Checked by default, this option allows your brush to sample similar colors to the one under the brush and mask those out as well. It allows more flexibility with the Keep and Drop brushes when there are several different shades of the same color, such as a blue sky fading into a darker blue near the top or bottom of the scene.

One additional feature of the Drop brush is the Remove Background button on the top right of the Tool Options bar (this button is also repeated in the Adjust Mask pane on the right side of the screen). When you have an obvious background you want removed, like a big blue sky or a solid-colored studio background, Perfect Mask finds and removes that background with just a click of the button. This feature is also available in the menu bar under Edit > Remove Background (**FIGURES 3.7** and **3.8**).

FIGURE 3.7 With the Drop brush selected, you can use the Remove Background button in the Tool Options bar. This button is also located in the Adjust Mask pane.

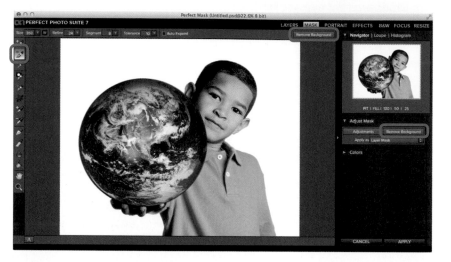

FIGURE 3.8 Clicking the Remove Background button instructs Perfect Mask to analyze the image and search for large groupings of color. Here it correctly identified the white area as the background and masked it out.

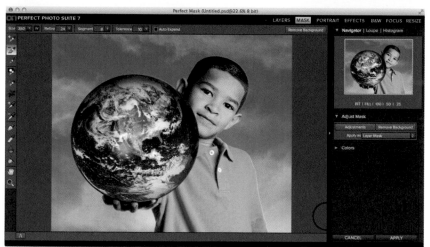

Refine Brush

After creating a mask, even a good one, you'll probably still want to refine it with the Refine brush. The Refine brush actively compares the colors that were masked out with the Drop brush to the colors still remaining in your image. It then removes the existing bits of background along the edges of your subject (**FIGURES 3.9** and **3.10**).

FIGURE 3.9 To use the Refine brush, paint over the area you want to refine. For this image I painted with the Refine brush to remove the halo around the leaves and branches.

FIGURE 3.10 The Refine brush from Figure 3.9 got me off to a good start for refining the edges of this mask.

I especially like the Refine brush's Color Decontamination option (**FIGURE 3.11**). One of the most frustrating things about masking and compositing is when your beautifully masked image is marred by a small amount of color remaining along the edges of your mask and feathered into your subject or foreground. To fix this, turn on the Color Decontamination feature (check the box at the top) and brush the image edges with the Refine brush. Perfect Mask fills in those colored areas with the surrounding color of your existing image.

FIGURE 3.11 This image is a perfect example of when Color Decontamination is useful; the green from the original background is still showing on the pink area. To remove this, select Color Decontamination, then paint over the edge of the pink area with the Refine brush.

NOTE

This feature may add unwanted pixels to your original image, which is necessary in order for the Color Decontamination option to work. You won't notice the changes when masking, but if you remove or hide the mask you'll likely see artifacting and a stray scattering of pixels around the outside of your subject.

HOT TIP

If you want to start over and erase all changes you've made to your mask, choose Mask > Reset Mask from the menu bar.

Masking with Color

One reason that Perfect Mask is able to do such a great job of masking is because it can analyze and separate out the colors in your image. When you have a tricky subject and want to fine-tune your mask, the Keep and Drop eyedroppers coupled with a few of the brush tools are your best option.

Keep Color and Drop Color Eyedroppers

When removing a background in an image, you usually have some type of color separation between the subject and whatever is behind it. Many of the masking tools in Perfect Mask work with that color separation automatically, but sometimes you want more control over what it's doing. In these cases, use the Keep Color and Drop Color eyedroppers.

In image editing, an eyedropper is a selection tool for color: You click an area with the eyedropper to select a specific color. Instead of simply selecting a color, however, the Keep Color and Drop Color eyedroppers also tell Perfect

Mask which colors you want to keep and which ones you want to remove, respectively (**FIGURE 3.12**).

When you click on your image with the Keep Color or Drop Color eyedropper, the colors you select appear in the Colors pane on the right side of your window (**FIGURE 3.13**). By default, this pane contains one color set for each eyedropper, but you can add more color sets depending on the complexity of your image. For images with areas that have vast differences in color, you can use multiple color sets to isolate the colors specific to various sections.

Adding, deleting, and editing a color set is simple. To add a set, click the Add button. Perfect Mask then asks you which type of Color Set you want to create (Keep, Drop, or Both). Make your choice, then as you select colors in your image they will show up in the pane. You can also add more colors to existing color sets by clicking on the top part of each color set. A blue line will appear around that set, indicating you can add colors with the eyedroppers or delete the entire set altogether (**FIGURE 3.14**). You can also delete individual colors by selecting them then clicking the Delete button at the bottom of the pane.

FIGURE 3.12 The Keep Color and Drop Color eyedroppers are great for refining the color analysis process inside of Perfect Mask.

FIGURE 3.13 I used the Keep Color and Drop Color eyedroppers to select the colors I wanted to keep (pink from the flower) and those I didn't (green from the background).

FIGURE 3.14 You can edit the Keep and Drop color sets by highlighting them in the Colors pane.

One thing to keep in mind is that the more colors you select in a color set and the more color sets you switch on, the more memory your computer will need to process that information. If you want to speed things up, be sure to minimize the number of colors in your color set (onOne recommends six or fewer colors). You also can turn off sets you aren't using by clicking the on/off switch at the top of each set (**FIGURE 3.15**).

The Tool Options bar settings for the Keep Color and Drop Color eyedroppers are pretty simple: Size and Add Continuously. The maximum Size setting is 20, and for good reason. Smaller sizes translate to more specific color

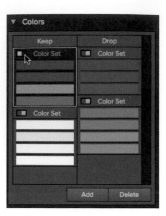

FIGURE 3.15 You can toggle color sets on and off by clicking on the switch next to the words "Color Set."

selections. Larger Size values (say, 10 or higher) still pull in only one color, but do so by averaging several pixels' worth of color information. With values over 10, you would lose the pinpoint control of the color selection. On by default, the Add Continuously feature enables you to add several colors to your color sets, one after another, through a series of clicks. If you want to select only one color in your color set, then deselect the Add Continuously check box.

Magic Brush

The Magic brush is, in all honesty, pretty amazing and will save you a ton of time creating your mask. In a way it's very similar to the Remove Background button and the Drop brush, but with a few exceptions. Because it works in harmony with the Colors pane, you can fine-tune your masking by selecting your keep and drop colors before using the brush. The Magic brush also has a few additional settings to be aware of in the Tool Options bar:

NOTE

The Threshold slider is tied in directly with the Transition setting and must always be a lower number than the Transition. If the slider won't let you change the setting, move the Transition to a lower number and then give it another try.

- **Transition:** This setting affects the transition between the keep and drop colors. The higher the number, the softer the transition. Very low settings produce a much harsher transition while painting. You'll probably want to keep Transition at its default of 255.

- **Threshold:** The Threshold determines how precisely the Magic brush sticks to the keep colors. In other words, at a setting of 0 only the exact colors from the Keep color set are protected. Higher settings protect colors similar to those in the Keep color set.

To see how well the Magic brush will work on its own, just double-click it in the tool-well. Perfect Mask then analyzes your photo and removes the background, along with any similar colors in all areas of your image (**FIGURES 3.16 and 3.17**). If you want to fine-tune this process and gain a bit more control over the colors Perfect Mask is analyzing, be sure to use the Keep and Drop eyedroppers before double-clicking the Magic brush. Using the eyedroppers first tells Perfect Mask the exact colors to remove and usually results in a much cleaner mask.

FIGURE 3.16 To remove the background from this image, I double-clicked the Magic brush icon in the tool-well.

FIGURE 3.17 Double-clicking the Magic brush icon did a great job of finding and removing the background colors in this image.

Even if you don't have a completely solid or simple background, you can still use the Magic brush. Start by clicking and holding the cursor in the background to paint it out. The brush analyzes the colors under it and recognizes when you start painting over something other than background (such as a person or tree, for example). It then ignores those areas and leaves them intact (**FIGURE 3.18**). Again, you can fine-tune this with the color sets to better refine which colors the Magic brush is keeping and removing (**FIGURE 3.19**).

FIGURE 3.18 I painted with the Magic brush in the sky, and then started painting over the tree. The brush did an okay job, but missed some of the white clouds in the original background.

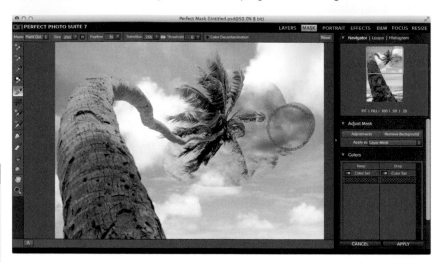

HOT TIP

If you find that the automation features aren't as accurate as you would expect, try changing the Segment Scaling under the Edit > Settings menu. The default of Smaller, Faster, Less Accurate is great from a speed and performance standpoint, but, well, less accurate. If you're okay with the processes being a bit slower, try the Medium setting or Larger, Slower, More Accurate. Both slow things down a bit when using tools such as the Magic brush, but you'll end up with more accurate masks.

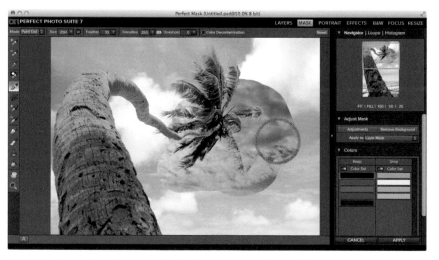

FIGURE 3.19 Adding color sets with the Keep Color and Drop Color eyedroppers greatly improves the accuracy of the Magic brush.

Color Spill Brush

Sometimes you may find unwanted color reflections on your subject after masking out the background, such as when you photograph someone against a green-screen and the color from the background bleeds on to the subject. These areas of color are not something you can necessarily mask out,

because you want to retain the subject at 100% opacity. Instead, you can correct that color imbalance by using the Color Spill brush in the tool-well.

To use the Color Spill brush, first make sure that you have some color sets specific to the area you want to work on. Say, for example, I want to remove the green cast from my photo of a DJ, starting with his arm. First, I create a color set and select only the skin tones with the Keep Color eyedropper, then paint over the green area with the Color Spill brush (**FIGURES 3.20** and **3.21**). I'll repeat this process for each block of color, such as the green cast on the blue area in his shirt.

FIGURE 3.20 A considerable amount of green reflected from the lights onto this man's arm.

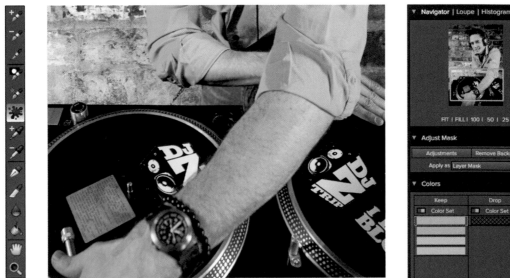

FIGURE 3.21 I used the Keep Color eyedropper to create a color set, then applied the Color Spill brush to bring the arm back to its original color.

Additional Cleanup Tools

The brush and color tools are great for getting the bulk of the masking accomplished, but the finer details separate a good mask from a great mask. To refine and perfect your mask, turn to Perfect Mask's cleanup tools:

- Pen
- Chisel
- Blur
- Bucket

They make the task simple and easy.

Pen Tool

The Pen tool allows you to draw an outline, called a path, to select an area you want to remove or keep. Because this tool uses edge detection instead of color to mask out your subject, it's useful for subjects with defined and contrasting edges but that are a color similar to their background. The Pen tool is great for fixing up blocks of areas missed by the other tools, as well as working with straight lines or horizons (**FIGURE 3.22**).

FIGURE 3.22 The Pen tool is a good choice to remove the background from the gap between the bird's legs.

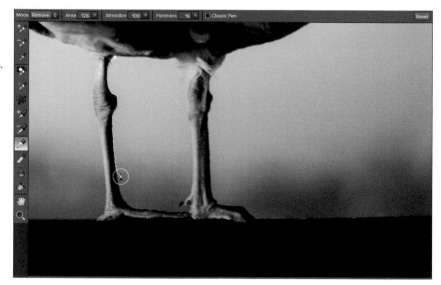

By default the Pen tool is in Magnetic mode, which makes it very easy to draw around curves and even corners by clinging to the edges as if it were a magnet. When using the Pen tool in Magnetic mode, try these tips:

- **Reverse to redo:** If the Pen strays from the edge while you're drawing, just trace the line in reverse to undo it as far back as you want to go.

- **Press the Shift key for straight lines:** When you come across a solid, straight line in your photo (like the side of a building or a horizon), press the Shift key and click from one point to another to create a straight line (**FIGURE 3.23**).

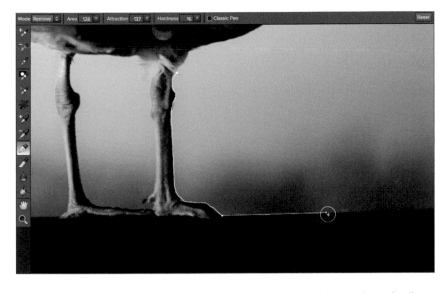

FIGURE 3.23 To create a straight line, hold the Shift key while clicking in your image with the Pen tool.

- **Click the points:** The Pen tool relies on points: small dots where the lines of the Pen tool connect (just think of it as an advanced form of "connect the dots"). If at any time you need to remove a point you created while working with the Pen tool, just click on it and it will disappear. You can also create points along the way by clicking on the path you created, and a new point will appear at each click. Points are an essential feature with the Pen tool because they allow you to re-edit certain areas of your path.

- **Lift up your cursor to go around corners:** The Pen tool doesn't need to be applied in one long swoop. Yes, it creates one long line wherever you draw with it, but you can pause, take your hand off the mouse, trackpad, or tablet during the process to create a new point. You can even work your way around the edge by making a series of clicks on the edge instead of following it with your cursor. This technique is especially useful for sharp angles and curves.

- **Set Area and Attraction settings for more refined selections:** These two settings, located in the Tool Options bar, will help you refine the pen selection. Area determines the amount of area the Pen tool looks at to create the edge; use as low of a number as possible for your images to get the best results. Attraction, on the other hand, determines how many different colors the Pen tool looks at when creating the selection. A lower number is best for simple selections to ensure smoother lines, and a higher number is best for more complicated selections.

HOT TIP

To move a point in your selection, hold the **Cmd** or **Ctrl** (PC) key and hover over the point you'd like to move. When the cursor changes into a solid-white arrow you can click and drag the point to a different location.

You can also use the Pen tool in Classic mode by selecting the check box in the Tool Options bar. In this mode, the Pen tool draws straight lines between each point you click and draws curves when you click and drag the cursor. Classic mode is a good choice for subjects with straight lines, such as architecture or flat horizons.

In either mode, you need to close your path before you can remove or reveal the selected area. To close the path, hover over the first point you created (the start point), then click when a circle appears (**FIGURE 3.24**). Alternately, you can **Cmd-click** or **Ctrl-click** (PC) in the image (make sure you're not hovering over a point); Perfect Mask will close the path automatically (**FIGURE 3.25**). Just make sure you have a clear, empty space between the beginning of your path and the end point so you don't cross over an area you want inside or outside of the path.

After the path is closed, you can either remove or add to the area you encompassed. As soon as you close the path you'll see the icon change to a hammer with either a plus sign (to add) or a minus sign (to remove) (**FIGURE 3.26**). You can change this setting on the top-left of your window in the Tool Options bar. Now, all you need to do is click on the image in the area you want to add or remove, either inside or outside of the path, depending on your image (**FIGURE 3.27**). You can also change the Hardness setting in the Tool Options bar to set how soft or hard the edge is when using the hammer. A low number gives the selection a very hard edge, and a high number gives it a softer edge.

FIGURE 3.24 To close a path with the Pen tool, hover over the first point you created and click when you see a circle appear around the cursor.

FIGURE 3.25 You can also close a path by **Cmd-clicking** or **Ctrl-clicking (PC)** anywhere in your image.

FIGURE 3.26 Once you have a closed path, a hammer icon will appear when you over over the image. Click inside the path or outside the path to remove (minus sign) or add to (plus sign) your mask. For this image I'm going to remove the area inside the path I created.

FIGURE 3.27 I clicked inside the image with the hammer icon to remove the area. For this image I used a Hardness setting of 15 to give the masked edge a harsher transition.

Chisel Tool

The Chisel tool is helpful for cleaning up the edges of your mask, such as when halos, fringes, or small pixels of your background color remain in the foreground or subject (**FIGURE 3.28**). Just brush along the edges of your subject to "chisel" away those remaining pixels (**FIGURE 3.29**).

FIGURE 3.28 Notice the light halo surrounding the edges of the hot air balloon.

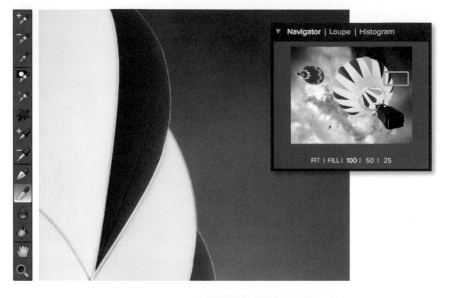

FIGURE 3.29 To remove the halo, I painted along the edge with the Chisel tool.

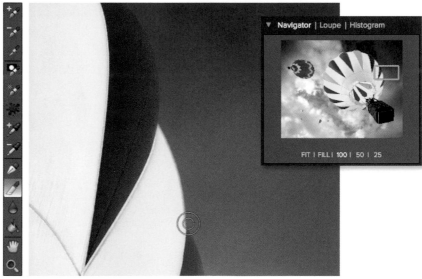

There are a few unique settings to be aware of when using this tool:

- **Chisel Amount:** The Amount slider determines how much of the edge the Chisel tool removes. Think of it as setting the depth of the edge. You don't want to go too high with this number or you'll start removing parts of the image you intended to keep.

- **Chisel Hardness:** This setting determines how harsh of an edge the tool produces. A low number will give you a sharp edge, whereas a high number will give you a much softer edge.

Blur Tool

The Blur tool is similar to the Chisel tool in that it cleans up the edges of your mask. Instead of removing pixels, however, it softens and blurs the edges. This is a great tool to use when masking out such objects as hair or flowing trees and grass—anything that is already blurred or even semitransparent.

Bucket Tool

The Bucket tool enables you to quickly fill in a large area in either Paint In or Paint Out mode. It may often serve as a last resort after you've already tried other tools to outline the edges of your subject yet still have a large area to remove (**FIGURES 3.30** and **3.31**). You want to make sure that you've fully outlined your image so that it has a transparent margin surrounding it or you'll end up removing much more than you intended.

> **HOT TIP**
>
> You can apply the Chisel tool or Blur tool to your entire image just by double-clicking the tool in the tool-well. This can save a lot of time when you have a large area of your mask to clean up.

FIGURE 3.30 I created an outline of the horizon of this image using the Magic Brush.

FIGURE 3.31 To fill in the remaining sky I used the Bucket tool and clicked in the top part of the image.

Previewing Your Mask

Sometimes viewing the actual mask you're working on can be helpful, and Perfect Mask allows you several different ways to do this. You can choose Mask > Show Mask from the menu bar or use the associated keyboard shortcuts. You can view your mask in one of seven preview modes (**FIGURES 3.32–3.38**):

- Before
- White
- Dark
- Grayscale
- Red Overlay
- All Layers (the default view)
- Segments

FIGURE 3.32 Before preview mode shows you a before version of your image.

FIGURE 3.33 Displaying a pure white mask, White preview mode is useful when you want to create an image isolated on a white background.

FIGURE 3.34 Dark preview mode allows you to view the mask as a low-opacity black overlay.

FIGURE 3.35 Grayscale preview mode is a good way to check the fine details of your mask, and also handy when trying Adjustments settings in the Adjust Mask pane.

FIGURE 3.36 With Red Overlay preview mode you can check your mask while still seeing your image composite.

FIGURE 3.37 Use All Layers preview mode when you want to preview the image as a composite with the new background. This is the default mask view mode.

FIGURE 3.38 Use Segments preview mode to preview the various color segment groupings in your image.

Adjusting and Applying Your Mask

You can adjust the mask by using the Adjust Mask pane on the right side of the window. Here you can refine your mask after it's created, especially in terms of adding contrast to clean up the masked areas (**FIGURE 3.39**). Simply click the Adjustments button in the Adjust Mask pane to access these settings:

- **White Contrast:** Use this slider when the white areas of the mask (the part you want to keep in your original photo) have a haze of the new background image still showing through. Basically, it intensifies the parts that are already white so that they become less translucent.

- **Black Contrast:** Use this slider when the black areas of the mask (the part you want to keep in your original photo) have a haze of the original image still showing through. Basically, it intensifies the parts that are already black so that they become less translucent.

- **Feather:** This applies a global feather to all edges of the mask. Use this sparingly (or not at all) as it can give the mask a too-soft look.

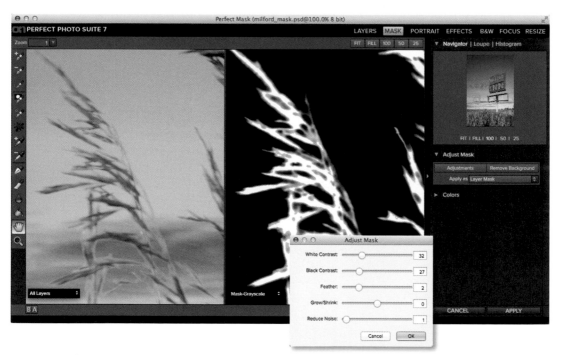

FIGURE 3.39 Clicking on the Adjustments button in the Adjust Mask pane allows you to make adjustments to your mask. I find that using a Left/Right Preview mode with All Layers on the left and Mask-Grayscale on the right the best way to view my mask when making adjustments with the Adjust Mask pane.

- **Grow/Shrink:** This setting expands or contracts the mask around your subject. If you have a mask with any small details (like wispy hair or strands of grass) then you probably don't want to use this, or you'll risk losing those details altogether.

- **Reduce Noise:** There may be times when you have leftover dots or specks in your mask that the other tools didn't find to mask out. This can be caused from a noisy image or even sensor spots in the original photo. When you move the Reduce Noise slider to the right, Perfect Mask automatically cleans up the mask and removes those little dots and specks.

NOTE

The Reduce Noise tool does not remove noise from the original image. It just cleans up any stray dots in the mask.

With your masking complete, you're ready to click the Apply button on the bottom of the screen (**FIGURE 3.40**). Keep in mind that there are four ways you can actually apply that mask to your document. The default is always Layer Mask and will probably be the method you'll end up sticking with. But it's good to know your options in case there's a situation when you need to make an exception:

- **Current Layer:** The Current Layer option refers to the image you are currently working on in Perfect Mask. This option permanently erases the masked area from your original image. Choose it, and you can no longer bring back any of the removed areas of your photo if you change your mind. I recommend steering clear of Current Layer, unless you have no desire to retain the ability to edit masked areas after applying your mask.

- **New Layer:** Offering more flexibility than Current Layer, the New Layer option first copies the current layer before erasing your masked areas. You retain your original image, but no longer have the mask information, meaning you can't refine your mask after applying it.

- **Layer Mask:** This is the default setting in Perfect Mask, and it's your best option for most images. Applying your mask as a Layer Mask has several advantages, the biggest being that it's a nondestructive application. You still retain your original image and can return to Perfect Mask to make more adjustments at any time. Because you can save your document as a .psd file, you also have the option of editing, transforming, or manipulating the mask in Photoshop.

- **Copy With Layer Mask:** Very similar to Layer Mask, Copy With Layer Mask creates a copy of your current layer and then adds the layer mask to the copy. Use this method to save your mask if you want to retain the original layer along with a duplicate layer with a mask.

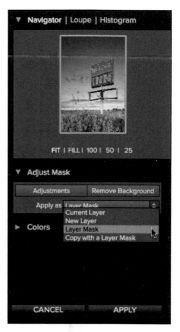

FIGURE 3.40 Choose among four ways to apply your mask in the Apply As drop-down. The default, Layer Mask, is usually the best choice for most masking jobs.

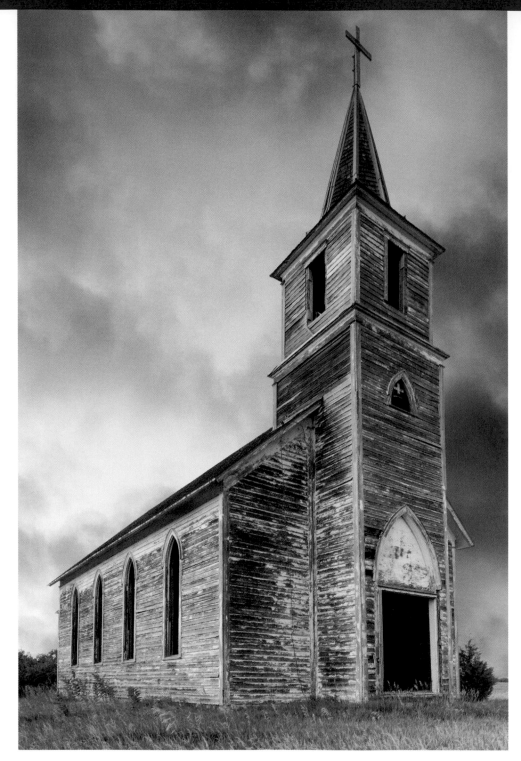

Replacing a Sky

We can't control nature, and sometimes you may find the sky leaves something to be desired when you create an otherwise beautiful image. Even the most average scene can be enhanced with an exquisite sky filled with colorful clouds, and with Perfect Mask replacing a sky is easy. Consider this photo of a beautiful, abandoned church. I wanted to replace the original shot's bland sky with a photo of some puffy pink clouds I photographed in another location. As you will see, the process was simple.

Step 1

With the church photo open in Perfect Layers, I navigated to and double-clicked the sky image. In the window that popped up, I clicked Add to add the sky as a new layer in my Layers pane. Because the sky image was horizontal and my church image was vertical, I needed to scale the sky to fill the document. I clicked the Transform tool, entered 145 for the Scale setting, dragged the sky upward a bit, and then clicked Apply. Then, I rearranged the layers so that the church was the top layer in the Layers pane.

Step 2

Next I clicked Mask in the Module Selector at the top to open the church image in Perfect Mask. Because this image has a very basic sky, I clicked the Remove Background button under the Adjust Mask pane to remove the majority of the background. This did a very good job of removing the sky, but there were still a few problem areas that needed to be addressed around the edges of the building and in the bushes on the bottom-right portion of the photo.

Step 3

First I addressed the edges of the building. In the first image, notice the light-blue halo around the corner of the steeple. To remove this, I used the Chisel tool. I set Mode to Remove, Amount to a low setting of **50**, and the Hardness to **50**, which softened the tool so that it wouldn't add a harsh edge. Instead of painting it around the entire building, I double-clicked the Chisel tool in the tool-well to apply it to the edges of the mask over the entire image.

Step 4

My next step was to fix the mask around the small bush to the right of the church. For this area, I decided to use the Keep Color and Drop Color eyedroppers to create color sets for the areas I wanted to keep and remove. I used the Keep Color eyedropper for the bush and building colors, and the Drop Color eyedropper for the sky. Then I used the Magic brush to paint over and remove most of the background from that area.

Step 5

Lastly, I used a combination of the Chisel and Blur tools to remove the rest of the background. I made sure to keep the Chisel amount setting low (**9** in this case) to avoid removing too much of the tiny branches. My result was a very beautiful and cloudy sky to add mood and drama to my photograph.

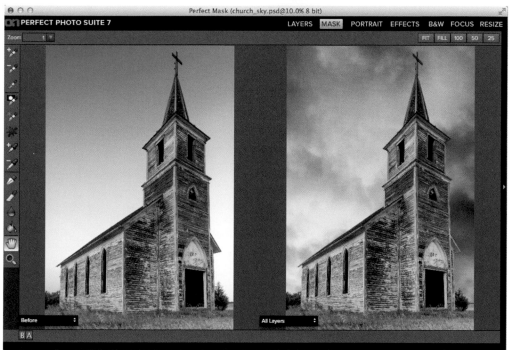

Removing a White Background

If you do any type of design work with isolated images or photograph subjects against a white background, Perfect Mask is a simple way to quickly remove the background so you can replace it with something else.

Step 1

I started out with my images opened in Perfect Layers: the main, white-background image as well as a studio backdrop from the Extras pane for the new background. (Even if you don't need to add your background right now, it's usually good to work with something behind your subject so you can preview how well your mask looks in the process; you can always change it to a different image down the road.)

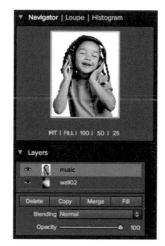

Step 2

Next, I made sure that I had the top layer selected (the image of the little girl) and then clicked Mask in the Module Selector. Once inside of Perfect Mask, I quickly removed the majority of the white background by clicking the Remove Background button in the Adjust mask pane. This did a pretty good job, but left some gaps in-between the girl's braids I needed to remove.

Step 3

I zoomed in to one of those areas, and selected the Drop brush from the tool-well, keeping the default settings. Then, I reduced the size so the brush was only over the white portion of the image and made a very short brush stroke to remove that section of white. I repeated this throughout the image wherever there was a gap that needed to be filled.

Step 4

Some of the gaps of white were too small for the Drop brush to work on. Using Mask-Red Overlay preview mode I was able to easily locate these areas, then I masked them out with a combination of the Drop brush and the Magic brush. First, I selected the Drop brush and clicked once over the white background to tell the software that I want to drop the white color. (Because the background was solid color of pure white I didn't need to add any Keep colors; Perfect Mask knew to keep anything that was not pure white.) Then, I selected the Magic brush and painted over the white areas to remove them.

Step 5

Next I painted with the Chisel tool, with the Amount set to **25**, to remove some of the excess white areas around the edges of some of the gaps to remove the white halo on the inside of the gaps.

Step 6

The last step was to preview the mask in Mask-Grayscale mode. I noticed that some of the masking was seeping into the girl, particularly in the hair and braid areas. To fix this, I clicked the Adjustments button in the Adjust Mask pane. Then, I set White Contrast to **104** to fill in those gray areas, and I also set Feather to **7** to soften the edges a bit. The result was a beautifully masked image with a brand-new background.

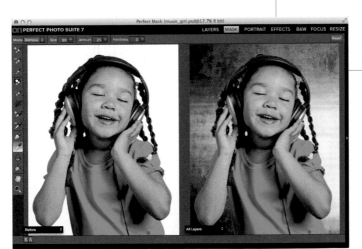

Working with Transparent Objects

One of the extremely useful features of Perfect Mask is its ability to successfully mask transparent objects, such as glass or windows. This can be a difficult task to do manually so you can save a lot of time when your composite or design calls for masking out one of these challenging subjects. I wanted to put this image of a champagne glass into a new environment, but the semi-transparent parts of the glass presented a bit of a challenge. By using Perfect Mask I was able to easily swap the background while retaining that transparency.

Step 1

Just like with the previous two images, I started out inside of Perfect Layers. I opened up both of my images, a champagne glass and a brand-new background from the Extras pane, and because they were both similar in size there was no need to do any transforming. So I rearranged them in the Layers pane, made sure that the champagne layer was selected, and then clicked on the Mask in the module selector at the top.

Step 2

Because this shot had a solid black background, I decided to double-click the Magic brush to see how it handled the image. It did a very good job of removing nearly all of the black background.

117

Step 3

A little bit of dark-gray lingered in the top portion of the glass, so I used a combination of the Keep Color and Drop Color eyedroppers and the Magic brush to remove it. I selected the Keep Color eyedropper and clicked the white reflection in the glass, as well as some of the yellow color in the champagne. Then, I used the Drop Color eyedropper to select the black background. Next I used the Magic brush to paint over those gray areas on the top portion of the glass and they immediately disappeared.

Step 4

Lastly, to clean up the edges I selected the Chisel tool and changed the Amount to **50**. Then I double-clicked on the Chisel tool in the tool-well to chisel away some of the halo surrounding the glass.

Step 5

To check my work I previewed the image in the Mask-Grayscale mode. My image now has the background fully removed and it only took a few simple steps inside of Perfect Mask.

An adorable face needs only subtle adjustments to enhance the photograph.

Nikon D200, 50mm, 1/500 sec at f/2.8, ISO 100

PERFECT PORTRAIT

Creating a beautiful portrait is an art form, and post-processing the image is part of that art. The elusive goal is a balance between keeping your model recognizable and enhancing facial qualities, but finding that balance can be a time-consuming challenge. After all, you're not trying to hide who the subject is, but rather exaggerate the beauty that's already there while removing the distractions, such as blemishes and harsh lines. Perfect Portrait automates these tasks, while still giving you full control over the retouching of your portraits, which not only helps you create beautiful images but also saves you precious time.

The Perfect Portrait Interface

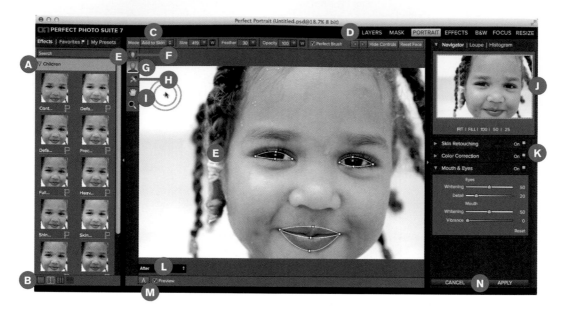

A Effects, Favorites, and Presets
B Browser mode
C Tool Options bar
D Module selector
E Tool-well

F Face Select tool
G Face Edit tool
H Retouch brush
I Hand and Zoom tools
J Navigator, Loupe, and Histogram

K Adjustment panes
L Mask View mode
M Preview mode
N Cancel and Apply buttons

When to Use Perfect Portrait

Not every photograph of a person is going to need extensive (or even basic) retouching, but when your subject's face is the main highlight of the frame, then Perfect Portrait is an excellent solution for your editing workflow. Here are a few other occasions when this software is a good choice:

- **Quick portrait edits:** Perfect Portrait uses facial recognition to locate key areas on the face, such as the eyes and mouth. Enabling you to automate your retouching, this feature makes quickly enhancing and beautifying any portrait easy.

- **Presets and batch edits:** For those occasions when you have several portraits of the same person, such as senior portrait or bridal sessions, for example, you can create a preset for that individual and then apply it to the rest of your images. What's even more impressive is the ability to batch edit with these presets (using Adobe Photoshop or Lightroom) to quickly go through a large set of images at once.

- **Individual retouches in group photos:** For groups of two or more people, you can separate and edit each face individually. Because each face is unique and requires different types of edits, this software allows you to fine-tune the adjustments specifically for each person.

Portrait Retouching

When retouching portraits, remember above all else that *subtlety is key*. When we photograph people, we hope to create a memory, a moment in time, and a glimpse of who they are. Because of this, you want to avoid overworking the image, but to instead enhance it *just enough* so that the subject's personality and true self shine through. Finding that balance of beautiful retouching without making a person's skin, eyes, or teeth look fake is something you can easily do with Perfect Portrait. Inside, you'll find tools to adjust each of these so that your images look beautiful *and* realistic.

Before you can do any portrait retouching, however, you first need to hone in on the face or faces you're going to work on. Perfect Portrait's automated facial recognition makes step is easy, plus you can refine the identified facial elements to make the rest of your editing a breeze.

Facial Recognition

When you launch Perfect Portrait, you'll notice that it does some initial "thinking" while it's searching for people in your image (**FIGURE 4.1**). The software locates these faces and then places each into its own Face Box. Next, it creates masks separating the various parts of the face, such as the eyes and mouth. You then can use these masks to selectively edit each area individually.

FIGURE 4.1 Perfect Portrait first searches for faces and finds their features. This usually takes only a few seconds for each face in your image.

Once Perfect Portrait finishes its work, you can start your own. First, make sure Perfect Portrait discovered all of the faces you want to edit. If you don't see boxes around all the faces you want, you need to do a little prep work to the face selection, such as:

- **Adding a Face Box:** If Perfect Portrait can't locate a face in your image automatically, it displays the Add Face dialog box informing you that you need to *add* a face (**FIGURE 4.2**). To do this, just drag the Face Box you see on your screen over the face, resizing it with the handles on the box border so that the entire face is in the box. Click the Apply button in the Add Face pop-up window when you're finished. Alternately, you can add a face by choosing Face > Add Face in the menu bar.

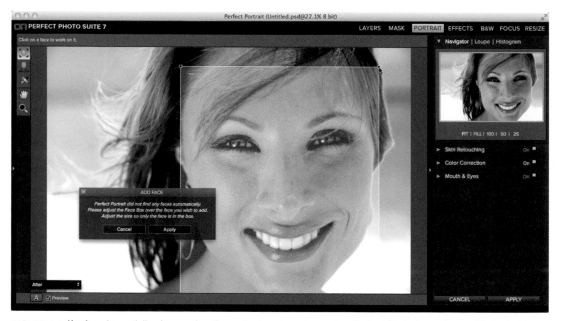

FIGURE 4.2 If a face is partially obscured or the entire face is not showing, Perfect Portrait may be unable to find it. When this happens, you can quickly adjust the Face Box to identify the face in your image.

- **Selecting multiple faces:** If Perfect Portrait found at least one face, but couldn't locate all the faces in your image, you can use the Face Select tool to add more faces. Click the new face you want to add, and resize the Face Box that appears so that only the face is inside the box (**FIGURES 4.3** and **4.4**). When you're satisfied, click Apply in the Add Face pop-up window.

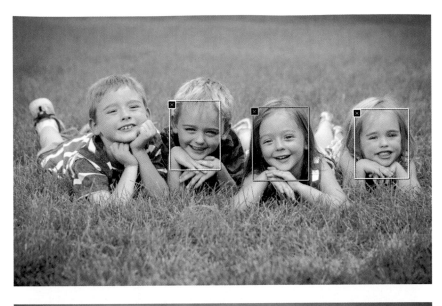

FIGURE 4.3 Perfect Portrait found only three of the faces in this group.

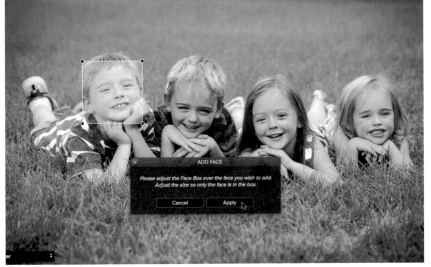

FIGURE 4.4 Too add a fourth face, I clicked the little boy's face on the left, resized the new Face Box that appeared, and clicked the Apply button.

- **Removing a Face Box:** You can also delete Face Boxes from inside your image using the Face Select tool, which can be helpful if the software didn't locate the face properly the first time. With the Face Select tool active, click the X in the top-left corner of the Face Box you want to remove (**FIGURE 4.5**). The software will delete it and display a new Face Box. You can then either add a new face or cancel the process.

Alternately, you can delete any face by clicking the Face Box and choosing Face > Delete Face in the menu bar.

FIGURE 4.5 To delete a Face Box, click on the X in the upper-left corner of the box.

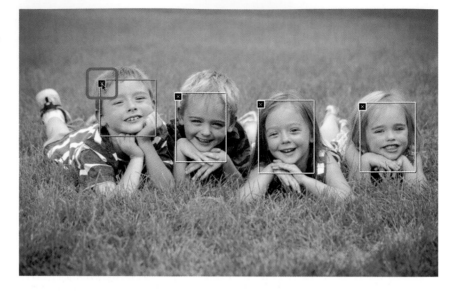

HOT TIP

You can remove a Face Box only when the image contains more than one Face Box, because the software needs at least one face in order to work.

Refining the Face

Perfect Portrait's facial recognition algorithm not only finds faces in your image; it also locates the eyes, lips, teeth, and skin within each Face Box. If the white control outlines are perfectly situated around each of these areas, then that's excellent! You can move along to the next section to start retouching your portrait. The algorithm doesn't always get the controls into their proper place, however, and you need a little bit of manual override. This is when the Face Edit tool will come into play.

The Face Edit Tool

To get started, first you need to activate a Face Box. If you're still inside the Face Select tool, click the Face Box you want to edit to automatically activate the Face Edit tool and zoom in. You can also click the Face Edit tool in the

tool-well to activate and zoom in to whichever box is highlighted in green
(**FIGURES 4.6** and **4.7**).

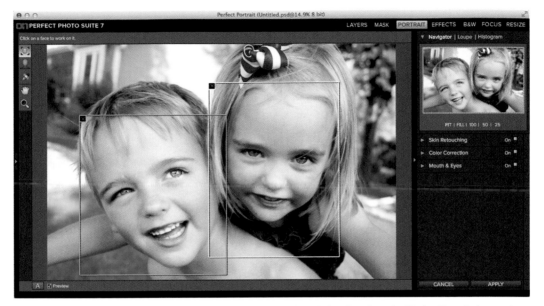

FIGURE 4.6 The boy on the left is highlighted in green, indicating his box is selected with the Face Select tool.

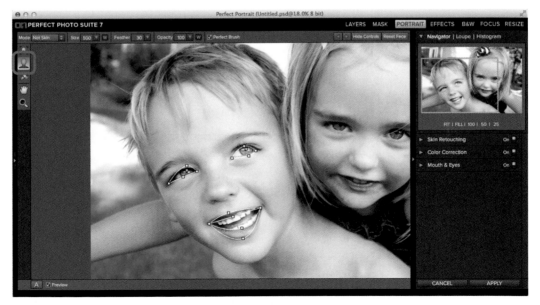

FIGURE 4.7 I can start editing this face with the Face Edit tool by clicking the face inside the green box or by clicking on the Face Edit tool in the tool-well. The preview zooms in on that face and displays the eyes and mouth controls.

Notice the controls that outline around the eyes and mouth. If the software was able to find the face well, then the controls will be in the right spots (**FIGURE 4.8**). If you need to adjust them, however, just drag the points to the correct locations. For the *eyes*, for example, be sure to put the blue point right on the pupil. Next, move the dots on the side to the corners of the eyes, and adjust the top and bottom points along the curve of the inside eyelids so that the eyeball is the only thing inside of the controls (**FIGURE 4.9**). For the *mouth*, three sections encompass your controls: two for the lips and one for the teeth. Make sure that the teeth are in the middle section, and the lips are in the top and bottom sections (**FIGURE 4.10**). For images with no teeth, just close the middle gap so it's no longer visible (**FIGURE 4.11**).

FIGURE 4.8 Perfect Portrait did an excellent job of initially finding the locations for the eyes and mouth.

FIGURE 4.9 To refine the controls, just use the cursor to click and drag them into position.

FIGURE 4.10 This example shows proper placement of the controls over a mouth with visible teeth.

FIGURE 4.11 This example shows proper placement of the controls over a mouth with no visible teeth.

Refining the Mask

Perfect Portrait also creates a mask to isolate the skin from the rest of the image, which allows you to use the Skin Retouching pane to edit only the skin areas of the face. As you can all other masks in the Perfect Photo Suite, you can adjust the skin masks by painting. When the Face Edit tool is active the cursor automatically defaults to a brush, so all you need to do is start painting to make changes.

Before you make any brush strokes in your image, preview the mask so you can see what, if anything, you need to adjust. Previewing the mask is *extremely* useful for this type of edit, as the changes the Skin Retouching tools make to your image are usually so subtle that you might not even know if something is awry until it's too late. To preview the mask, click **Ctrl+M**. You'll see a red overlay of the areas that are masked out. The portions of your image that are not in red should be the skin areas. You can choose among four mask view modes: Red, White, Black, and Grayscale (**FIGURES 4.12** through **4.15**). To access each of these, choose View > Mask View Mode, or use the black box on the bottom left of the Preview window.

FIGURE 4.12 The default preview, the Red mask can help you locate areas of skin or no skin that need to be corrected.

FIGURE 4.13 The White mask is another way to preview the mask in Perfect Portrait.

FIGURE 4.14 Use the Dark mask preview when your image has areas of red already, such as a red backdrop or bright red hair.

FIGURE 4.15 The Grayscale mask helps you refine your mask by showing a black-and-white preview.

Now that you know what your mask looks like, you're ready to start fixing it. Here are some of the settings in the Tool Options bar you can use when painting the mask to reveal only the skin (**FIGURE 4.16**):

Mode: Not Skin | Size: 350 | W | Feather: 30 | Opacity: 100 | W | ☑ Perfect Brush | ◄ | ► | Show Controls | Reset Face

FIGURE 4.16 The Tool Options bar allows you to change your settings when refining the mask.

- **Mode:** There are two options for the Mode setting: Add to Skin and Not Skin. Use the *Add to Skin* option when you want to reveal the skin areas of your portrait, and use the *Not Skin* option when portions of the mask reveal more than skin, such as hair or clothing (**FIGURE 4.17**).

- **Size:** The Size setting determines the overall size of the brush, and ranges from 1 (a small brush) to 500 (a large brush). Use the smallest brush size possible in your image for more accurate results.

- **Feather:** The Feather setting determines how soft or harsh the edge of your brush is, and ranges from 0 (a very harsh edge) to 100% (a very soft edge). To soften the transition of your mask, keep the feather at a higher setting, usually above 50.

- **Opacity:** This setting determines how transparent your brush stroke is, and ranges from 0 (completely transparent) to 100 (completely opaque). For most cases you'll be okay leaving this setting at 100. If you want to refine the edges of your mask around a hairline, wispy bangs, or men's facial hair, try lowering the opacity slightly and painting along the border of the area (**FIGURE 4.18**). This will give you a smoother transition when making heavy adjustments with the Skin Retouching pane.

FIGURE 4.17 (left) I used the brush to paint with a Mode setting of Not Skin over the area just to the right of her face.

FIGURE 4.18 (right) Painting with the Not Skin mode at 20% opacity allowed me to mask out a stray strand of hair over this little girl's face.

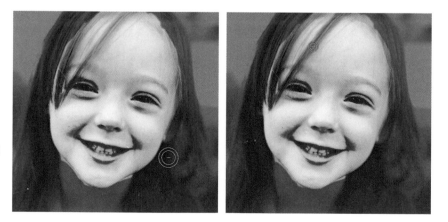

A few additional buttons on the far right side of the Tool Options bar are also handy:

- **Next and Previous Face Arrows:** When you're working on more than one face, these buttons are the quickest way to jump back and forth between the Face Boxes in your image. Click on the right arrow to go to the next face, and use the left arrow to move back to the previous face. The Preview window will automatically fill with the new Face Box and allow you to make your refinements and retouching adjustments.

- **Hide Controls:** After you have the eyes and mouth controls set in the right place, you can click on this button to hide the white outlines (**FIGURES 4.19** and **4.20**). Hiding the outlines will give you a clearer viewing experience when using the adjustment panes on the right side of your window, particularly when making adjustments to the eyes and mouth.

- **Reset Face:** If you want to start over with any of the adjustment panes (Skin Retouching, Color Correction, Mouth & Eyes), click the Reset Face button. This feature resets the edits and the mask to only the currently selected face; it will not reset the eyes and mouth controls, or any edits you made with the Retouch brush.

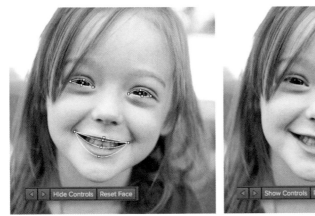

FIGURE 4.19 By default, Perfect Portrait displays controls over the eyes and mouth. To hide these, click the Hide Controls button in the Tool Options bar.

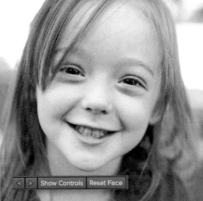

FIGURE 4.20 After you hide the controls, the toggle changes to a Show Controls button; click it to show the controls over the eyes and mouth.

Skin Retouching

Smooth and beautiful skin is something you will likely strive for in many of your images, and with Perfect Portrait you have the tools to create blemish-free portraits very quickly *and* easily. The key with skin retouching is to not overdo the effect so much that the skin looks like plastic, or that freckles are completely gone. (Freckles can be cute, especially on little kids!) Keeping that texture in a person's face keeps the reality alive while still showing each individual at his or her best.

Inside of this software you will find two main adjustments for retouching skin: the Retouch brush and the Skin Retouching pane. The Retouch brush clears away individual blemishes and lines, and the Skin Retouching pane applies global adjustments to the skin in your portrait.

Retouch Brush

When you need to remove a blemish or a flyaway hair, reach for the Retouch brush in the tool-well. You can find the tool's three settings in the Tool Options bar on the top of your window:

- **Size**: The Size setting ranges from 0 to 2500 pixels. For the majority of your retouching needs, you will usually want to set this to a low number. To prevent any smudging in the surrounding skin, keep Size set to just larger than the blemishes you're trying to remove.

- **Feather**: The Feather determines how soft the edge of your brush will be and ranges from 0 (a very harsh edge) to 100 (a very soft edge). Try keeping this setting to at least 25 to ensure smooth blending of the retouch areas with the existing skin.

- **Opacity**: Opacity, ranging from 0 to 100, refers to how transparent or opaque the brush will be when you make your edits. A high number, such as 100, completely removes the blemish. If you want to make more subtle adjustments to areas of the skin, try setting this to around 50 or lower. This is a good way to subtly remove lines and wrinkles, as well as to brighten the areas underneath the eyes.

Consider a few of the ways you can use the Retouch brush to make your portraits clean and beautiful:

- **Remove blemishes:** Just one click on your image will immediately erase any blemishes. When using the brush for specific areas, keep it to about the same size, or maybe just a little larger than the blemish you're erasing and make individual clicks instead of brushing over larger areas (**FIGURES 4.21** and **4.22**).

FIGURE 4.21 (left) A Size of 90 and a Feather of 11 with the Retouch Brush is enough to remove this blemish.

FIGURE 4.22 (right) By clicking just once with the Retouch Brush, I removed the blemish completely.

- **Fade wrinkles and lines:** The Retouch brush is great for softening lines and wrinkles in an image. You'll still want to keep some definition of the lines intact to keep the face looking natural, so the key is to reduce the Opacity setting below 50% and then make a few brush strokes over the lines. Also, be sure that your brush size is at the smallest setting possible so that you're affecting only the lines on the face (**FIGURES 4.23** and **4.24**).

FIGURE 4.23 (left) To fade away the lines around this woman's mouth I will use the Retouch Brush at a low opacity.

FIGURE 4.24 (right) With the Opacity set to 50% and the Size set to 50, I was able to subtly remove the lines in the image. I don't want to completely remove them, just fade them a little.

- **Lighten under the eyes:** Many people, even children, will have dark areas below their eyes, and you can use the Retouch brush to fade that area away. To do this, use the brush at a low opacity (30% is a good start) and a size just large enough to fit the area (about the same size as the iris of the eye is usually good). Paint a few brush strokes over the area—just enough to remove some of the darkness but not so much that it starts to look "smudgy" (**FIGURES 4.25** and **4.26**).

FIGURE 4.25 (left) Most people have dark areas under their eyes.

FIGURE 4.26 (right) To fade the dark areas away without completely removing them and making them look "smudgy," I used the Retouch brush with the Size set to 150, Feather at 125, and the Opacity set to 50%.

Skin Retouching Pane

The Skin Retouching pane is where the magic happens. Here you can remove blemishes, smooth skin, and more! The pane is set up for you to start with the top setting, Blemishes, and work your way down. Working in order will give you the best overall results (**FIGURE 4.27**).

FIGURE 4.27 These are the default settings of the Skin Retouching pane.

- **Face Size:** The Face Size setting determines the initial mask size for the face: *Large*, *Medium*, or *Small*. This sets the masking area to look for flesh colors beyond the default mask; change it if the surrounding mask is encompassing too much or too little of the skin on the face. You can preview the mask by clicking the drop-down and hovering over the sizes. In addition, you can refine the mask by using the Brush tool.

- **Blemishes:** Ranging from 0 to 100, the Blemishes slider removes medium-size blemishes, such as acne, freckles, large pores, and even lines in the face while retaining the pore structure in the skin. When

using this slider for females and children, try setting it between 60 and 80. For males, keep the setting under 50.

- **Smoothing:** This setting smoothes the skin and is a good complement to the Blemishes slider and helps add a soft, healthy glow to the face. Be careful to not be heavy-handed with this slider, or you'll end up with skin that looks plastic and surreal (**FIGURE 4.28**). Although it ranges from 0 to 100, aim to keep the setting under 30, which is a good guideline for most skin types (**FIGURE 4.29**).

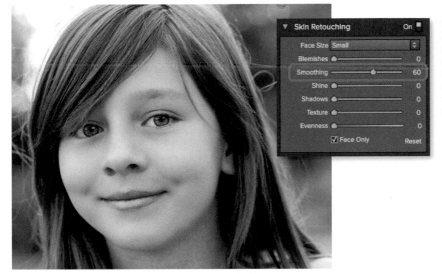

FIGURE 4.28 Be careful to not overdo the smoothing slider. This image has a Smoothing setting of 60, which adds too much softening to the skin.

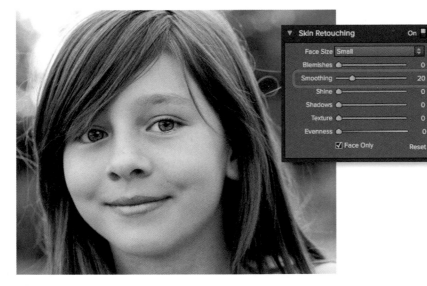

FIGURE 4.29 Using a lower Smoothing setting will typically give you the best results; here a setting of 20 adds a subtle softness to the skin without losing detail.

- **Shine:** Light can emphasize any oil on the skin, making it look shiny. To counteract this, use the Shine slider to even out those shiny areas and better blend them with the surrounding skin (**FIGURE 4.30**). The slider has settings ranging from 0 to 100; simply move the slider to the right until the shine has disappeared (**FIGURE 4.31**).

FIGURE 4.30
This woman has some shine on her face; I'm going to use the Shine slider to make it less apparent.

FIGURE 4.31 I used the Shine slider at a setting of 75 to reduce the shine on the woman's face.

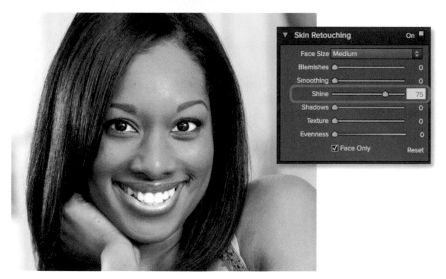

- **Shadows:** The Shadows adjustment (between 0 and 100) helps when you have an image with harsh shadows on the face. Moving this slider to the right softens those shadows and evens out the light over the face.

- **Texture:** Usually used in conjunction with the Smoothing slider, the Texture setting adds texture to the skin. If you inadvertently smooth out too much of the skin's natural texture but need to be a bit heavy on the Smoothing slider, use the Texture slider to replace some of what you lost. The setting ranges from 0 to 100, but you're better off using the lowest setting possible to add just a small amount of texture back into the image.

- **Evenness:** When your subject's face has areas of redness (blotchy patches or just rosy cheeks), you can use the Evenness slider (0 to 100) to even out the overall skin tone. As you slide the slider to the right, the red slowly disappears (**FIGURES 4.32** and **4.33**). Be careful, however, not to push the slider too far to the right or you'll lose a lot of the overall color in the face.

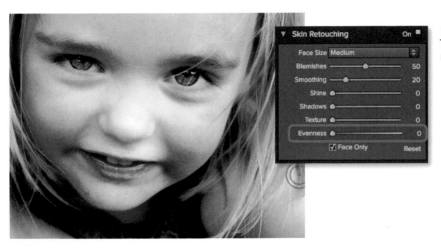

FIGURE 4.32
This little girl has very red, rosy cheeks.

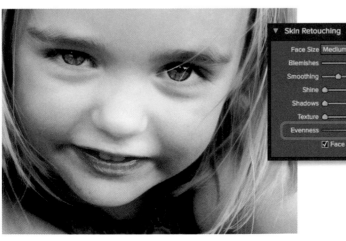

FIGURE 4.33
By moving the Evenness slider to 50 I was able to remove much of the redness in her face.

- **Face Only check box:** On by default, Face Only constrains adjustments to the skin on the face and any area you have painted in with the Brush tool. When you deselect this box, Perfect Portrait will search for other flesh-colored areas of your image and apply the corrections there as well. When working on an individual portrait, leave Face Only checked (**FIGURE 4.34**). If you're retouching a portrait with very little or no clothing or you want to apply the same skin edits to an entire group portrait without selecting individual Face Boxes, then deselect the box to edit the entire group at the same time (**FIGURE 4.35**).

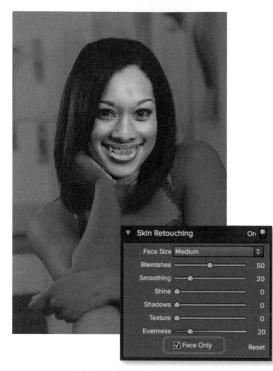

FIGURE 4.34 With the Face Only box checked, only the face will be affected by the Skin Retouching adjustments.

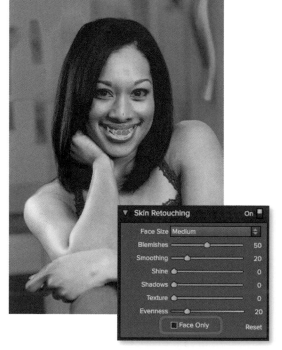

FIGURE 4.35 When you want to adjust all skin in your image, deselect the Face Only box.

NOTE

Be careful toggling Face Only if your image contains manual adjustments (like brushing in skin), as it will reset the mask and you would need to redo your changes. You can see the areas affected by toggling the mask view (**Ctrl+M**).

HOT TIP

To reset any of the individual adjustment panes, click Reset in the bottom right.

Color Correction

Most portraits look their best when they have a warm color cast to them. After all, people are most attractive when they have healthy, radiant, and even flushed skin. The opposite is a cool color cast, which can be an interesting stylized effect, but in a typical portrait it's usually more of a distraction. If your shot's color cast is less than idea, the Color Correction pane can help (**FIGURE 4.36**).

FIGURE 4.36 The Color Correction pane enables you to warm up or cool down the colors in your image.

Even if you already made your color corrections to the image, sometimes it doesn't hurt to make a few last-minute adjustments can really sell a look. Or, if you used a setting such as the Evenness slider in the Skin Retouching pane (which removes redness in the face), you may want to add some warmth back into your portrait to balance it out. Again, this is when Color Correction pane can be very useful. This pane's settings will affect the *entire image*, not just the face and skin.

- **Amount:** Ranging from 0 to 100, this setting determines the overall amount of color correction in your image. The more you move this slider to the right, the more intense the color correction in your image will be. By default the Color Correction pane is turned on but the Amount slider is set to 0, so you'll need to adjust it for the additional settings to take effect.

- **Warmth:** Use the Warmth slider to warm up or cool down the color tones in your portrait. The slider ranges from 0 to 100; by default it is set at the "original" warmth of your image (usually around a setting of 27). To warm up your image slide it to the right, and to cool it down slide it to the left (**FIGURES 4.37** and **4.38**).

HOT TIP

The sliders in this pane work from top to bottom and are dependent on one another. You must first adjust the Amount slider in order to "activate" the Warmth slider, and after setting your Warmth you can then change the Color Shift setting.

FIGURE 4.37 This is an example of warming up your image with the Warmth slider; in this example it's at a setting of 53.

FIGURE 4.38 This is an example of cooling down your image with the Warmth slider; in this example it's at a setting of 0.

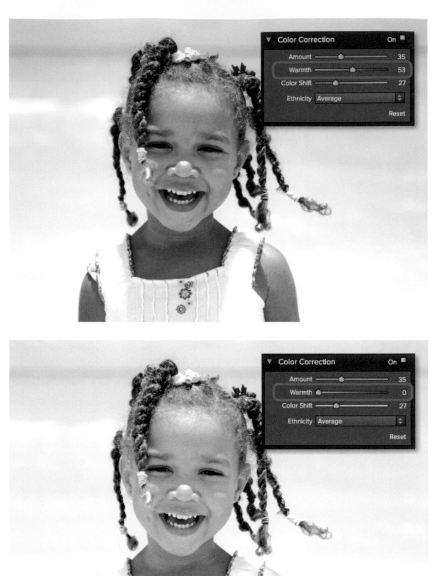

- **Color Shift:** The Color Shift setting gives you more control over the type of warmth in the image. Slide the slider to the left (toward 1) to give your image reddish warmth, and slide it to the right (up to 100) to give it more yellow warmth. Keeping the slider somewhere in the middle (between 25 and 75) creates a standard orange warmth (**FIGURES 4.39–4.41**).

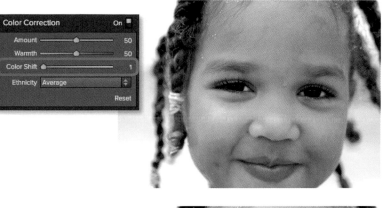

FIGURE 4.39 To add reddish warmth, move the Color Shift slider toward the left.

FIGURE 4.40 To add yellowish warmth, move the Color Shift slider toward the right.

FIGURE 4.41 To add an orange warmth, keep the Color Shift slider in the middle.

- **Ethnicity:** The type of correction needed for each image depends on the original color of a person's skin. Perfect Portrait includes six presets you can use to help the software find a good color match for your photo. These are usually good starting points for your image, or you can leave the setting's default of Average and make your adjustments manually (**FIGURE 4.42**).

FIGURE 4.42 The Ethnicity drop-down gives you a good starting place, depending on the skin-tone of your model.

> **HOT TIP**
>
> If you have more than one Face Box in your photo and want to use the same settings for the other faces, you can copy and paste the settings over to the other faces. Select the face you want to copy, choose Face > Copy Settings in the menu bar, use the Face Select tool to select a different Face Box, and then choose Face > Paste Settings. All the settings from the adjustment panes on the right will be applied to your currently selected face.

Enhancing the Eyes and Mouth

> **HOT TIP**
>
> When using this pane, try hiding the controls over the eyes and mouth so that you can see your changes much more clearly. Simply click on the Hide Controls setting in the Tool Options bar.

The Mouth & Eyes pane is where you will be able to make adjustments specifically to, not surprisingly, the eyes and mouth. A person's eyes are the most important aspect of nearly all portraits, and this pane offers tools specifically to make those beautiful eyes stand out. Also, nobody likes yellow teeth, and you can use a slider to remove the yellow and brighten your subject's pearly whites faster than a dentist. Each of these settings is directly related to the controls over the eyes and mouth you adjusted earlier in this chapter, so be sure that they're properly positioned to get the best results (**FIGURE 4.43**):

FIGURE 4.43 The Mouth & Eyes pane allows you to make enhancements to the eyes and mouth.

Eyes Whitening: The Eyes Whitening slider brightens the white portion of the eyeball and ranges from 0 to 100. Between 20 and 50 is a good place to start, and be careful about pushing too far with this setting. White eyeballs are nice, but slide it too far to the right and they might start to look unrealistic (**FIGURES 4.44** and **4.45**).

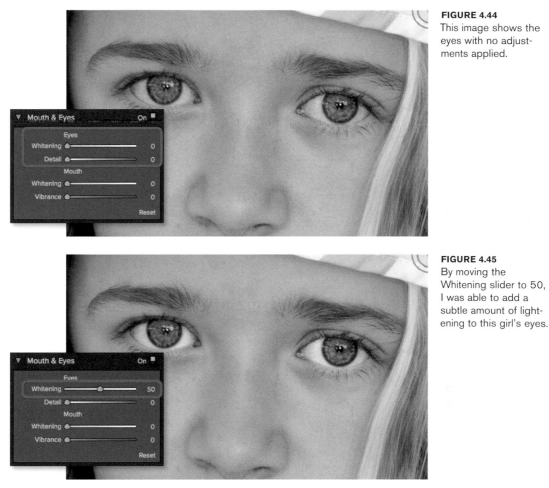

FIGURE 4.44
This image shows the eyes with no adjustments applied.

FIGURE 4.45
By moving the Whitening slider to 50, I was able to add a subtle amount of lightening to this girl's eyes.

- **Eyes Detail:** When we look at a photograph our eyes always go to the sharpest portion of a scene. Because the eyes are the most important area in most portraits, adding a bit of sharpening and clarity to them makes sense. The Eyes Detail slider ranges from 0 to 100; to add a

touch of sharpness to the eyes, move the slider to the right. Sharpening the eyes can make them sparkle and give your image the balance it needs, but to keep it realistic don't be too heavy-handed with this setting (**FIGURE 4.46**).

FIGURE 4.46 Setting the Detail slider to 25 adds a good amount of detail to the eyes without overdoing it.

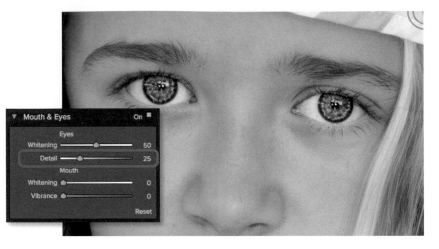

- **Mouth Whitening:** Ranging from 0 to 100, the Mouth Whitening slider brightens and whitens the teeth all at once. Try to keep this setting at around 50 for most images, because pushing the number too high may give your subjects unnaturally whitened teeth. Also, if there are no teeth in your portrait keep this setting at 0 (**FIGURES 4.47** and **4.48**).

FIGURE 4.47 This image shows the mouth with no adjustments applied.

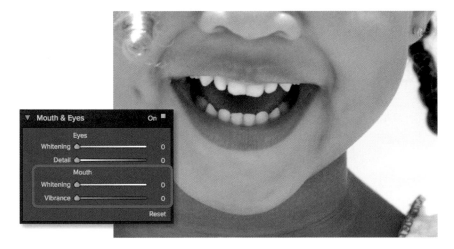

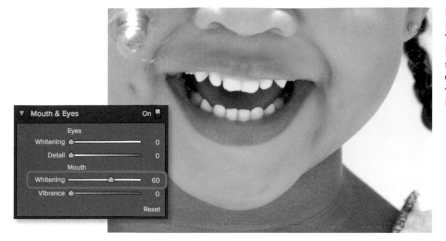

FIGURE 4.48
By moving the Whitening slider to 60 I was able to add a subtle amount of lightening to this girl's teeth without affecting the inside of her mouth.

- **Mouth Vibrance:** This setting adds saturation to the lips to make them a brighter color. The setting ranges from 0 to 100, and I find that setting it anywhere under 50 does a good job of making the color pop without overdoing it (**FIGURE 4.49**).

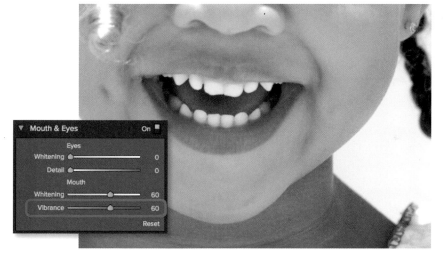

FIGURE 4.49
The Vibrance slider intensifies the red in the lips.

Effects and Presets

Perfect Portrait ships with a good selection of effects you can use with your images. When you launch the application, Perfect Portrait applies basic adjustments to your image, and from there you can play with the effects to see if another works better. If you want to set the initial settings for the adjustments that will be applied upon launching Perfect Portrait, go to Edit > Settings. Here you can select the intensity of the default adjustments (Natural or Strong), apply adjustments only to the skin (Skin Only), or select your own preset from the My Settings option at the very bottom (**FIGURE 4.50**). This is a great way to customize the intensity and application of the default settings to ensure that your portraits come out perfectly every time. After you make changes in the Settings window, the effects will be applied to all future images launched in Perfect Portrait.

FIGURE 4.50 You can set the default Perfect Portrait adjustments in the Settings dialog box.

To apply an effect, select the face you want to work on by clicking it with the Face Select tool, click the folder drop-down, and then click an effect in the Effects tab to apply it (**FIGURE 4.51**). If you want to apply different effects to more than one person in your image, such as with a group photo, use the arrows in the Tool Options bar to select the individual Face Boxes and then apply the appropriate effect. Both effects and presets will override any changes you have made in the adjustment panes, so apply these before making additional refinements.

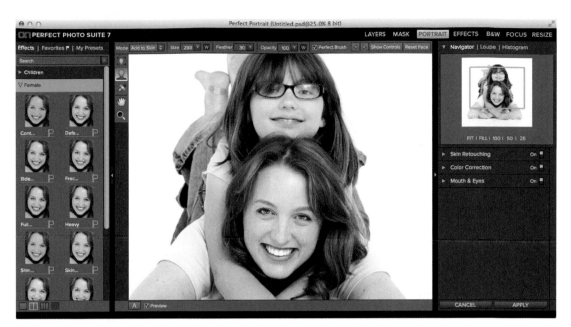

FIGURE 4.51 Perfect Portrait offers several effects for use with your portraits.

Another great thing you can do in Perfect Portrait is save your own presets and then apply them to future images. To do this, make sure that a Face Box is selected and then choose Preset > Save Preset. These presets will then appear in the Presets tab on the left side of the window. Custom presets are especially useful when you have a large number of images to edit from the same person or group of people, such as from a senior portrait or engagement shoot. You can save the settings made in the adjustment panes (Skin Retouching, Color Correction, and Mouth & Eyes) and use them for your group of images. As with some of the other products in the suite, you can favorite any effect or preset and save it to the Favorites tab by clicking on the flag icon to the right of its thumbnail.

You also have the ability to batch process images with Perfect Portrait; please turn to Chapter 1, "Getting Started," for a detailed explanation on how to do that using Lightroom and Photoshop.

HOT TIP

Batch processing in Perfect Portrait works only with photographs that have a single person in the image. You need to process group photos manually to tell the software which preset should be applied to each individual face or use a "skin only" preset, which will not make adjustments to the eyes and mouth.

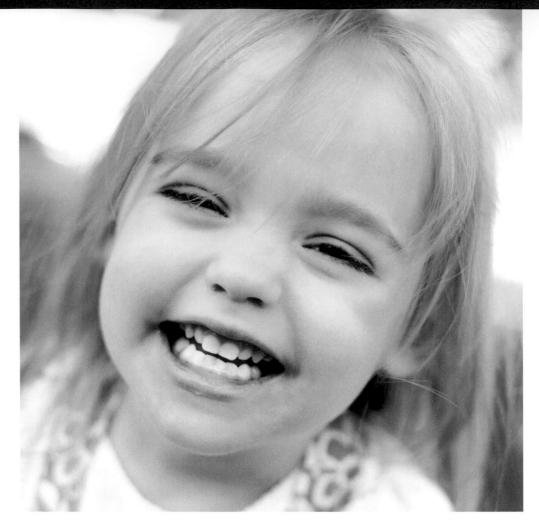

Cleaning Up Skin

Faces with several blemishes are some of the more difficult images to edit. In this image of my niece, I was able to get rid of the blemishes under her chin and make it blend well with the rest of her face by using Perfect Portrait.

Step 1

I started off with my image inside of Perfect Portrait. The software immediately found the girl's face, so I clicked once inside the green square to start my edits and Perfect Portrait immediately located the eyes and mouth.

Step 2

The controls over the eyes and mouth needed some adjustment, so I fixed them by clicking on the points and dragging them to the correct spots. I also used the brush to make certain that the skin on the face was fully showing, especially the areas where the blemishes were most severe.

Step 3

Then I went over to the Effects tab on the left and applied the Heavy Retouch effect from inside the Children category. This did a good job of smoothing away most of the blemishes on the chin.

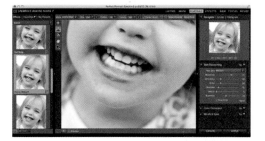

Step 4

To continue the retouch process, I selected the Retouch brush from the tool-well. Then I set the Size to 125, the Feather to 25, and the Opacity to 50%, and clicked several times in the image over the areas where the blemishes were most severe. I did this until I removed the majority of the blemishes while keeping the skin tone and texture intact.

Step 5

Next I directed my attention to the Mouth & Eyes pane on the right side of the screen. Since her eyes are squinting and not very visible, I decided to move both sliders to 0. Then I increased the Whitening slider for the Mouth to 85.

Step 6

The last step was to apply the effect. When I preview the before and after images, I can tell that the blemishes have faded away nicely without a loss of detail in the skin.

A basket filled with ripe red currants; processed using Perfect Effects 4.

Canon 5D Mark III, 100mm Macro lens, 1/10 sec at f/4.5, ISO 100

PERFECT EFFECTS

Perfect Effects is a great tool to have at your fingertips when you want to creatively stylize an image. It's definitely one of the most popular products in the Perfect Photo Suite, partly because it's so much fun to use! Along with adding presets, borders, and textures, you can use Perfect Effects to add subtle enhancements and adjustments, and even refine your effects with its masking tools. As you'll learn here, Perfect Effects offers endless possibilities for beautifying and enhancing your images.

The Perfect Effects Interface

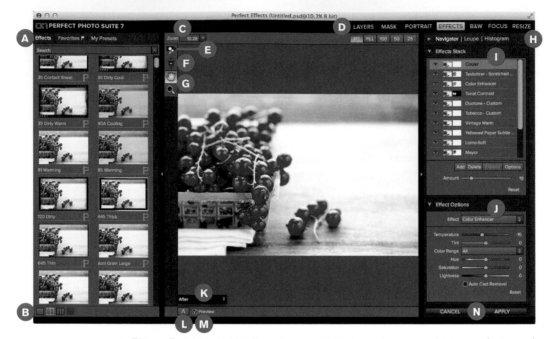

A Effects, Favorites, and My Presets

B Browser mode

C Tool Options bar

D Module selector

E Masking brush

F Masking Bug tool

G Hand and Zoom tools

H Navigator, Loupe, and Histogram (collapsed)

I Effects Stack pane

J Effect Options pane

K Mask View mode

L Preview mode

M Preview toggle

N Cancel and Apply buttons

When to Use Perfect Effects

One of the appeals of Perfect Effects is that you can use it with any image. Simply experimenting with effects to enhance an already beautiful photograph is also great fun. Some of the reasons Perfect Effects is the perfect tool are:

- **Complete creative control:** The great thing about Perfect Effects is that you are not bound to applying only pre-installed effects. By using the Effects Options pane, along with blending options, and masking you can completely customize your image and even save your own effects as presets to use with future images.

- **Color and tone correction:** Perfect Effects is not only for stylization. You can apply basic color adjustments to your images as well. Sometimes a simple change to the color or tones of an image is all that's needed to enhance the photo and take it to the next level.

- **Selective adjustments:** One extremely valuable tool inside of Perfect Effects is the ability to apply masking to individual effects. This allows you to add gradient adjustments to a sky without affecting the rest of the scene, make selective adjustments to specific areas of a photo, and similar fine-tuning.

Applying Effects

Perfect Effects allows you an enormous amount of creativity to enhance and stylize your images. You can use the factory-built effects in the pane on the left to apply professional looks your photographs, or you can start off with the Effects Options pane on the far right to create your own unique presets and completely customize the look. Or use a combination of the two—just have fun with it! Ultimately there are *endless* combinations of ways to stylize and beautify your images.

> **NOTE**
>
> For more information on opening your image into the Perfect Effects interface, please see Chapter 1, "Getting Started."

The Browser Pane

To give you a convenient visual of how both effects and presets will look on your images, the Browser pane on the far left of your window is the place to start. Here you'll find a library of factory-built effects you can apply to your image or study for a boost of inspiration, along with a tab for storing favorites and presets. You can also change the view mode and toggle between any of the four views—one column, two columns, three columns, or a list view—by clicking the options at the bottom of the pane (**FIGURE 5.1**).

FIGURE 5.1 The Browser pane on the left of the window includes Effects, Favorites, and My Presets tabs. You can also change the view mode of the columns; here it's set to Two Column Thumbnail view.

One of the best features of the Browser pane is that the thumbnails are updated in real time so that you will see a preview of how that effect will look when you apply it to your photo. As photographers, we're very visual people, so it's an added bonus (and huge time-saver) to be able to scan through the effects and view them exactly as they will look before adding them to the photograph.

Effects

Perfect Effects comes with a library of factory-built effects for you to use with your images. Sorted into categories, these are located in the Browser pane on the left of your window under the Effects tab. The effects are a great place to start or to just get those creative juices flowing.

HOT TIP

If you know the name of the effect you want to apply, the Search box at the top of this pane is a handy tool. Just start typing the effect preset you want, and it will appear in the Browser pane below.

To try out an effect from the Effects pane all you need to do is click once on an effect thumbnail; the Preview window then shows you the results. After applying the effect, you can make changes, such as adjusting the opacity and blending options, using the Effects Stack pane on the right. If you don't like the effect you selected, simply click on another effect to try it out. The work in Perfect Effects will be committed to your image once you click Apply. While you're still editing your image you can go back and redo, remove, or swap any of the effects along the way.

Favorites

The more you use Perfect Effects the more likely you'll gravitate toward certain effects, whether they're your own creations or the built-in effects in the Effects tab. This is when the Favorites tab comes in handy: It allows you to collect all your most frequently used presets in one easy-to-access location. To add effects to it, just click the flag icon next to the preset in either the Effects or the Presets tab. The selected effects appear in the Favorites tab listed alphabetically by effect name (**FIGURE 5.2**). To remove an effect from Favorites, click the flag again until you see only the outline of the flag.

Aged Paper

FIGURE 5.2 To add a preset or effect to the Favorites tab, click the flag icon in the bottom-right of the preview icon. A completely white flag indicates that it's in the Favorites; to remove it from Favorites, click the flag icon so all you see is its outline.

My Presets

The My Presets tab is for storing presets you create yourself inside of Perfect Effects, as well as presets you import from other photographers, such as those found in the onOne Marketplace (http://ononesoftware.com/marketplace). The My Presets tab organizes presets alphabetically and includes a Recently Used folder, which lists your 10 most recently applied presets. Also, presets you make yourself and most of those you import are fully customizable, meaning you can edit, mask, and delete the individual effects of presets stored in the Presets panel. For more information on creating, saving, and importing presets head to the "Working with Presets" section later in this chapter.

HOT TIP

By double-clicking the effect you want to add in the Effects pane, you automatically apply the effect and create a new effects layer. This makes it easy to work quickly with effects in Perfect Effects without having to click the Add button each time.

Effects Stack

When you launch an image into Perfect Effects, you'll notice two small thumbnails in the Effects Stack pane on the right side of the window. This pane is similar to the Layers pane in Perfect Layers, but instead of stacking images you're stacking *effects* (**FIGURE 5.3**). The Effects Stack pane allows you to add, remove, blend, and change the effects as you add them. In addition, here you also can create presets to use with future images while retaining the ability to edit and change the effects in the presets.

FIGURE 5.3 The Effects Stack is comprised of one or more effects layers; when you open your image into Perfect Effects you will have your Original image on the bottom layer and an empty layer above it where you will add your first effect.

When you launch Perfect Effects, you'll see a thumbnail of your original image with no effects applied at the bottom of the stack. Above this, Perfect Effects adds a new stack called Empty Layer. Think of this new layer as an empty canvas on which to apply your effect: At first it's blank, but as you add effects or presets to that stack you'll start to see those change the overall image. If you want to add more than one effect to your image you can add layers to customize your image even further.

As you edit your photos, remember that the order of the layers in the Effects Stack panel affects the way they look in the photo, especially if you're using any type of Masking Brush or Bug. To move your stacks around, just click on the stack you want to move and drag it up or down to the new location.

Here are some additional features of the Effects Stack that will help you editing your photos:

- **Amount slider:** The Amount slider determines how strongly the effect will be applied to your image, and it's very similar to the Opacity sliders you'll see in some of the other products. The effect is strongest at a setting of 100, and the lower you set the slider, the weaker the effect will appear.

- **Add button:** The Effects Stack starts out with two layers: your original image and an empty layer for adding an effect. After applying that one effect, if you want to add more effects just click the Add button to add a new effects layer to the pane, and an empty layer will appear in the Effects Stack pane (**FIGURE 5.4**). Next, select an effect to apply to that layer (from either the Browser on the left or the Effects Options pane on the right). In this way, you can continue adding and applying effects until you're satisfied with your image.

- **Delete button:** If you want to delete a layer, highlight it by clicking it in the Effects Stack pane, and then click the Delete button to remove it.

- **Expand button:** When you apply a preset, the effect will show up as a single effect in the Effects Stack pane with italicized text. To make changes to the effect (such as adjusting the Amount setting or blending options), you must first *expand* the preset to access all of the effects as new layers in the Effect Stack. To do so, simply select the stack, then click the Expand button. This enables you to edit and manipulate the stacks to customize the effects for your image (**FIGURES 5.5** and **5.6**).

> **HOT TIP**
>
> Make sure to add a new stack with the Add button when you're ready to apply a new effect or you'll overwrite the effect you just applied.

FIGURE 5.4 Clicking the Add button adds a new empty layer to your Effects Stack.

FIGURE 5.5 Click the Expand button to reveal the contents of your preset.

FIGURE 5.6 After expanding the preset from Figure 5.5, I can edit the individual effects it is composed from.

> **HOT TIP**
>
> When you apply a preset to a layer in the Effects Stack pane, the layer will appear with italicized type, indicating it as a preset and can be expanded.

- **Options:** Clicking the Options button enables you to further adjust and manipulate individual layers in the Effects Stack pane by using blending modes. Using these options, you can also apply the effect to specific tones or colors, as well as protect parts of your image from having the effect applied to those areas. More detailed information on the Blending Options window is further along in this section.

- **Stack visibility icon:** Each effect in the Effects Stack pane has an eyeball icon 👁 to the left of it (**FIGURE 5.7**). This eyeball icon indicates that the stack is visible and that you are currently previewing it in the Preview window. To hide an effect, just click its eyeball. The icon will then change to a closed eyelid icon, indicating the effect is no longer visible ▬ (**FIGURE 5.8**). To make that layer visible again, just click on the closed eyelid.

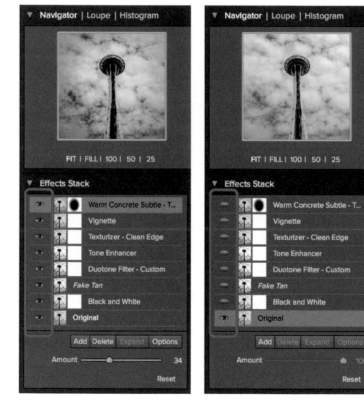

FIGURE 5.7 This Effects Stack shows all layers visible; this is apparent by the eyeball icons to the left of each layer.

FIGURE 5.8 I hid all layers by clicking the eyeballs next to each layer, which then changed to closed eyelid icons.

Effect Options

The Effects Options pane contains all of the building blocks of Perfect Effects. Here is where all of the effects originate, making up what you see in the Effects tab, and it's an area you need to become familiar with if you want to have complete control over the look of your image (**FIGURE 5.9**). The Effects Options drop-down contains 11 effects, each with its own associated settings.

The available effects in the Effect Options pane are:

FIGURE 5.9 The Effect Options pane has 11 different effects you can apply to your images.

- **Black and White:** With the Black and White effect you can quickly change an image to black and white. You can set the contrast and color filter, and even add a bit of styling with the Toner and Grain settings (**FIGURE 5.10**).

- **Blur:** This effect blurs your image. You can specify a basic Gaussian or Surface blur, or even add a motion effect with a Radial blur setting (**FIGURE 5.11**).

FIGURE 5.10 I used the Black and White setting with the filter moved near the red color to brighten the little girl's skin, and added a soft brown Toner color as well.

FIGURE 5.11 I used a Radial blur type to give this image a unique motion effect.

- **Borders:** While the Effects tab contains some border presets, you'll find even more borders and options here. You can change the border's blending mode, strength, or scale, as well as flip or rotate the border with the buttons on the bottom of the pane (**FIGURE 5.12**).

- **Color Enhancer:** Use the Color Enhancer effect when you want to apply color adjustments to your image, mostly with the Temperature and Tint sliders. You can add saturation, alter the hue, or even change the brightness of your image as well. There's even a drop-down menu that enables you to isolate your changes to specific color sets (**FIGURE 5.13**).

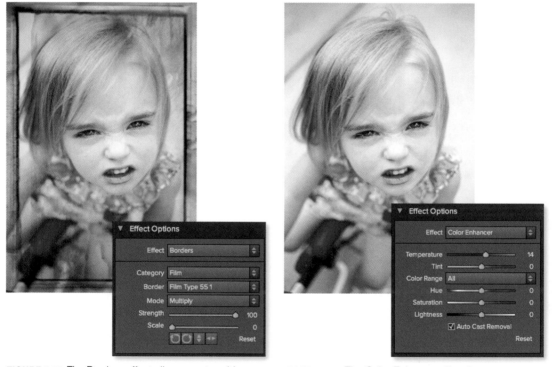

FIGURE 5.12 The Borders effect allows you to add and customize borders for your images. For this photo I used a film border and blended it using the Multiply blending mode.

FIGURE 5.13 The Color Enhancer effect is a great way to make basic color adjustments to your images, as I did here with this photo. You can make changes to the Hue, Saturation, and Lightness of your image as well.

- **Duotone:** This setting is for adding a split-tone, or cross-processed, effect to your image. You get started by choosing from the supplied presets, or you can customize the colors by clicking on the color swatches in the pane. You can also edit the strength of the effect, the Midpoint setting for the colors, and change the mode as well (**FIGURE 5.14**).

- **Glow:** The Glow effect adds a subtle glow to your image. You can change the type of glow (Gaussian, Radial, or Surface), along with the Strength, Halo, and Mode settings (**FIGURE 5.15**).

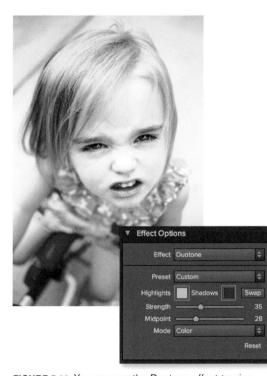

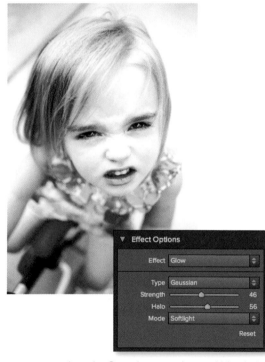

FIGURE 5.14 You can use the Duotone effect to give your images a cross-processed look. You can use one of the several presets or change the colors and other settings on your own to give it a customized look.

FIGURE 5.15 I used a Gaussian-type glow and blended it in with a Soft Light blending mode to soften and brighten this portrait.

- **Photo Filter:** This effect adds a colored filter to your image, similar to adding a filter to your camera lens. You can choose from several presets, or you can use the color picker to choose your own custom filter color. The Filter Type setting enables you to specify a color filter, a graduated filter, or a bi-color filter (**FIGURE 5.16**).

FIGURE 5.16 You can use the Photo Filter effect to either correct the color in your images or to stylize it. I "cooled down" this photo by using a light-blue solid filter.

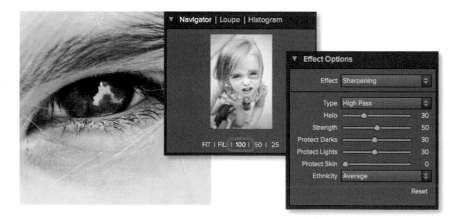

- **Sharpening:** When you want to sharpen your image, use the Sharpening effect. You can even add masking to the effect to selectively sharpen a small area of your photo (**FIGURE 5.17**). In both cases, I recommend zooming in close by clicking on the 100 button in the Navigator so you can see what's happening to the pixels.

FIGURE 5.17 When using the Sharpening pane, zoom in to your photo; here I clicked 100 in the Navigator pane for 100% zoom.

- **Texturizer:** One of my favorites, the Texturizer is a fun effect to play with. You can hover over each of the textures in the drop-down list to see them preview live in your Preview window. You can also specify Mode, Strength, and Scale settings, as well as flip or rotate the texture with the icons at the bottom of the pane (**FIGURE 5.18**).

- **Tone Enhancer:** The Tone Enhancer allows you to make basic tone adjustments to your image. If you're confident with such adjustments, you can try your hand at the curves adjustment near the bottom of the pane (**FIGURE 5.19**).

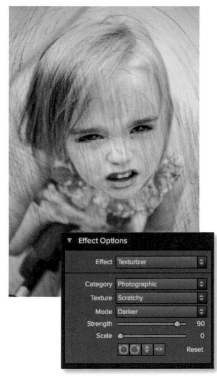

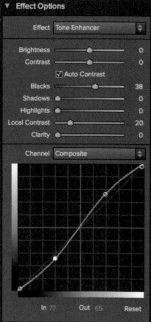

FIGURE 5.18 Use the Texturizer effect in the Effect Options pane for a large assortment of pre-installed textures.

FIGURE 5.19 The Tone Enhancer effect is great for changing the tones of your image. You adjust the settings or the curve to brighten, darken, or alter the contrast of your photos.

165

- **Vignette:** This effect allows you to apply a vignette to your image and adjust the Brightness, Midpoint, Feather, and Roundness settings of the vignette. You can also choose Soft or Subtle mode to keep the vignette from being too harsh (**FIGURE 5.20**).

FIGURE 5.20 The Vignette effect is a quick way to add a simple vignette to any photo.

HOT TIP

To see a quick before-and-after preview of your image, press **Cmd+P** or **Ctrl+P** (PC) or choose View > Preview On/Off. You can also see a live preview of your image by choosing one of the options from the View > Preview Area Mode menu or clicking the Preview checkbox on the bottom of the window.

Blending Options

One very powerful feature of Perfect Effects is the ability to change the blending modes and settings for each effect layer. Earlier, in Chapter 2, I discussed the blending modes you can use with your layers. You can apply those same blending modes in Perfect Effects along with a few additional ones unique to this application.

To access the Blending Options window, make sure that you have an effect added to your Effects Stack, highlight the effect you want to work on, and click the Options button in the Effects Stack pane to open a new Blending Options window (**FIGURE 5.21**). Here you can select your blending mode, along with the strength of your effect underneath. You can also limit the effect to certain colors or tones by specifying them with the Apply Effect To option. The Protect setting enables you to specify tones or colors you do not want affected. All of the settings show a live preview on your screen, so you can try various combinations of options to see what each of them does with your effect and image.

FIGURE 5.21 The Blending Options window gives you an enormous amount of control in blending effects within the Effects Stack.

You can get very creative with your images when using the blending options, to spark your imagination here are a few examples:

- **Add drama:** To give an image a "punchy" dramatic look, first add a Black and White effect. Then, go into the Blending Options window and change the blending mode to Overlay. This will add contrast to your image and give it a slightly desaturated look (**FIGURE 5.22**).

- **Play with texture:** The Texturizer effect gives you a few settings in the Effect Options pane, but you can further stylize the texture by using the blending options (**FIGURE 5.23**).

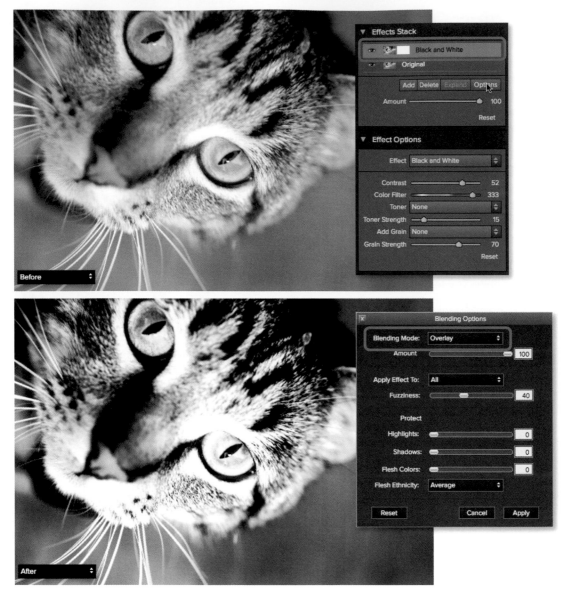

FIGURE 5.22 By using the Overlay blending mode, I was able to add contrast and a desaturated look to this photo of my cat, Fuji.

FIGURE 5.23 I was able to further blend this Texturizer effect by changing the settings in the Blending Options window.

- **Add color pop:** To add a burst of color to an image, first select either a Blur or Glow effect from the Effect Options pane, and then change the blending mode in the Effects Stack pane to Soft Light. Finally, reduce the Strength slider down to around 50 (**FIGURE 5.24**).

FIGURE 5.24 By using the Soft Light blending mode with a lower opacity, I blended a Blur effect into the original image, resulting in more contrast with saturated colors.

- **Blend borders:** If you want to add a border to your image, you can do this from the one of the effects in the Effects tab on the left, or from the Borders effect in the Effect Options pane. You can also change the blending mode of the border directly inside of the Effect Options pane, or double-up the effect with the blending options to further edit and blend in that border to your image (**FIGURE 5.25**).

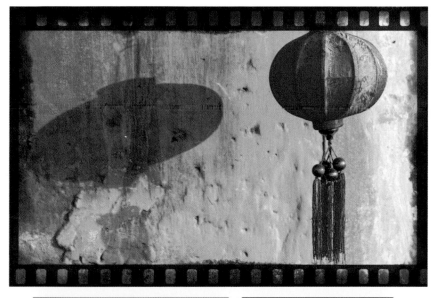

FIGURE 5.25 Although the Borders effect has a Mode setting in the Effect Options pane, you can add even more blending to the layer by using the Blending Options, just as I did here with this film border effect.

Working with Presets

One really cool thing about Perfect Effects is the ability to save your effects stacks as presets and then reuse them with other images in the future. Creating presets is a great way to speed up your workflow and still maintain your own personal style with your photographs. When you create a preset, Perfect Effects saves it into the My Presets tab in the Browser pane.

HOT TIP

One feature of presets inside of the Perfect Photo Suite is the ability to batch them with large groups of images out of Lightroom and Photoshop. See Chapter 9 for a step-by-step explanation of batch-processing images with presets.

Saving Presets

The process of saving a preset is simple: Arrange your effects as desired in the Effects Stack pane, then choose Preset > Save Preset. In the window that pops up, you can type a name for your preset, select a category (or create a new one), and optionally enter your name as the creator as well as a description (**FIGURE 5.26**). Click Create, and Perfect Effects immediately saves your new preset in the Presets section of the Browser pane.

NOTE

When saving a preset, it's important to note that masks created with a Masking Bug will be saved in your preset, allowing you to create customized gradation in your presets (such as enhancing only the sky with a rectangular-shaped bug, or by adding a vignette effect with a round-shaped bug). However, any brush strokes applied to the mask will not be saved.

FIGURE 5.26 The New Preset window allows you to name and categorize your customized presets.

You also have the ability to edit and resave your presets by overwriting old presets with new effects. I often overwrite a preset if I'm doing a *lot* of intense editing to an image in Perfect Effects and want to make sure my progress gets saved, just in case the unavoidable happens. (Computers can be finicky at times and decide to close applications on us without any warning.) So, to save myself any possible extra time and energy, I will save a preset—the same preset—a few times during the editing process. Start off by saving the preset very early into your edits in Perfect Effects, you don't even need to be finished with what you're working on. To update the saved preset with your new changes, choose Preset > Save Preset and give it the same name and category when the window pops up. Perfect Effects will ask if you want to overwrite it; click the Yes button if you do (**FIGURE 5.27**). That same warning is also helpful to prevent you from unintentionally overwriting the wrong preset, in case you accidentally give different presets the same name.

FIGURE 5.27 When you save a preset with the same name as an existing preset, a warning window will pop up. Click Yes to overwrite the preset, or No to cancel.

HOT TIP

While the Save Presets window is open, you can open the folder that contains your presets. Click the Open Presets Folder button, and a file browser window will open with your categories (folders) and presets (files). You can even rename the folders and files from the Presets folder, and they will appear with the new names inside of Perfect Effects.

Importing Presets

Whether downloading presets from the onOne Software Marketplace or passing them to friends, you can easily share presets among computers. To add existing presets to your Browser pane, choose Preset > Import Preset (**FIGURE 5.28**). In the file browser window that pops up, navigate to the presets you want to import, highlight them, and click Open. In the next dialog box that appears, select a category to add them to and click OK (**FIGURE 5.29**).

NOTE

You may need to restart Perfect Effects for the new preset to show up in your Preset tab.

FIGURE 5.28 You can import presets from the Preset menu.

FIGURE 5.29 When you import presets, Perfect Effect lets you specify the category in which they belong.

Another quick way to import presets is to double-click the files you down-loaded (either from the Marketplace or from other Perfect Effects users). Perfect Effects will automatically recognize them as presets and ask which category you'd like to place them in. You can also import your presets manu-ally by choosing Preset > Show Presets Folder. A file browser window pops up containing all of your saved and imported presets (**FIGURE 5.30**). To add presets to this folder, just drag them from their current location. You can rename and reorganize your presets from within this folder as well. Be aware, however, that you may not see any of these changes until after restarting Perfect Effects.

FIGURE 5.30
Accessing the Presets folder on your com-puter is a good way to stay organized. You can also copy and paste these files into another folder to back them up.

HOT TIP

If you're looking for additional presets to import to your collection, check out the onOne Software Marketplace (http://ononesoftware.com/marketplace) where you can purchase Perfect Effects presets, Lightroom and Aperture presets, and such additional resources as backgrounds and album templates. You can launch the Marketplace directly from within the Perfect Photo Suite by choosing Preset > onOne Marketplace.

Masking Tools

You won't always need to make global changes to the entire image. In Perfect Effects, you can apply your adjustments selectively to specific areas of an image using the Masking Brush or the Masking Bug. With these masking tools you can, for example, add drama to a sky without affecting the fore-ground, brighten eyes without changing a person's skin tone, and even do selective coloring after converting a photo to black and white.

The Masking Brush

The Masking brush is the best way to add specific adjustments and detailed masking to your photo. First, highlight the effect you want to mask in the Effects Stack, then click the Masking brush icon in the tool-well.

When you select the Masking brush, the options in the Tool Options bar change. Starting from the left, the options are:

- **Mode:** With this toggle, you can select whether you want to add to (Paint In) or remove from (Paint Out) the mask. The default for the Masking brush is Paint Out, so you will see your effect start to disappear from the screen where you paint (**FIGURE 5.31**). If you change your mind, just click on the setting to toggle it to Paint In and paint your effect back into your image.

NOTE

You can activate the Masking brush only when you have an effect applied and highlighted in the Effects Stack.

FIGURE 5.31 You can use the Masking brush to paint the effects in and out; here I'm using the Paint Out mode to reveal the original layer.

HOT TIP

With the Mode setting you can use the keyboard shortcut X to toggle between Paint In and Paint Out.

- **Size:** This setting determines the size of the brush and ranges between 1 and 2500. When you use the Perfect Brush option, however, Size is limited to a maximum of 500.

- **Feather:** The Feather setting determines how soft or hard the edges of your brush are as you paint. The higher the number, the softer the feather. You will usually want to feather your brush for softer transitions in your image, so you probably won't want it set too low.

- **Opacity:** The Opacity setting determines how transparent or opaque the brush is as you paint over your image. If you want to add a subtle adjustment to an area, such as changing its brightness, then keep Opacity at a very low value (such as 10 or 20 percent). By default it's set to 20%, which is good for most masking jobs. Also, as you paint over your image the brush strokes will compound on top of each other and eventually add up to 100% opacity if you continue to paint over the same area again and again (**FIGURE 5.32**).

FIGURE 5.32 For this image I used a low Opacity setting (20%) and made several brush strokes over the flower to incrementally remove some of the texture effect.

- **Perfect Brush:** The Perfect Brush option is great to use when you want to mask an effect in or out of a specific area of your image without having the mask spill over to another part. Also, due to the nature of how the Perfect Brush works, it is limited to a maximum size of 500; if your Masking brush is larger than 500 when you activate Perfect Brush, Perfect Effects will automatically resize the brush to a size of 500. To activate the Perfect Brush, click on the check box in the Tool Options bar. Now, as soon as you click on an area in your image the brush analyzes the color from the center of the brush (the crosshair) and masks out similar colors *only* (**FIGURE 5.33**). If the crosshair of the brush crosses over into a new color, it will start using that color as its guide and begin masking out new similar colors. I recommend using the Perfect Brush option at a size around 250 when masking against hard edges.

> **HOT TIP**
>
> To adjust the Size, Feather, and Opacity settings, you can use the "scrubby slider," enter a numerical value, use the respective keyboard shortcuts, or click the disclosure triangle to reveal the slider.

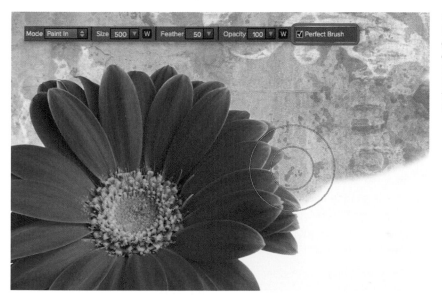

FIGURE 5.33 The Perfect Brush is a great way to mask only certain areas of your image; for this photo I'm masking only the texture layer into the background.

The Masking Bug

The Masking Bug allows you to add either round or planar-shaped masks to your image. Some examples of when this tool is extremely useful are when you want to selectively edit the sky in a landscape images, add a custom vignette effect, or soften the effect of a texture. The Masking Bug can be a quicker option than the Masking brush, especially if you want to mask out a large area at once.

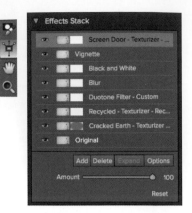

FIGURE 5.34 Make sure you have the correct layer selected in the Effects Stack before adding your Masking Bug.

To add a Masking Bug mask to your image, select the layer you want to add the bug to, click on the icon in the tool-well, and then click in your image to add the bug (**FIGURE 5.34**). From here, you can resize the bug and move it as necessary. Once you create a new effects layer or activate a different layer in the Effects Stack pane, you are unable to re-edit the bug on that layer. Instead, you'll be forced to reapply the bug from scratch. The Masking Bug also works in tandem with the Masking brush, but be sure to apply the Masking Bug *before* doing any additional masking with the Masking brush.

To move the Masking Bug around in your image, just drag the body of the bug. You'll see the changes as you move it around. You can also resize and rotate the bug by clicking and dragging on the small handlebars with solid-filled circles. In addition, you can change several settings in the Tool Options bar:

- **Feather**: The Feather option refers to the softness (or hardness) of the edge of the bug. For example, if you're using a round bug then the oval shape will be more defined when Feather is set to 0, and the higher the number is, the softer the edge will be (**FIGURES 5.35** and **5.36**).

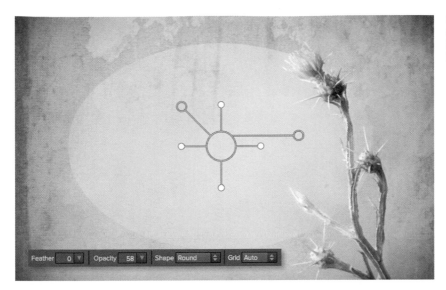

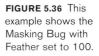

FIGURE 5.35 This example shows the Masking Bug with Feather set to 0.

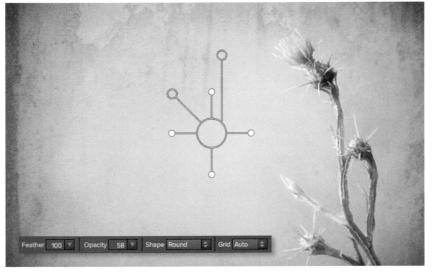

FIGURE 5.36 This example shows the Masking Bug with Feather set to 100.

• **Opacity**: Ranging from 0 to 100%, the Opacity setting determines how much of the mask is showing through (**FIGURES 5.37** and **5.38**). Its default is 100%, which means that the black areas of the mask are completely opaque. You can also change the Opacity setting with the handlebar in the top-right corner or area of the bug.

HOT TIP

You can change the Mask Opacity, Layer Opacity, and Feather settings with the handlebars in the top-right and -left corners (or areas) of the bug.

FIGURE 5.37 Setting your bug to a lower opacity can allow you to keep some of the effect while fading it away. For this image, I set the Masking Bug to 40% to soften the texture but still have it show through.

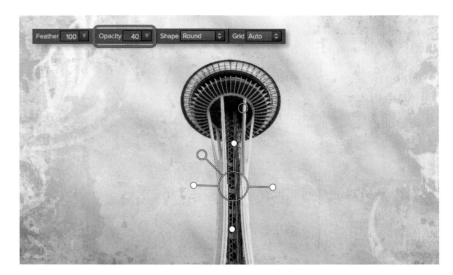

FIGURE 5.38 This shows the Masking Bug at its default opacity of 100%.

- **Shape**: This toggle sets the bug's shape: Rectangle (the default) or Round. A rectangle-shaped bug creates a rectangular area of masking that can stretch from one end of your image to the other. Rectangular bugs work great for creating a gradient of masking skies and landscapes (**FIGURE 5.39**). Round bugs create a circular or oval area of masking and can be used for creating circular-shaped adjustments or even creating custom vignette effects (**FIGURE 5.40**).

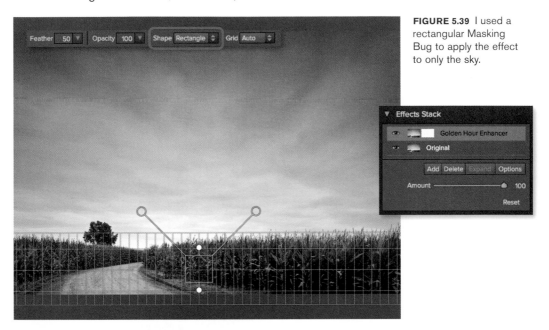

FIGURE 5.39 I used a rectangular Masking Bug to apply the effect to only the sky.

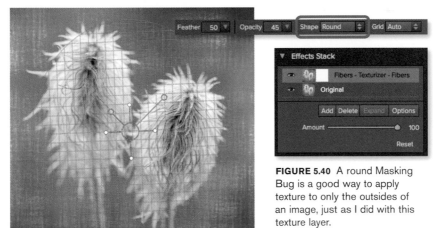

FIGURE 5.40 A round Masking Bug is a good way to apply texture to only the outsides of an image, just as I did with this texture layer.

- **Grid**: You may have noticed a grid overlay on the Masking Bug when you hovered over the image, which is helpful for resizing and placement. If you'd like to change the view settings of this grid, choose Masking > Masking Bug Grid then the view you prefer. Choose *Auto* to show the grid only when you move or click on the bug, *On* to display the grid when you hover over the bug, or *Off* to keep the grid hidden at all times. You can also change the opacity of the grid by choosing Masking > Masking Bug Tool Opacity and specifying a percentage (**FIGURE 5.41**).

FIGURE 5.41 You can reduce the opacity of the actual Masking Bug from the Mask menu.

The Masking Menu

To go along with the masking tools, the Masking menu at the top of your screen contains a few options that can help and improve the process of masking your effects. These menu items include:

- **Show Mask:** When using the Masking brush or Masking Bug, it can be useful to view the mask while you paint. To do this, go to Masking > Show Mask and select from Red, White, Dark, or Grayscale. Previewing the actual mask can be helpful when making subtle adjustments where it's difficult to see the changes (**FIGURE 5.42**). You can also change these settings from the Mask View Mode box on the bottom left of the Preview window.

- **Copy and Paste:** If you want to use the same mask in multiple effects, you can copy and paste your mask from one stack to another. To do so, highlight the effect with the mask you want to copy and choose Masking > Copy Mask. Next, highlight the layer into which you want to paste the mask and choose Masking > Paste Mask. The mask will now appear in the second effect (**FIGURE 5.43**).

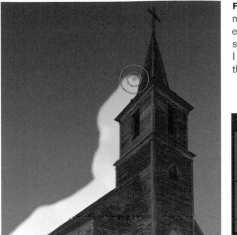

FIGURE 5.42 Showing the mask while painting can make it easier to see where your brush strokes are in your image. Here I have the preview set to view the Red mask.

FIGURE 5.43 I was able to copy my mask from the Texturizer layer and pasted it into the Duotone layer so that only the sky was affected.

- **Invert Mask:** There may be times when you are working with a mask, or possibly a tool (like the Masking Bug) but the mask is reversed: The areas you want to show are hidden and vice versa. When this happens you'll need to *invert* the mask so that the black areas are white and the white areas are black (**FIGURES 5.44** and **5.45**). You can access this feature by clicking the Invert button in the Tool Options bar (or choosing to Masking > Invert Mask) when you have either the Masking brush or Masking Bug active.

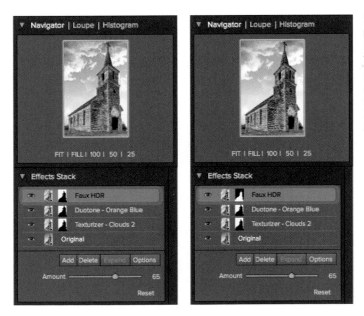

FIGURE 5.44 (left) I copied and pasted the mask into the new effect layer, but want to invert it to apply it to the church (not the sky).

FIGURE 5.45 (right) This is the result of inverting a mask (from Figure 5.44); the church is now being affect by the layer, and the sky is masked out.

- **Reset Mask:** When you want to start your masking from scratch, or just completely remove it, then the Reset Mask option is the best choice. When you have either the Masking brush or Masking Bug active, either click the Reset button in the Tool Options bar or go to Masking > Reset Mask in the menu.

Brush Effects

Inside of the Effects tab in the Brower pane is a folder of presets called Basic Brushes (**FIGURE 5.46**). These *paint-in brush effects* are made specifically to use with masking, but are always defaulted to Paint In (instead of Paint Out) and work a little differently than standard presets. Brush effects also have a small brush icon in the top-left corner of the preview in the Effects tab so you can distinguish them from standard effects.

When you first apply a brush effect you'll get a prompt indicating that you are adding a brush effect (**FIGURE 5.47**). If you no longer wish to see this window, just check the box at the bottom. By default, the mask will be inverted so you are not seeing the effect, and the Masking brush (in Paint In mode) will automatically be selected so you can immediately start masking the effect your image. As you use the brush inside of your image you'll see the effect appear over those areas.

FIGURE 5.46 The paint-in brush effects in the Effects pane have a brush icon in the upper-left corner to distinguish them from "regular" effects.

You have added a Paint-In Effect. You won't see any effect until you brush it in where you like. The Masking Brush is already selected for you, just start painting.

OK

☑ Do not show again

FIGURE 5.47 When you add a paint-in brush effect you'll see a window pop up to remind you of how it works.

Enhancing the Color and Tone of an Image

Stylizing a photo with effects, presets, and textures can be fun, but oftentimes it's the *subtle* adjustments you do to an image that really make it shine. With Perfect Effects, you can add basic color and tone adjustments to your image, and for this example I'm going to show how I used both blending modes and masking to add an image to bring out its natural beauty.

Step 1

I started by opening my image into Perfect Effects. Because I planned on using effects from the Effect Options pane only, I collapsed the Browser pane on the left by using the keyboard shortcut **Cmd+left arrow (Ctrl+left arrow, PC)**.

Step 2

This image was straight out of camera, so it was in need of some tonal adjustments to give it a little bit more brightness. I started off by adding a Tone Enhancer effect in the Effect Options pane. I increased the Brightness slider to 50 to make it brighter, set Contrast to 16, and also made sure that the Auto Contrast box was checked to help level out some of the contrast in the image. Then, I increased the Shadows slider to 20 to soften some of the shadows.

Step 3

I wanted to add a new effect, so I clicked the Add button in the Effects Stack pane. Then I selected the Blur effect from the Effect Options setting. I kept the blur type set to Gaussian, and increased Halo to 40.

Step 4

The final step in this process was to change the blending mode of the Blur layer in the Effects Stack pane. So, I clicked the Options button, and the Blending Options window popped up. Here I chose the Soft Light blending mode and specified 30 for the Amount setting. This blended the Blur layer into the rest of the image, resulting in a very colorful and bright image.

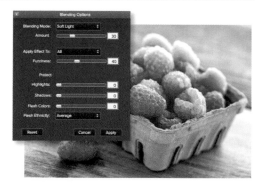

Stylizing a Landscape Image

Landscape images are fun to work with in Perfect Effects, and this image was no exception. Here I'll show you how I took a landscape photo and used Perfect Effects to bring out the contrast in the sky and also add some color to the clouds.

Step 1

I started with my image open in Perfect Effects, and then clicked on the All folder in the Effects pane to browse through my choices, and double-clicked on the Contrast Only effect. Double-clicking added the effect to the Effects Stack and also added a new layer at the same time.

Step 2

Next, I scrolled down and added the Dawn Treader effect by clicking on it once. I didn't want my image to be black and white, but rather to use this effect along with a blending mode to change the contrast and colors. So, I clicked the Options button in the Effects Stack pane, selected the Soft Light blending mode, and reduced the Amount setting to 70. Then I hid the Effects pane by clicking the vertical bar to the left of the tool-well.

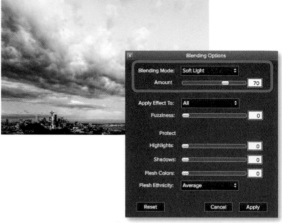

Step 3

I wanted to add some color to the clouds, so I added a new layer to the Effects Stack and selected Duotone from the Effect drop-down in the Effect Options pane. I created a custom setting with gold highlights and soft-blue shadows, and specified 42 for the Strength setting and 73 as the Midpoint.

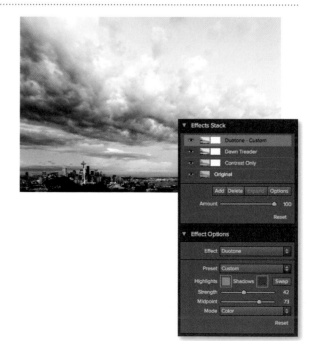

Step 4

Lastly, I only wanted the Duotone effect to affect the sky, so I clicked on the Masking Bug in the tool-well and clicked over the city skyline. I resized the bug to fit just over the city to ensure the final image revealed a city skyline with added contrast, drama, and a much more colorful sky.

Enhancing a Portrait

Perfect Effects is a great tool to use when you want to enhance a portrait. In this example I took a simple portrait and stylized it using several effects and blending modes, and added some masking as well.

Step 1

I started off with my portrait image inside of Perfect Effects and selected the Brush Skin Smoother effect. The brush effects apply an effect and then also invert the mask and select the Brush tool at the same time, so there was no apparent change to my image after applying the brush effect. To make it visible, I needed to paint with the Brush tool in Paint In mode, and to make it easier I also checked the Perfect Brush option at the top. I toggled the mask by pressing **Ctrl+M** and painted over the areas I wanted to work on, in this case the skin. When I was finished, I pressed **Ctrl+M** again to hide the mask view.

Step 2

Next I wanted to give some lightness to the eyes, so I added a new layer by clicking the Add button in the Effects Stack pane. Then I selected the Brush In Highlights effect. Just like with the previous step, I had to use the Brush tool to paint the effect into my image. Because I wanted this to affect the eyes only, I zoomed in close to just the eyes, reduced the size of the brush to 80, made sure it was set to Paint In and that the Perfect Brush was checked, and painted over the eyes one at a time.

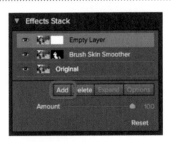

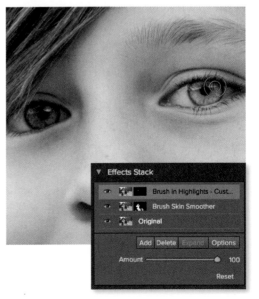

Step 3

Next, I added a new layer to the Effects Stack pane. I scrolled down the Effects pane to find the Dreamland effect. I clicked it, and then scaled the Amount down to 50 in the Effects Stack pane.

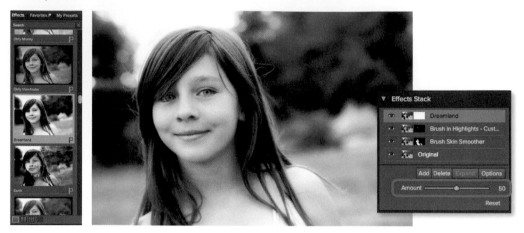

Step 4

Because I was finished adding effects from the Effects pane, I hid the pane by clicking the vertical bar to the left of the tool-well. I added another new layer to the Effects Stack pane and selected Duotone from the Effects drop-down. Then, I selected the Orange Blue Preset and reduced the strength down to 20.

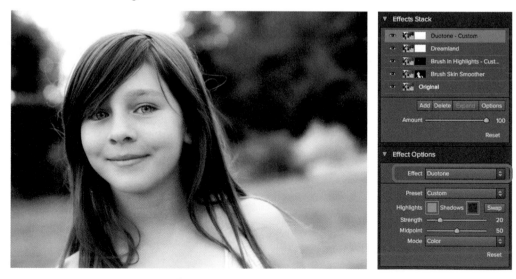

Step 5

Lastly I wanted to add a border, so I added a new layer to the Effects Stack and selected Borders from the Effects drop-down. I chose the Emulsion 001 border, and then changed the Mode to Overlay. I saved a preset to use for later by choosing Preset > Save Preset, and then clicked Apply to apply all of my changes.

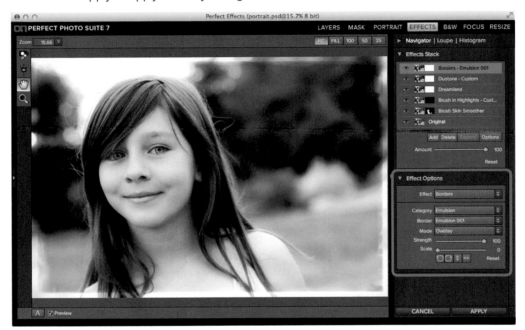

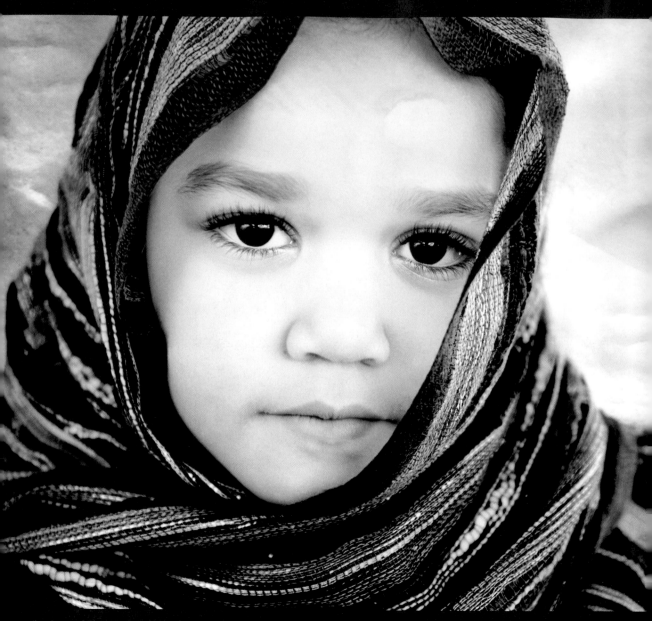

I enhanced the mood of this image by converting it to black and white.

Nikon D200, 24-70mm lens, 1/125 sec at f/2.8, ISO 100

PERFECT B&W

Converting an image to black and white involves more than just desaturation of the color. A true black-and-white photograph has depth, contrast, rich blacks, and silky smooth whites. As artists we need to have the ability to control those tones and use the color in our images to creatively mix together and output a beautiful black-and-white photograph. Perfect B&W makes this possible, and also allows you to stylize and enhance an image beyond the basics.

The Perfect B&W Interface

A Effects, Favorites, and Presets
B Browser mode
C Tool Options bar
D Module selector
E Brightness brush
F Contrast brush

G Detail brush
H Targeted Brightness tool
I Selective Color brush
J Hand and Zoom tools
K Navigator, Loupe, and Histogram

L Adjusment panes
M Mask View mode
N Preview mode
O Preview toggle
P Cancel and Apply buttons

When to Use Perfect B&W

Sometimes an image just looks its best in black and white. And, to be honest, it's not always an easy decision to make. After all, as digital photographers our photos will come out of the camera in full color, so it's a deliberate choice to convert and stylize them as black-and-white images. When you do want to make that conversion, Perfect B&W is an excellent tool to get the job done beautifully and quickly.

Here's a taste of what you can do best with Perfect B&W:

- **Maintain creative control:** Just like with most of the onOne products, you can customize individual areas of your photo and selectively adjust the tone, contrast, and detail with the brushes and tools inside of Perfect B&W. These are essential tools for creative photographers who want complete control over the processing in their image.

- **Create a classic or vintage look:** Perfect B&W has stylization and finishing touches, such as Film Grain and Borders, that you can use to give your image a classic B&W look and feel. To enhance and intensify that classic black-and-white effect, you can also add color toning to give the image a sepia, split-toned, or colored look.

- **Selectively color a photograph:** Perhaps you want to selectively color an image, keeping a certain portion of the photo in color and changing the rest to black and white. Perfect B&W has a special brush just for selective coloring that makes this process extremely easy.

Converting to Black and White

Creating a black-and-white image from a digital color photograph allows you a great deal of control over how the colors are converted to various shades of gray. With Perfect B&W you can adjust the luminosity and contrast of individual colors; use brushes to selectively paint in brightness, contrast, and detail; add such finishing touches as colored toner, vignettes, and borders; and so much more!

The Browser Pane

The best place to start with Perfect B&W is the Browser pane. Located on the far-left side of the window, this Browser pane is identical to the Browser pane in Perfect Effects. Here you can locate and store effects, favorites, and presets specifically for Perfect B&W.

NOTE

For more information on opening your image into the Perfect B&W interface, please see Chapter 1, "Getting Started."

Effects

Perfect B&W comes with a selection of effects broken down into categories, listed on the far-left tab within the Browser pane (**FIGURE 6.1**). The great thing about these effects is that they are completely customizable, so if you aren't sure where to start then you can apply one of the effects and work from there. To apply an effect, just click the one you want to use and you'll see the changes to your image appear in the Preview window.

Another thing I love about the effects in the Effects tab (and the entire Browser pane, really) is that you see a live preview of how the preset will affect your image. This makes it easy to select the preset you that like the most and that works the best with your photograph.

HOT TIP

To reset the adjustments back to their defaults so that the image looks desaturated without any tone adjustments or stylization, click the Default Settings effect. You can also return to the default settings by choosing Edit > Reset All.

Favorites

The Favorites tab allows you to place some of your favorite effects and presets into an easy-to-access section on the left portion of your screen. To add an effect or preset to the Favorites tab, click on the flag icon to the right of the thumbnail (**FIGURE 6.2**). The list will generate in alphabetical order. If you want to remove something from this list, just click the flag icon again and the item will disappear.

HOT TIP

If you know the name of your effect or preset, you can type it in the Search box on the top of the Browser pane, and Perfect B&W will list the appropriate results as you type.

FIGURE 6.1 Perfect B&W comes with a selection of effects you can use with your images.

My Presets

The My Presets tab is where any presets you create or import are stored. The category called Recently Used will store up to seven of your most recently applied effects or presets. Saving and storing presets is a great way to create your own unique looks, or maybe just starting points you want to use for future images (**FIGURE 6.3**).

FIGURE 6.2 Click the flag icon to add a pre-set or effect to the Favorites tab.

FIGURE 6.3 These are some of the presets I have created inside of Perfect B&W.

HOT TIP

When you apply an effect or preset to your image, it will automatically overwrite any changes you have made to the settings of the panes on the right side of the window. Any edits you have created with the brushes, however, will not be overwritten.

Adjustment Panes

On the right side of your window you'll see a long list of panes you can use to adjust the tone, grain, color, and stylization of your black-and-white image. These panes are where you perfect your image by adding finishing touches and stylization.

Some of the panes are turned off by default, so to edit them you'll need to switch them on. To activate these effects, click the On/Off toggle switch to the right of the pane. The settings will unlock, and you can then apply those effects to your image (FIGURE 6.4).

FIGURE 6.4 Some panes are switched off by default; to make adjustments to these panes, change the toggle switch to On.

HOT TIP

Perfect B&W also offers a keyboard shortcut for each pane that will expand or collapse it, depending on its current state. You can find a list of these shortcuts in the Window menu.

199

Tone

The Tone pane enables you to make basic adjustments to the tone of your photo, which will essentially make it brighter or darker (**FIGURES** 6.5 and **6.6**). The settings inside the Tone pane are:

FIGURE 6.5 This is the Tone pane with its default settings.

FIGURE 6.6 I increased the brightness and contrast of this image by making adjustments to the Tone pane.

- **Brightness and Contrast:** These two sliders increase or decrease the brightness and contrast of your image. Slide to the right to increase, and slide to the left to decrease.

- **Blacks and Whites:** These settings affect the black point and white point in your image. Increasing the Black slider enhances the black areas.

Increasing the White slider exaggerates the white areas. This is another way to control and play with the contrast of your photo. Also, if you want Perfect B&W to set these sliders automatically, just make sure that the Auto Levels box is checked.

- **Shadows and Highlights:** The Shadows and Highlights sliders lighten the shadows and recover the highlights. Just move each to the right to see their effects. Avoid being too heavy-handed with these settings, as they may introduce artifacting (blotchy pixels) or halos around the objects in your photo if pushed too far.

- **Detail:** The Detail setting adds a bit of stylized sharpening to your image. When you move the slider to the right it gives your photo the appearance of being clearer and more "crisp." Be careful to not use this too heavily or you may introduce halos around your subject.

HOT TIP

When making changes to the tones in your images, you can preview the black and white clipping (areas with no detail) by holding the J key while making your adjustments. The red areas indicate whites that are clipped, and the blue areas indicate clipped blacks.

Color Response

The Color Response pane is very useful and is the essence of why creating a black-and-white image from a color photograph is so beneficial (**FIGURES 6.7** and **6.8**). When you start with a color photograph you can isolate your adjustments to specific colors and tell them to go darker or lighter when being converted to black and white. That is exactly what the Color Response pane does.

FIGURE 6.7 This is the Color Response pane with its default settings.

FIGURE 6.8 You can drastically change the look of your images by either using the color filters or making changes to the color sliders in the Color Response pane.

To make adjustments to this pane you can start out by clicking one of the color filter presets on the top. This will filter the colors and automatically set the sliders below. If you want more control over the settings you can move the sliders on your own. Just think of the settings as "brightness" sliders that affect only the color group of the slider you are adjusting. Moving the slider to the right will make that color group lighter, and moving it to the left will make it darker.

Tone Curve

An advanced setting inside of Perfect B&W, the Tone Curve allows you to adjust the brightness and contrast of your image by changing the shape of the curve (**FIGURES 6.9** and **6.10**). To give an image contrast, change the shape of the curve to an S by clicking on the line and dragging it. To decrease contrast, change the curve so that it's a reverse S shape.

Glow

The Glow pane adds a nice, soft glow effect to your photo. This is a good way to soften an image or stylize a portrait (**FIGURES 6.11** and **6.12**). To activate this pane, click the switch at the top right of the pane. Now you can adjust three settings:

- **Style:** The Style drop-down sets the blending mode of your glow effect. Click the arrow to select a new style, and as you hover over each setting you'll see the changes in the Preview window.

- **Amount:** This slider increases or decreases the amount of glow in the image. Slide to the right to increase, and move it to the left to decrease the effect.

- **Halo:** The Halo setting increases or decreases the glow effect around the edges of items within your image. When the setting is all the way to the left, you'll see very little haze and the edges of your subject will be crisp. As you move the slider to the right, you'll start to see a very soft glow on the edges of your subject.

FIGURE 6.9 This is the Tone Curve with its default settings.

FIGURE 6.10 I created an S curve in the Tone Curve pane, which added contrast to my photograph.

FIGURE 6.11 This image shows the Glow pane turned off.

FIGURE 6.12 I turned the Glow pane on, set Style to Soft Light, Amount to 87, and Halo to 54, which added a contrasty glow to my photograph.

Film Grain

When you want to give your photo a "film" look, the Film Grain pane is the best place to start (**FIGURES 6.13** and **6.14**). The settings in this pane are not digitized or re-created; they're actual scans of real black-and-white film. Pretty cool, right?

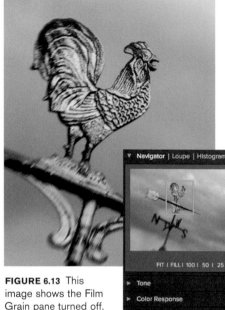

FIGURE 6.13 This image shows the Film Grain pane turned off.

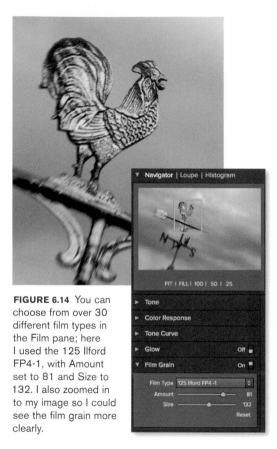

FIGURE 6.14 You can choose from over 30 different film types in the Film pane; here I used the 125 Ilford FP4-1, with Amount set to 81 and Size to 132. I also zoomed in to my image so I could see the film grain more clearly.

The three settings associated with the Film Grain pane are:

- **Film Type:** The Film Type setting is where the magic happens, because you get to choose between actual scans of film. Click the drop-down menu to make your selection. You'll see the changes applied "live" as you hover over each option to make the selection process easier.

- **Amount:** Amount is very similar to an Opacity setting in some of the other products: It determines how harsh the Film Grain effect is in your image. With the slider all the way set to the left, you will see no grain in

your image, and as you move the slider to the right the Film Grain setting will become more apparent and opaque.

- **Size:** The Size setting adjusts the physical size of the grain in your image. When the slider is at a low number, the grain will be small and very fine. As you move the slider to the right, the grain enlarges and becomes much more prominent in your photo.

Toner

One of my favorite techniques is to add a toning effect to a black-and-white photo. This goes back to the days of film when photographers would literally dye their prints in a solution to colorize the photo. It oftentimes would fade out the black portions of the image as well and add a soft toning effect to the entire image.

Perfect B&W mimics this process and enables you to add an overall coloring effect, bleach out the shadows, or even add a split-toned effect (**FIGURES 6.15** and **6.16**).

FIGURE 6.15 This image shows the Toner pane turned off.

FIGURE 6.16 I clicked the Toner pane's switch to On and used a Preset to apply color to the image.

Here are each of the settings associated with the Toner pane:

- **Preset:** Perfect B&W ships with a good selection of toning presets you can apply to your image. These are usually a good place to start, and you can then customize the colors after applying the preset. Plus, you can see the changes as you hover over each preset, which can end up saving you a lot of time.

- **Paper (Highlights):** The Paper (Highlights) setting affects the light areas of the image, basically anything lighter than 50% gray. You can change the color by clicking the color swatch and then using the Select Color window. The Amount slider decreases or increases the effect in the highlights of your image.

- **Silver (Shadows):** Similarly, the Silver (Shadows) setting affects the dark areas of the image, basically anything darker than 50% gray. You can change the color by clicking the color swatch and then using the Select Color window. The Amount slider decreases or increases the effect in the shadows of your image.

- **Balance:** You can change the balance between the Shadows and Highlights by moving this slider left or right. Move the slider to the left to show more of the Shadows color, and move the slider to the right to show more of the Highlights color.

Vignette

Sometimes adding a vignette to a photo is the perfect finishing touch. With the Vignette pane, you can quickly add a vignette to suit your tastes. Click the switch at the top right of the pane to turn it on, and then you can make your adjustments (**FIGURES 6.17** and **6.18**).

FIGURE 6.17 This image shows the Vignette pane turned off.

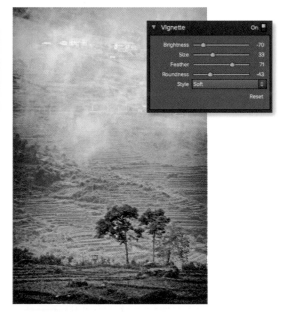

FIGURE 6.18 I turned the Vignette pane on and added a soft, dark vignette to this photograph.

Five settings are associated with the Vignette pane:

- **Brightness:** For a dark vignette, more the slider left. If you prefer a light vignette, simply move the slider right.

- **Size:** The Size setting determines the size of the circular area inside of the vignette. The higher the setting, the less of your vignette you'll see on the edges.

- **Feather:** The Feather allows you to give the vignette a sharp or soft edge. Move the slider to the left for a harsher edge, and move it to the right for a softer edge.

- **Roundness:** The slider gives you a rectangular vignette or a circular vignette. Move the Roundness slider to the left to make your vignette more rectangular, and move the sider to the right for a more circular vignette shape.

- **Style:** The Style setting is similar to a blending mode for the vignette: You can choose between Normal, Subtle, or Soft.

Border

Adding a border is a fun finishing touch to any photograph, and Perfect B&W offers several border choices (**FIGURES 6.19** and **6.20**). What's great about the Border pane is that you can further customize its look by using the adjustment sliders within the pane:

- **Border:** Perfect B&W comes with a very large selection of borders. To select one, just click the drop-down and hover over the names to preview them in the Preview window. Click the border you'd like to add to your image after you've made your selection.

- **Blending:** You can change the way your border blends into the photo using the Blending setting. Just click the drop-down and hover over the modes. You'll see the border change as you move through them.

- **Opacity:** You can also set the overall opacity of the border, so if you want to make it softer or fade into the image then just move the Opacity slider to the left. The numbers are listed in percentages and usually default to 100%.

- **Size:** The Size setting is a good way to balance the border for your particular photograph. Not all images will be the exact same size, and some elements will be larger (or smaller) and closer to the edge than others. With the Size setting you can increase or decrease the width of

the border. A smaller number shows the most amount of border, whereas a larger value pushes the border closer to the edge of the frame.

- **Rotate and Flip:** At the bottom of the pane are two pairs of icons you can use to add even more customization to the border in your image: Rotate and Flip. You can rotate both clockwise and counter-clockwise at 90° increments, and also flip the border vertically or horizontally.

FIGURE 6.19 This image has no border applied.

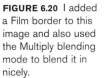

FIGURE 6.20 I added a Film border to this image and also used the Multiply blending mode to blend it in nicely.

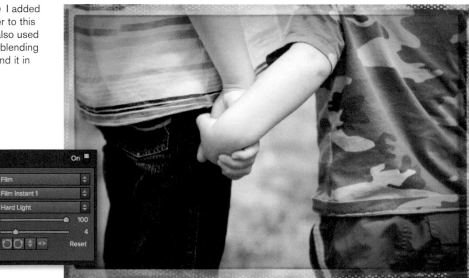

Sharpening

The Sharpening pane is for global sharpening of the entire image. Remember, however, you can't make an out-of-focus image tack-sharp by using the Sharpening pane. Instead, use sharpening to enhance the existing sharpness of a photo and to prepare it for sharing on the Internet or printing (**FIGURE 6.21**).

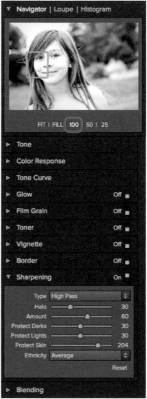

FIGURE 6.21 When using the Sharpening pane, zoom in to your image at 100% to see how sharpening is affecting the pixels. You can do this quickly by clicking 100 in the Navigator pane.

Here are the different settings you can adjust with the Sharpening pane inside of Perfect B&W:

- **Type:** With Perfect B&W you can choose three main types of sharpening: High Pass, Progressive, and Unsharp Mask. Progressive is the default setting and adds a contrasted sharpness to the image. If you want a more subtle sharpness, use either High Pass or Unsharp Mask. As with any adjustment such as this it's always a good idea to zoom in to 100% so you can see what the adjustment is doing to your image at the pixel level.

NOTE

The Halo setting appears only when either High Pass or Unsharp Mask is selected.

- **Halo:** The Halo setting adds a contrast effect to the image along with a "halo" effect around the edges. You'll want to make sure to not use this too excessively, but in small amounts it can add a pleasant contrast and glowing effect to your image.

- **Amount:** The Amount slider adjusts the overall amount of sharpening for your image. When this slider is set at 0, then all of the other settings in this pane are not visible. The more you increase the setting the more the other adjustments will come in to view.

- **Protect Darks/Lights/Skin:** These three adjustments protect the dark areas, light areas, and skin from being overly sharpened in your photograph. Just move the slider to the right to increase the amount of protection.

- **Ethnicity:** When using the Protect Skin slider, you can specify the color of skin by using the Ethnicity drop-down menu. The default is Average, which should work for most skin types, but you can use the drop-down and hover over other selections to see if another setting works better with your image.

Blending

The Blending pane enables you to blend your entire black-and-white adjustment into the existing color image with a blending mode. It also allows you to lower the overall opacity of the effect in your image. **FIGURES 6.22** and **6.23** illustrate an example of using a blending mode and how it can affect a color image.

FIGURE 6.22 This is an image converted to black and white with no blending applied.

FIGURE 6.23 By changing the blending mode I was able to blend the black-and-white conversion into the original image; this photo shows the result of using the Soft Light blending mode, which adds contrast and mutes the colors of the original photo.

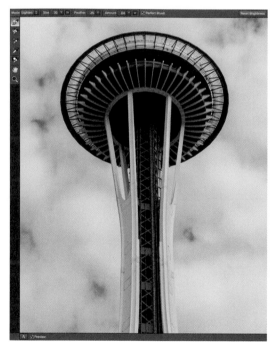

FIGURE 6.24 The brushes in the tool-well allow you to selectively adjust certain areas in your photograph.

Brushes and Tools

The brushes and tools inside of Perfect B&W enable you to selectively adjust specific areas within the image just by brushing over them. These tools are all located in the tool-well on the left of the Preview window (**FIGURE 6.24**).

- **Brightness brush:** This brush is for brightening or darkening specific areas of your image (**FIGURES 6.25** and **6.26**). The default is set to Lighten and can be changed to Darken by clicking the drop-down in the upper-left portion of the Tool Options bar, or by using pressing the X key. You can reset changes made using this brush by clicking the Reset button on the far-right side of the Tool Options bar.

FIGURE 6.25 The center part of this image of the Space Needle is too dark and could use some selective brightness.

FIGURE 6.26 By painting the Brightness brush over the dark areas I was able to brighten them up to balance out the tones.

- **Contrast brush:** With the Contrast brush you can selectively increase the contrast in your image. To add contrast, make sure that the setting in the Tool Options bar is set to More Contrast. If you want to erase your changes, change this setting to Less Contrast and paint over those same areas (**FIGURES 6.27** and **6.28**).

FIGURE 6.27 This is an image before using the Contrast brush.

FIGURE 6.28 I used the Contrast brush here to add contrast to the face.

- **Detail brush:** If you want to do any selective sharpening to your photo, the Detail brush is a great tool to use. Just click on the Detail brush and start painting over the areas you want to add more detail to, such as eyes, lips, or main elements of your scene. It's best to use the Detail brush on areas that are already in focus and that you want to stand out. You won't be able to add sharpness to an already out-of-focus scene with this brush. To add detail, make sure that the setting in the Tool Options bar is set to More Detail. If you want to erase your changes, change this setting to Less Detail and paint over those same areas (**FIGURES 6.29** and **6.30**).

FIGURE 6.29 (left) This is a zoomed-in area of an image before using the Detail brush.

FIGURE 6.30 (right) I painted with the Detail brush over the rooster in this weather vane to add detail.

- **Targeted Brightness:** The Targeted Brightness tool increases or decreases the brightness in your image; simply click within the image and drag the cursor left to darken the image or right to lighten it (**FIGURES 6.31** and **6.32**). When you click the image, Targeted Brightness samples the surrounding colors and affects the luminosity of only those color values in your entire image. It also works in conjunction with the Color Response pane; as you drag the cursor left or right, you can see the settings change on the pane in the right side of the window.

HOT TIP

If you click the image and an error window pops up, then just keep clicking around the image to find a dominant color with more saturation. What's happening is you're clicking an area of the image with very little color detail, and in order for the Targeted Brightness tool to work properly it needs to find a color to sample from.

FIGURE 6.31
No corrections have been made with this image using the Targeted Brightness tool. Notice the Color Response pane has everything set at 0.

FIGURE 6.32 With the Targeted Brightness tool, I clicked and dragged to the left inside this image to darken it; notice how it also changed the corresponding color inside of the Color Response pane.

- **Selective Color brush:** The Selective Color brush works similarly to a masking brush: It removes the black-and-white effect and allows the colored image to show through. It defaults to Paint Out, which will remove the black and white from the photo (**FIGURE 6.33**). If you want to paint the black-and-white effect back in to your image, just change the setting to Paint In. You can also easily toggle back and forth between Paint In and Paint Out by pressing the X key.

FIGURE 6.33 The Selective Color brush allows you to paint the original color back in to your images.

With each of these brushes (the only exception being the Targeted Brightness tool) there are four common settings in the Tool Options bar that you can change:

- **Size:** The Size setting determines the size of the brush and ranges from 0 to 500. To decrease the size, click on the arrow and move the slider to the left, or drag to the right to increase it. You can also type a value directly into the box, or click and drag from left to right over the word "Size" to change the number setting. The quickest way to change the Brush Size, however, is through keyboard shortcuts: The left bracket ([) key decreases the brush size, and the right bracket (]) key increases it.

- **Feather:** The Feather sets the amount of softness around the edges of the brush. A low number gives your brush a harsher edge, and a high value gives the brush a softer edge. You can change the Feather setting by clicking the drop-down and moving the slider, typing a number into the box, or clicking and dragging over the word "Feather." You also can press Shift+[to decrease the size or Shift+] to increase the size.

- **Opacity and Amount:** The Opacity and Amount settings, listed in percentages, determine how transparent or opaque the brush is as you paint in your image. A lower number equates to a much lighter and transparent brush stroke; the higher the number the more opaque the brush stroke will be.

- **Perfect Brush:** The Perfect Brush option is great to use when you want to paint an effect in or out of a specific area of your image without having the effect "spill over" to another part. To activate the Perfect Brush, click on the check box in the Tool Options bar. Now, as soon as you click on an area in your image the brush analyzes the color from the center of the brush (the crosshair) and adjusts only areas with similar colors (**FIGURE 6.34**). If the crosshair of the brush crosses over into a new color, it will start using that color to use as its guide and begin painting out new similar colors (**FIGURE 6.35**).

FIGURE 6.34 The Perfect Brush option allows you to make selective adjustments in specific portions of your image without "spilling over" to other areas. For this example, I used the Selective Color brush with the Perfect Brush box checked to make a cleaner and more accurate adjustment.

FIGURE 6.35 This shows the Selective Color brush without the use of the Perfect Brush feature; notice how the color is "spilling over" onto the background of the image.

Saving Presets

With Perfect Mask you can save presets, just as you can with nearly all of the products in the Perfect Photo Suite. To create a preset, choose Preset > Save Preset at the top of your screen and give your preset a name and a category. Your new preset will appear in the My Presets tab on the left of your screen. For more information on working with presets please turn to Chapter 1.

NOTE

Adjustments made with the Targeted Brightness tool will save with presets because that tool is directly connected to the Color Response pane.

When saving presets in Perfect B&W, you need to be aware of a few things. First, if you have the Auto Mix box checked in any of the panes then that mix of color or tone will be applied differently depending on how Perfect B&W analyzes the image. If you deselect the box, then the preset will be saved and applied with those specific settings, regardless of the image to which it's applied. Also, if you used the Brightness brush, Contrast brush, Detail brush, or Selective Color brush with your image, then those brush strokes will not save with the preset.

Creating a Black and White Film Look

One reason I want to convert my images to black and white is to give them an old-fashioned or classic-film look. Plus, some images just work better in black and white, especially those with a lot of texture, such as this image of a woman's hands on a pottery wheel. To enhance this image I exaggerated the existing texture and contrast, as well as added grain and a subtle border to mimic the look of black and white film.

219

Step 1

I started by adjusting the tone in the Tone pane. I wanted to boost the overall contrast in the image, so I set Contrast to 23, Blacks to 16, and Whites to 10. I also increased the Highlights slider to 21 to bring back a little detail in the whites and added some detail with the Detail slider (set to 15).

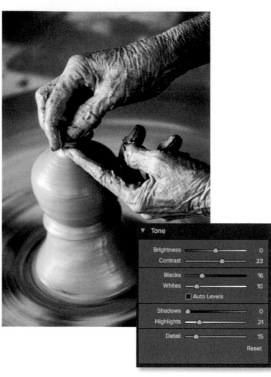

Step 2

Next, I zoomed in to the image to get a closer look and switched the Film Grain pane to On. Then I selected the 200 Ilford SFX-1 film grain and also increased Amount to 90 and Size to 170.

Step 3

After switching on the Border pane, I selected the Film Type 55 2 border, and then I changed the blending mode to Soft Light to blend the border with the image. I also increased the Size setting to 6 so it didn't take up too much room in the frame.

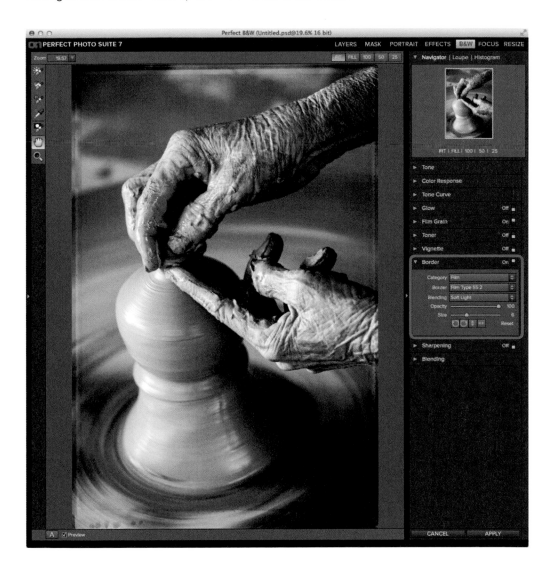

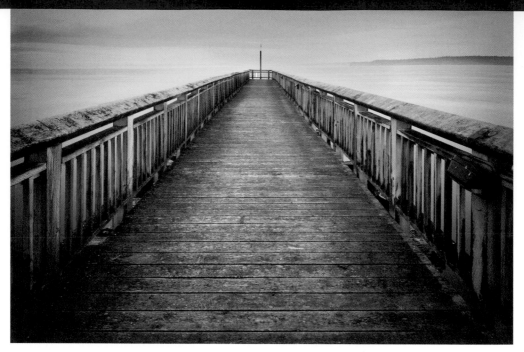

Creating a Black and White Landscape Image

Some photographs have more potential as a black and white image than as a color image. For this photo of a pier in Port Townsend, Washington, I felt that the color was too subtle to have enough impact and that the image would be much more stimulating as a black and white.

Step 1

I started out with this image by adjusting the Tone Curve. I dragged the curve into an S shape to add a good amount of contrast.

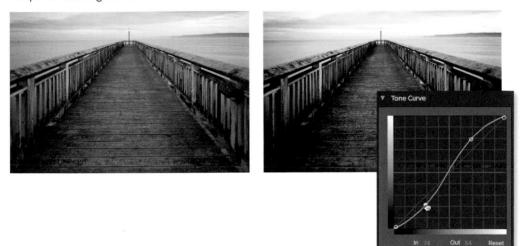

Step 2

Next, I wanted to add some selective lightness and darkness in the image, so I activated the Brightness brush. After deselecting the Perfect Brush check box, I set Size to 600, Feather to 100, and Amount to 10 and then painted in the Lighten Mode over the center part of the dock. Adding this brightness helps draw the eye toward the main part of the photograph. I then changed the Mode to Darken and painted in the sky to darken it up a bit.

Step 3

I wanted to add a bit of a color effect, so I toggled on the Toner pane and then changed the settings until I came up with a soft silver-like color over my image.

Step 4

Lastly, I added a simple Vignette effect to finish it off. I set Brightness to −57, Size to 46, Feather to 66, and Roundness to −45. I also kept the Style set to the default setting of Normal.

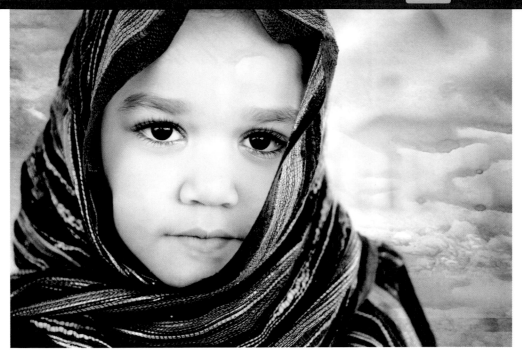

Converting a Portrait to Black and White

There's something about a black-and-white portrait that helps us see a little bit deeper into a person's soul, don't you think? It sheds away all possible distractions and brings us right to the subject's eyes. The little girl in this photo has such piercing and thoughtful eyes, it just made sense to process it with a glowing black-and-white effect.

Step 1

For this portrait, I began in the Color Response pane. I clicked the Red filter and then made adjustments from there. I moved the Red slider down to 30 and the Yellow slider to 17 to keep some of the glow on the face. I also darkened the scarf even more by moving the Blue and magenta sliders all the way to −100.

Step 2

Next, I selected the Detail Brush and painted over the eyes to make them sharp. I set Mode to More Detail, Size to 300, Feather to 75, and Amount to 50. I painted over the eyes to add detail to the eyelashes.

Step 3

I wanted to add a bit of contrast and glow, so I toggled on the Glow pane and there set Style to Screen, Amount to 69, and Halo to 1.

Step 4

Finally, I added a border to the image. After turning on the Border pane, I selected the Film Tyle 55 1 border, changed the blending mode to Multiply, kept Opacity at 100%, and increased the border's size to 17. This gave the image a textured look.

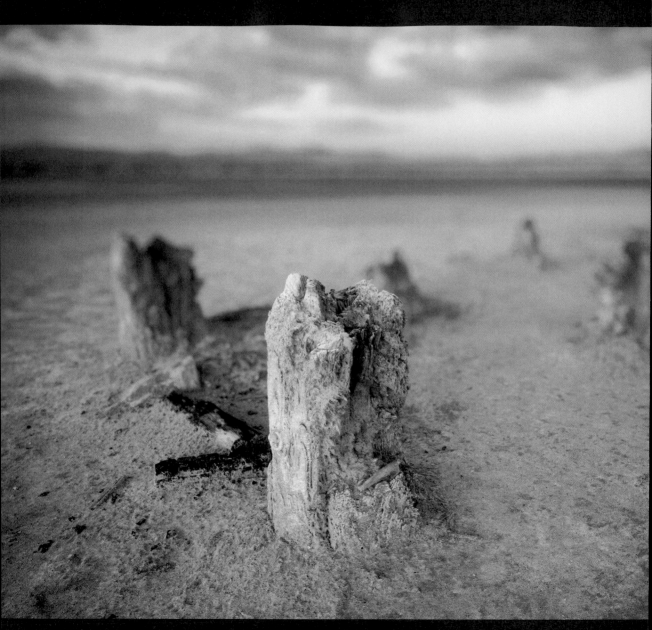

Canon 5D Mark II, 24mm, 0.3 sec at f/8, ISO 100

The Great Salt Lake, Utah 2011

FOCALPOINT

Say hello to my favorite product in the onOne Software suite: FocalPoint. With FocalPoint you can manipulate the perspective, depth of field, and focus of your photographs as well as re-create the look of unique and expensive lenses. It's also a great way to remove distractions and draw the eye to certain parts of an image by creating and changing the blur and bokeh. I love this product because it allows me so much creative control over my images and can really give an image that wow factor we all strive for.

The FocalPoint Interface

A	Focus Bug	G	Brush tool
B	Preview window	H	Focus Bug tool
C	Navigator	I	Hand (Pan) tool
D	Adjustment panes	J	Zoom (Magnify) tool
E	Find More Online (launches	K	Cancel button
	the onOne Software website)	L	Apply button
F	Preview toggle (On/Off)		

What Is Depth of Field?

Before diving too far into how to use this product, you need to understand what depth of field actually is. After all, the main purpose of FocalPoint is to play with, create, and manipulate the depth of field in your photograph to push portions of it out of focus. After you learn a few basic photographic principles, the software will be more enjoyable and you'll create better-looking images in the process.

Deep versus Shallow

There are two main ways to describe depth of field (also referred to as DOF) in any given photograph: deep or shallow. Deep DOF is when the majority of a photo is in focus and has no blurry background or foreground (**FIGURE 7.1**). This is often achieved with a small aperture (such as $f/11$ or higher), and you'll also oftentimes have a deep DOF with images created with wide-angle lenses.

FIGURE 7.1 This is an example of deep depth of field. The entirety of the scene is in focus.

Canon 5D Mark II, 24mm, 0.8 sec at f/11, ISO 100

Shallow DOF, on the other hand, is when a portion of the image is in focus and the rest, usually the background, is blurry (**FIGURE 7.2**). This typically happens when a very wide aperture is used, such as $f/4$ or lower. The out-of-focus and blurred areas you see in an image are called bokeh, and the aesthetic quality of the bokeh can often determine the overall quality of the lens. The great thing about FocalPoint is that it can mimic the quality of expensive lenses and re-create beautiful bokeh in your photograph.

FIGURE 7.2 This is an example of shallow depth of field. The flower is the only thing in focus, and the rest of the image is blurry.

Canon 7D, 50mm, 1/2000 sec at f/1.8, ISO 100

When to Use FocalPoint

At the very basic level, FocalPoint adds blur to a photograph and allows you to control the point of focus to a specific area of your image. But why would you do this when you can just use your lens to do it in-camera? Or, why can't you just use the Blur filter in Adobe Photoshop to do the same job? Sometimes those approaches can't produce the look you're striving for, but FocalPoint can give your photos that extra boost. Consider a few situations when FocalPoint is a good fit for your photography:

- **You're unable to use a wide aperture with your photograph.** If you're in a lighting situation where it's too bright to open up your aperture, or if your lens is so wide that it's not blurring the background the way you'd like, then FocalPoint is a great alternative to give your image the look you desire.

- **You want to create a tilt-shift look.** Tilt-shift lenses are fantastic, and one of their benefits is the ability to give an image a miniaturized look. They are, however, expensive. FocalPoint allows you to (very easily) create a tilt-shift look to your photographs without having to spend the money on extra gear. Heck, I even own a tilt-shift lens and don't use the tilt feature to add blur in camera. I prefer to use FocalPoint for the

flexibility and ease of using software to make certain my image looks exactly as I envisioned it.

- **You want flexibility with your focus.** If you know you want a certain look, but aren't quite sure which way to photograph it (or you're photographing something that moves a lot, like children or pets) then you can plan ahead of time to create the blur in post-processing. Doing this ensures that you have images sharp where they should be sharp and blurry where they should be blurry.

- **There is no lens to create the look you want.** With FocalPoint you can "alter reality" and add blur to a photo in a way that would be impossible with any lens. There's a ton of flexibility with the Focus Bugs and settings, which allow you to create beautifully realistic or even bizarrely surrealistic images.

- **You get actual bokeh quality in the blur.** The difference between FocalPoint and using a blur filter is that you're getting lens-quality blur in your images, as opposed to just a smudgy, soft background. onOne has analyzed several different lenses (which you can choose from in the built-in lens database) to allow you to customize the look and quality of the blur. The bottom line is that if you want it to look realistic, it will.

Using FocalPoint

Like all of the products in the Perfect Photo Suite, FocalPoint can be opened from within Perfect Layers, Apple Aperture, Adobe Lightroom, or Adobe Photoshop. But one thing that's a little bit different from the other products is that it launches in its own separate window outside of the main application. In other words, you won't see the module selector at the top of the screen when working in FocalPoint. (If you need any help with opening your images in the Perfect Photo Suite from Aperture, Lightroom, or Photoshop, head on over to Chapter 1, "Getting Started.")

If you're using Perfect Layers to access FocalPoint, click the Focus button in the module selector on the top right of your window. FocalPoint will launch, and you're ready to roll. So, let's get started!

HOT TIP

If you're using Photoshop, you can also launch FocalPoint from the onOne Photoshop palette. To access the palette, choose Window > Extensions > onOne. To launch FocalPoint (or any other Suite Module), double-click the module name and your image will open inside of the Perfect Photo Suite.

The Focus Bug

The first thing you see when you launch FocalPoint is the Focus Bug in the middle of your image. The Focus Bug is your "steering wheel" with this product, because it determines where your main point of focus lies. The center of the bug is in focus, while the areas surrounding the bug will fade to a blur.

You'll also notice small handlebars, or antennae, sticking out of the sides of the Focus Bug. You can use these antennae to edit the Size, Vignette, and Blur settings (**FIGURE 7.3**). Most of these settings (all but Size and Blur Tilt) are repeated in sliders on the panes to the right of the screen, which will be discussed in detail throughout this chapter. I personally find the sliders to be much easier to work with when controlling the blur, but go ahead and give the antenna a try. Sometimes it's fun to see what they do, and maybe you'll discover a new style of blur you didn't realize you could create.

FIGURE 7.3 The Focus Bug determines the main point of focus. You can adjust several settings using the antennae.

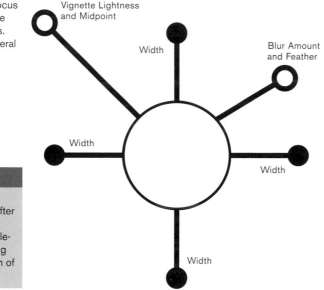

Vignette Lightness and Midpoint

Width

Blur Amount and Feather

Width

Width

Width

Width

The Focus Bug Is Just a Mask

To take the mystery out of what the Focus Bug does, just think of it as a fancy mask. After all, that's really all it is. (If you need a refresher on masks and masking, see Chapters 2 and 3.) If you're like me and you love to know why things work the way they do, understanding that simple concept makes the software much easier to work with.

There are three different ways to view the mask in FocalPoint. The first is to press **Cmd+M** or **Ctrl+M** (PC) to toggle the mask visibility on and off. You can also view the mask by choosing the menu command at the top (View > Show/Hide Mask) or clicking the Show/Hide Mask button in the Focus Brush panel (**FIGURES 7.4** and **7.5**).

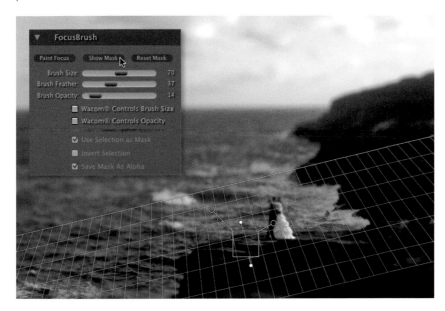

FIGURE 7.4 Here you can see the Focus Bug overlay on an image with the mask hidden.

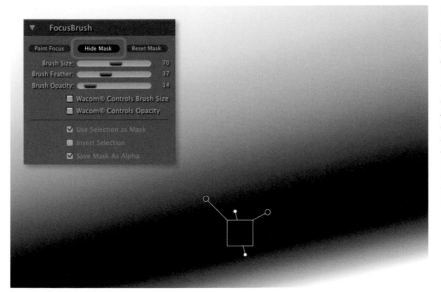

FIGURE 7.5 When you make the mask visible you see the black-and-white representation of the Focus Bug. The black areas are in focus and the white areas are out of focus. Additionally, the gray areas are the transition areas from in focus to out of focus. By clicking the Show/Hide Mask button you can toggle the mask's visibility on and off.

Focus Bug Settings

The Focus Bug is the hero of FocalPoint; it's what does the magic in this product to create your overall effect. The Focus Bug can be moved around, resized, and set to be either very intense or very soft. You can use one bug or several, all with their own unique settings. Let's go through each of those controls one by one so you're familiar with them:

- **Moving and Resizing:** To place the Focus Bug on the area you want to remain in focus, just drag the body of the bug to where you want in your image. You'll see the changes as you move it around. You can also resize the bug by clicking and dragging the small handlebars with solid-filled circles (**FIGURE 7.6**).

FIGURE 7.6 To resize the Focus Bug, just drag any of the solid-circle handlebars.

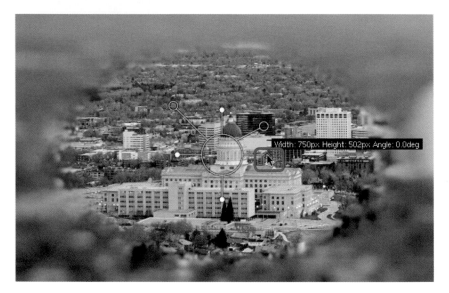

- **Viewing the Grid:** When you hovered over the image, you may have noticed a grid overlay on the Focus Bug, which is helpful for resizing and placement. If you'd like to change the view settings of this grid (hide it or show it) you can do so in the menu settings. To change the view settings of the grid, go to View > Focus Bug Grid and choose between Auto (the grid shows when you move or click on the bug but is hidden otherwise), On (the grid always appears when you hover over the Bug), or Off (the grid is off at all times) (**FIGURE 7.7**). You can also change the opacity of the Focus Bug and grid by choosing View > Focus Bug Opacity and then specifying a percentage between 20 and 100. This will allow the grid to be much less apparent when working on your image.

File	Edit	View	Window	Help

Zoom-In	⌘+
Zoom-Out	⌘−
Fit to Screen	⌘0
Actual Pixels	⌥⌘0
Show/Hide Mask	⌘M
Show/Hide Preview	⌘P
Show/Hide Focus Bug Info	⌘T
Focus Bug Opacity ▸	
Focus Bug Grid ▸	✓ Auto
	On
	Off

FIGURE 7.7 You can change the view mode of the Focus Bug grid from the menu bar.

- **Round versus Planar:** You can use two different shapes of bugs in your images: round and planar. A planar-shaped bug creates a rectangular area of focus that can stretch from one end of your image all the way to the other (**FIGURE 7.8**). This is one of the more popular bug shapes to use, and it works great for creating a tilt-shift look. The round-shaped bug is the default shape when you launch FocalPoint, and it creates a circular or oval area of focus. It's a great choice for many headshots, portraits, and also any type of photograph where you want to localize your focus to one specific spot (**FIGURE 7.9**).

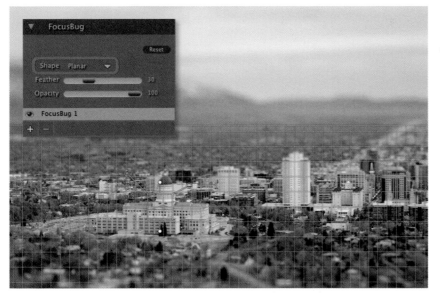

FIGURE 7.8 Set the Focus Bug shape to Planar for a rectangular area of focus.

FIGURE 7.9 The default
Focus Bug shape set-
ting is Round.

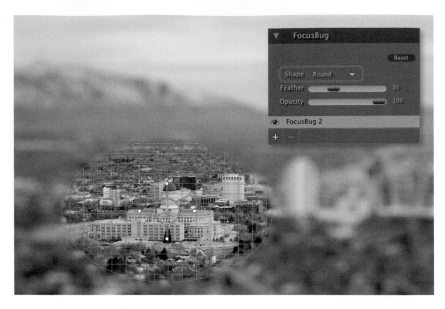

- **Feather:** The feather is the softness (or hardness) of the edge of the bug. For example, if you're using a round bug, then the oval shape will be more defined when the Feather setting is 0. The higher the number, the softer the edge will be (**FIGURES 7.10** and **7.11**).

FIGURE 7.10 A Feather
setting of 0 gives the
Focus Bug a hard
edge.

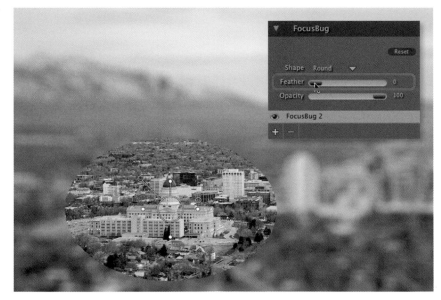

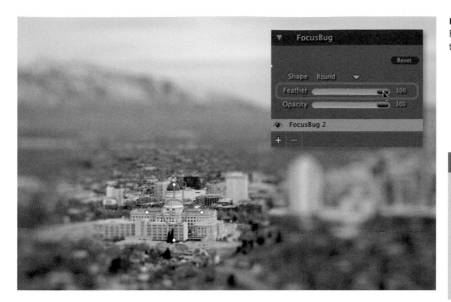

FIGURE 7.11 Setting Feather to 100 softens the Focus Bug.

HOT TIP

Another use for bug opacity is to have a single Focus Bug with Opacity set to 0%, which allows you to then use the Focus brush to paint focus in specific areas of the image.

- **Opacity:** The opacity of the bug determines how much of the in-focus area is showing through (**FIGURES 7.12** and **7.13**). The default setting of 100 means that the bug is 100% in focus wherever the mask is completely black. This is where you will usually keep this setting. Sometimes, however, you may want to reduce the Opacity setting. When using multiple Focus Bugs, for example, you may want to place your main bug at a setting of 100 and soften the rest of the bugs by reducing their opacity.

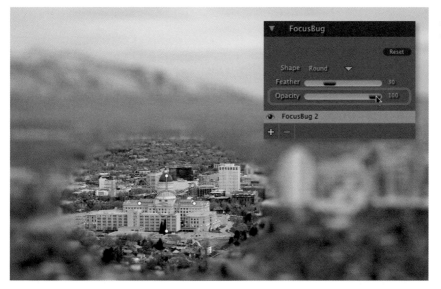

FIGURE 7.12 By default, Opacity set to 100 for the Focus Bug.

239

FIGURE 7.13 Here the Focus Bug's Opacity setting is 0.

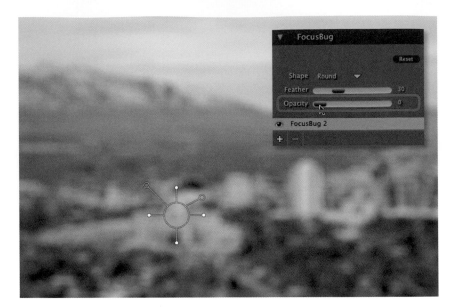

Adding Multiple Focus Bugs to Your Photograph

NOTE

FocalPoint allows a maximum of six Focus Bugs in your image at a time.

When you launch FocalPoint, it automatically adds a Focus Bug to your image, so there's no action required to get the ball rolling. What if you want to add more than one Focus Bug to a photo? In this case all the action is going to happen over in the Focus Bug pane on the right side of the window. At the bottom of this pane notice the word "FocusBug" followed by a number, which indicates the current number of bugs open. The eyeball to the left indicates that the Focus Bug is currently visible on your image. To add another Focus Bug, just click the + (plus) icon below the Focus Bug list; a new bug will appear in the list and on your screen (**FIGURE 7.14**).

You can edit each Focus Bug separately, so make sure that you have the bug you want to work on highlighted in the list in the Focus Bug pane. To make a bug active, click it either in the Preview window or in the Focus Bug pane. You can also hide the visibility of each bug separately by clicking on the eyeball icons to the left of the Focus Bug in the list (**FIGURE 7.15**).

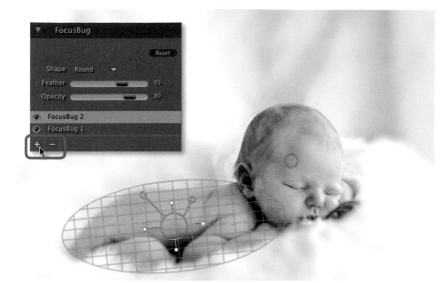

FIGURE 7.14 To add or remove Focus Bugs, click the + and − (plus and minus) icons at the bottom of the pane. In this example, I added a second Focus Bug to the image: one for the face and another (at a lower opacity) for the body.

FIGURE 7.15 You can toggle the visibility of each Focus Bug by clicking the eyeball next to the bug you want to show or hide. In this example, I hid the Focus Bug used to bring focus back to the baby's body.

The Blur Pane

With your Focus Bugs in place and their feather and opacity set, your next step is to play with the actual blur of the image. The Blur pane features seven settings (**FIGURE 7.16**):

FIGURE 7.16 The Blur pane enables you to control the actual blur of your image.

- **Version:** Because this is FocalPoint 2, Version is set to Version 2 by default. This is the newest version and uses an algorithm that allows you to mimic the look of a standard lens and change the style of the bokeh (**FIGURE 7.17**). If you choose Version 1 instead, you lose many of the options in the Blur pane (they would be grayed out) and the blur changes to more of a motion-type blur, similar to the blur a Lensbaby lens produces (**FIGURE 7.18**).

FIGURE 7.17 The default blur you'll see when you use FocalPoint 2, Version 2 mimics the look of the blur that naturally occurs in most standard lenses.

FIGURE 7.18 For this example, I changed the blur to Version 1 and increased both the Amount and Motion sliders to 100. This creates a motion blur and mimics the look you would see in most Lensbaby lenses.

- **Lens:** The default setting is Custom, but the drop-down menu lists several different Canon and Nikon lens choices. Using these lens presets is a great starting point for your image, and you can customize the look even further with the other settings. Don't worry, you don't need a Canon or Nikon camera to use these lens presets; they work on any photograph from any camera.

- **Amount:** The Amount slider determines the strength of the blur in your photo. A low setting adds a small amount of blur to the image, and a high setting adds a very large amount of blur (**FIGURES 7.19** and **7.20**).

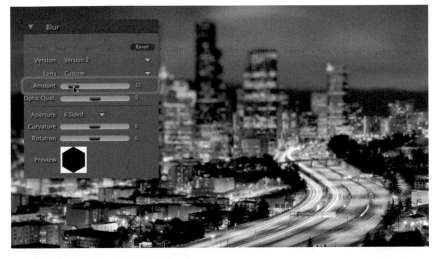

FIGURE 7.19 Setting Amount to 15 adds a small amount of blur.

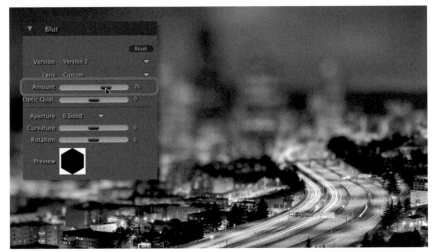

FIGURE 7.20 Setting Amount to 70 adds more blur.

- **Optical Quality:** This setting changes the bokeh to be completely filled, slightly feathered, or even donut-shaped. When you set Optical Quality to 0, the result is similar to most types of bokeh: completely solid (**FIGURE 7.21**). By moving the slider to the right, the edges of the bokeh will start to get soft and feathered, making the bokeh a little bit blurred (**FIGURE 7.22**). Move the slider to the left to create rings of light in your photograph for some really interesting looks (**FIGURE 7.23**).

- **Aperture:** The Aperture setting specifies the number of sides for your bokeh, which helps determine its overall shape. There are nine side settings to choose from, ranging from 3 Sided to 11 Sided (**FIGURES 7.24** and **7.25**).

FIGURE 7.21 Optical Quality set to 0 creates a completely solid bokeh.

FIGURE 7.22 Increasing Optical Quality to 100 softens and feathers the bokeh.

FIGURE 7.23
Decreasing Optical Quality to −100 produces rings of light.

FIGURE 7.24 Set Aperture to 4 Sided for a four-sided shape.

FIGURE 7.25 Higher values for Aperture produce more sides, such as the nine shown here.

- **Curvature:** The curvature of the blur determines how sharp or soft the edges of the corners are in your bokeh. The default of 0 is a good middle ground and gives the bokeh a realistic look (**FIGURE 7.26**). When you set Curvature all the way to the left, the edges are very sharp and harsh and start to become concave (**FIGURE 7.27**). Move the setting to the right, and the corners become much more rounded. If you push it all the way to the right, the shape turns into a circle, regardless of the amount of sides you have in the aperture setting (**FIGURE 7.28**).

- **Rotation:** This setting rotates the bokeh in your photo and is much more apparent in images with low Aperture settings, such as 3 or 4 Sided (**FIGURES 7.29** and **7.30**). The rotation is set in degrees and ranges from −180 to 180.

FIGURE 7.26 The default setting for Curvature is 0.

FIGURE 7.27 Moving the Curvature slider to −100 produces a sharp-cornered bokeh.

FIGURE 7.28 For a rounder look, try higher values for Curvature, such as 100 as shown here.

FIGURE 7.29 Blur Rotation is set to 0.

FIGURE 7.30 Blur Rotation is set to 40.

The Options Pane

Everyone loves options, right? Well, with FocalPoint you can add more than just blur to your photos. If a few subtle changes are all you need to really enhance a photograph, turn to the Options pane. The settings here affect only the blurred areas of your image created by the Focus Bug.

- **Highlight Bloom:** This is probably one of my favorite options. The Highlight Bloom setting brightens or darkens the bright areas of bokeh, which usually translates to any dots of light, or specular highlights, in your photo, such as streetlights or candles (**FIGURES 7.31** and **7.32**). It also changes the brightness or darkness of visible bokeh in an image, so it can be used for any type of photograph.

FIGURE 7.31 The default setting for Highlight Bloom is 100.

FIGURE 7.32 With the Highlight Bloom set to 323, notice how the bokeh lights in the buildings became brighter.

- **Brightness and Contrast:** These settings are pretty straightforward. The Brightness slider increases or decreases brightness, and the Contrast slider increases or decreases the contrast of the blurred parts of your image. Because our eyes tend to gravitate toward the brightest part of an image, you'll typically want to decrease the brightness to darken the surrounding areas, but do so only slightly if you're going for a realistic look.

- **Film Grain:** This setting adds a grainy look to the blurred parts of your image. Although turned off by default, Film Grain is helpful when you're working on an image with existing film grain or noise. FocalPoint tends to blur out the original grain, but you can use this setting to bring it back. It's also helpful if you happen to create any banding in your image while working.

The Focus Brush

While working on an image in FocalPoint, you may need a portion of the image in focus only to discover the Focus Bug is covering it up. This is when the Focus brush comes in handy, as it allows you to paint focus (or blur) in areas where you need detailed control (**FIGURES 7.33–7.35**). The brush is located at the bottom of the window, and all of its options are in the pane at the right of your screen.

FIGURE 7.33 For this image I used only the Focus Bug, which is visible. Notice how the top half of the bride and groom is out of focus.

> **HOT TIP**
>
> If you want to preview you're the changes to your images, just click the Preview check box on the bottom of the window. You can also do this quickly by pressing **Cmd+P** or **Ctrl+P** (PC).

FIGURE 7.34 I used the Focus brush to paint focus on the couple, and I also painted a subtle amount of blur in the water on the left part of the image. This brings focus back to the main subject and makes them pop out of the scene.

FIGURE 7.35 By previewing the mask (**Cmd+M** or **Ctrl+M**, PC), you can view the actual changes you make to the focus in an image. The black represents the in-focus areas, and the white represents areas that are out of focus.

To use the Focus brush, first click to activate it, then resize it so it works with what you intend to paint. You can set the size in the Focus Brush pane (**FIGURE 7.36**), but the easiest way to resize your brush is to use keyboard shortcuts. The [(left bracket) key decreases the brush size, while the] (right bracket) key increases it.

By default the brush is set to Paint Focus (**FIGURE 7.37**), which is the setting you'll use most. Simply paint the brush over the area you want to bring into focus. Clicking the Paint Focus button once toggles it to Paint Blur, which paints blur in whatever area you focus; click again to toggle it to Erase, which is just like an "undo" brush. When set to Erase, the Focus brush erases any changes you made to your image and brings it back to the defaults set by the Focus Bug.

The Focus Brush tool has two additional settings to fine-tune your painting. Brush Feather determines the softness or hardness of the brush's edge. The higher the setting, the softer the edge, and at a very low number the edge becomes very hard. I recommend keeping this number set fairly high for most images, between 50 and 100. The Brush Opacity setting determines how much focus or blur you paint back into your image. The lower the number, the less you're painting in for that brush stroke. I always use a low number, especially when I paint in blur, and then I make several passes with the brush tool over the same areas until I get the image looking right. You'll get much softer transitions and a more controlled blur using this method.

A few additional features of the Focus brush apply to working with Wacom tablets. If you have a Wacom pressure-sensitive tablet you can take full control of both brush size and opacity. Just select (place a check next to) the features you want to use and set the maximum size or opacity in the sliders above. For example, I checked the Wacom Controls Opacity box and set the maximum opacity to 30. Now, when I paint with the Focus brush, if I press softly on my Wacom tablet the opacity will stay at a low setting. If I press very hard, then the Opacity slider will go up to 30.

The last setting in the Focus Brush pane is the Save Mask As Alpha check box, which is useful if you work directly out of Photoshop. Select Save Mask As Alpha, and you can save your FocalPoint mask as an alpha channel when you apply your settings. You can then bring that alpha channel back into Photoshop (**FIGURES 7.38** and **7.39**) and use it to make selective adjustments to the image.

FIGURE 7.36 The Focus brush pane enables you to customize your brush.

HOT TIP

When painting with the Paint Blur mode, set the brush at a very low opacity setting (under 10) with a very large feather (**FIGURE 7.37**). This will ensure that you don't paint in too much blur, which could result in a smudgy look.

FIGURE 7.37 A low Brush Opacity setting is best when using the Paint Blur mode.

FIGURE 7.38 When working on an image imported from Photoshop, you can click the Save Mask As Alpha check box in FocalPoint to save the FocalPoint mask as an alpha channel for Photoshop.

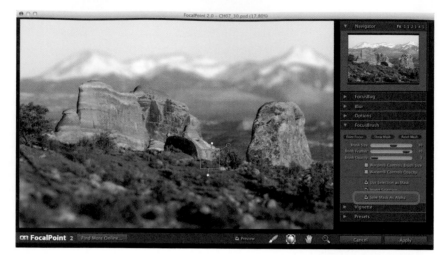

FIGURE 7.39 After you apply your blur, the alpha channel will appear in the Window > Channel panel inside of Photoshop. You can then use this as a mask in Photoshop to make selective changes to the blur or in-focus parts of your photograph.

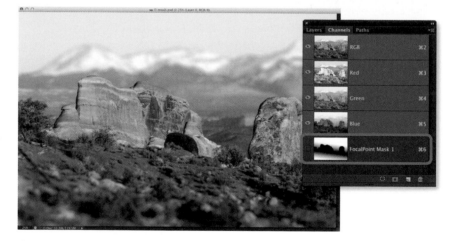

HOT TIP

Did you know that you can create a selection in Photoshop to use as a mask for your Focus Bug? This is a great alternative to the Focus brush when you have an intricate subject to mask out. To see how this works, be sure to check out the "Advanced: Working with Selections from Photoshop" section in this chapter for a detailed walkthrough of the process.

Adding a Vignette

Finishing touches to photos are always nice, and with the Vignette pane you can add a nice, soft vignette to your image. Vignettes do a great job enhancing the area of focus and drawing the viewers' eyes in to your subject. The Vignette pane's settings are:

- **Lightness:** This slider determines the darkness or lightness of your vignette. The default setting is 50, which adds no vignette to your image. Moving the slider to the left darkens the vignette, whereas moving it to the right lightens the vignette (**FIGURES 7.40** and **7.41**).

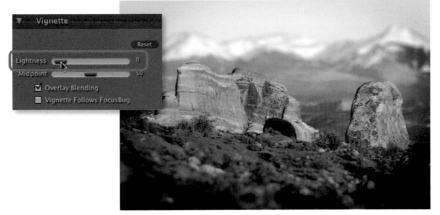

FIGURE 7.40 The Lightness slider set to the left creates a dark vignette.

FIGURE 7.41 The Lightness slider set to the right creates a bright vignette.

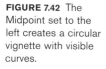

- **Midpoint:** This slider decreases or increases the size of the vignette's oval-shaped midpoint. Move the slider to the left to make the midpoint smaller and wrap the vignette fully around the inside edges of the photograph (**FIGURE 7.42**). Moving the slider to the right increases the midpoint, and the vignette starts affecting only the corners of the image (**FIGURE 7.43**).

FIGURE 7.42 The Midpoint set to the left creates a circular vignette with visible curves.

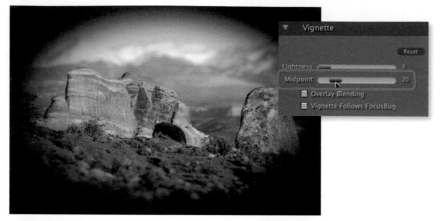

FIGURE 7.43 The Midpoint slider set to the right pushes the curves outside of the edges of the photograph.

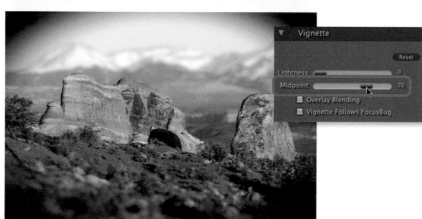

- **Overlay Blending:** When selected, this setting blends the vignette into the photo, which intensifies the colors and contrast of those areas (**FIGURE 7.44**). Deselecting this will give you a much darker, more opaque black vignette (**FIGURE 7.45**).

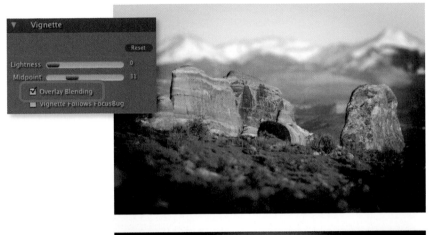

FIGURE 7.44 When turned on, the Overlay Blending option blends the vignette into the photograph.

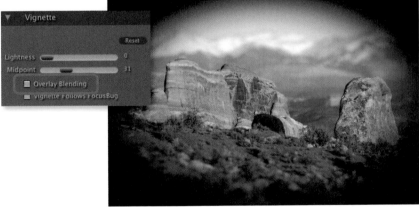

FIGURE 7.45 When you turn off the Overlay Blending option, the result is a darker, more opaque vignette with no blending.

- **Vignette Follows Focus Bug:** By default, this very important setting is selected, which means that the vignette will follow the area surrounding the Focus Bug. If your Focus Bug is off center, then you'll also have an off-center vignette (**FIGURE 7.46**). If you'd like a vignette that sticks to the edges of your photograph instead, be sure to deselect this setting (**FIGURE 7.47**).

FIGURE 7.46 When turned on, the Vignette Follows FocusBug option places the vignette around the Focus Bug.

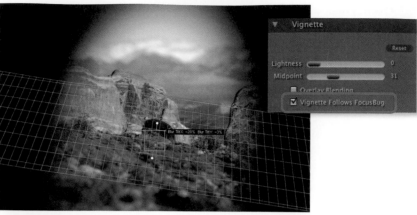

FIGURE 7.47 Turn off Vignette Follows FocusBug to keep the vignette to the edges of the image.

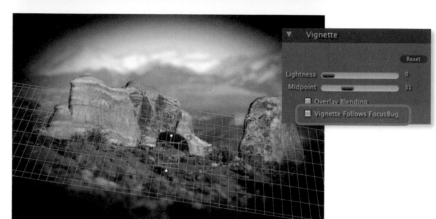

Presets

Presets are a great way of saving your settings to apply those same settings to other images. They save time and make your workflow much easier, even if they're just used to give you a solid starting point. By default FocalPoint 2 ships with a set of standard presets. Give them a try; you just might find them useful. (I know I do!) You can also save, edit, and share your own presets from the Presets pane on the bottom-right portion of your window (**FIGURE 7.48**).

FIGURE 7.48 Access built-in presets and those you create from the Presets pane.

Creating a preset is simple: Edit an image in FocalPoint, and when you're finished, click the + (plus) icon in the Presets pane (you can also access this from the File > Save Preset menu option). The New Preset dialog box pops up asking you to input a name, category, creator, and description, but only the Name and Category fields are mandatory (**FIGURE 7.49**). Now when you open up a new image you can go back to that preset and apply it instantly.

NOTE

Presets save all data from your settings except for any masking created with the Focus brush.

FIGURE 7.49 Name and Category are required fields in the Presets dialog box.

If you'd like to import presets from another source, you can do this from the File > Import Presets menu option. A window will open up for you to navigate to the preset. Locate your preset (it will be an .fpp file), select it, and click Import. You may need to relaunch FocalPoint for your new presets to appear.

Now that we've gone through all of the basics of FocalPoint, let's jump into some practical applications of the software to see how it can be used with three different images.

HOT TIP

If you'd like to easily locate your presets folder to back up or share your presets, choose File > Show Presets Folder and the window will pop up in your file browser.

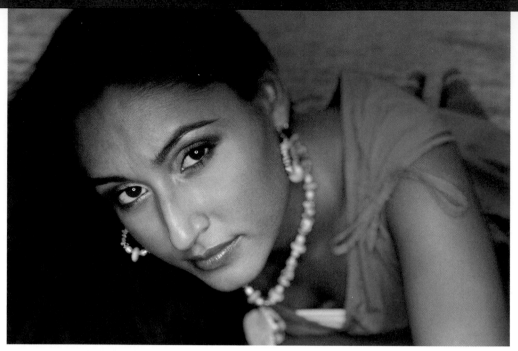

Portrait Blur with a Round Focus Bug

A simple way to enhance a portrait with FocalPoint is by using a round Focus Bug. This technique tends to work best with images in which the subject's face is closer to the lens than the subject's body, and is a good way to reduce the depth of field for a portrait photograph taken with a wide-angle lens.

Step 1

Starting with my image inside of FocalPoint, I first reset the Focus Bug settings by choosing Edit > Reset All. This gives my image a clean slate to work from.

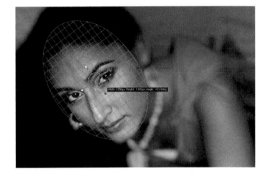

Step 2

By default, the Focus Bug is a round shape. Because that's what I wanted, all I needed to do was click and drag on the bug to position it. I centered the bug over the face, then I resized and rotated the bug to keep most of the focus inside of the face area.

Step 3

Some skin areas (chin, ear, and forehead) were still blurry, so I clicked on the Brush Tool icon at the bottom of the window and used the Focus brush to bring focus back to those areas. I didn't want to make drastic changes, so I set Brush Feather to 90 and Brush Opacity to 25. I painted over the face areas that needed focus, making several passes until I was satisfied with the focus.

HOT TIP

When using the Focus brush, the quickest way to resize your brush is with keyboard shortcuts: The [key decreases the brush size, and the] key increases it.

Step 4

Next, I adjusted the Blur and Options settings. I reduced the Blur Amount to 8, giving the blur a soft, natural look. I also set Optical Quality to −47, Curvature to 100, and the Highlight Bloom to 202 to make the bokeh a bit brighter and give them a subtle outline.

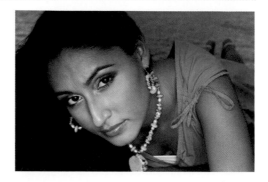

Step 5

Finally, I wanted to check my changes by previewing the before and after versions. I pressed **Cmd+P** (**Ctrl+P**, PC) to toggle the preview on and off.

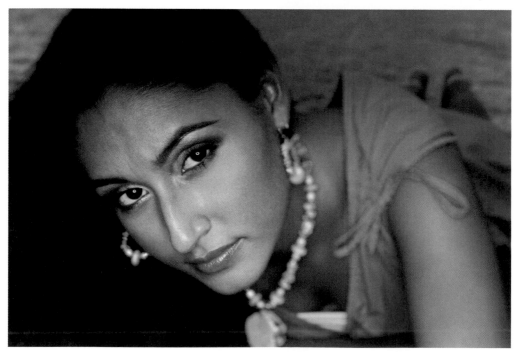

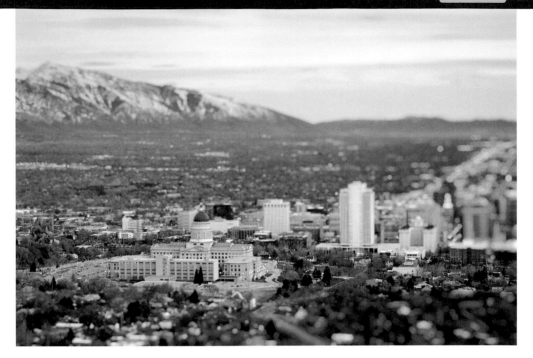

The Tilt-Shift Look

FocalPoint gives you a very realistic tilt-shift look without having to use an expensive tilt-shift lens. Not only does FocalPoint excel at creating this look, you can accomplish it with just a few steps, just like I did with this image of the Utah state capital. I photographed this from a hill with a standard lens, but wanted to make the scene look as if it were photographed with a tilt-shift lens by using FocalPoint.

Step 1

With my image inside FocalPoint, I first reset the Focus Bug settings by choosing Edit > Reset All. In the Focus Bug pane, I then set Shape to Planar, because I wanted to add a tilt-shift effect.

Step 2

Next, I resized and moved the Focus Bug to the correct location. I wanted to find a specific point of focus, something to draw the eye toward, for the tilt-shift effect to work well. In this case, I focused in on the Salt Lake City Capitol building and placed the Focus Bug horizontally so the plane of focus was right on top of it.

Step 3

To give the bug that tilt-shift blur effect, I put the cursor into the body of the bug and then held the **Option key** (**Alt**, PC). Next I dragged the cursor upward until I could see the tilt effect change with the grid. While doing so I could see the units change in a pop-up box, showing me the X and Y axes of my tilt. You can tilt the bug either forward or backward, and for this image I gave it a forward tilt by dragging the cursor up.

Step 4

The top of the building was a little bit blurry, so I fixed that with the Focus brush. I selected the Brush tool from the bottom of the window, set my brush to Paint Focus mode with a Feather of 90 and an Opacity of 25, and then painted over the building.

NOTE

It's usually a good idea to zoom in to 100% (1:1 ratio) or closer when doing detailed masking in window.

Step 5

I wanted the scene to really pop. So I set the Blur Amount to 10, the Optical Quality to −21, selected 5 Sided from the Aperture drop-down, and set the Curvature to 63 in the Blur and Options panes. I also increased the Highlight Bloom to 743, and adjusted the Brightness and Contrast of the photo as well.

Step 6

Lastly, I toggled the preview (Cmd+P or Ctrl+P, PC) on and off to see the results.

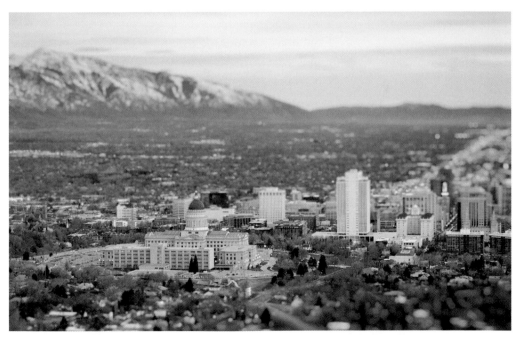

Advanced: Working with Selections from Photoshop

One thing I love about the Perfect Photo Suite is how well it integrates with other types of software. For example, I use both Lightroom and Photoshop on a daily basis, and Perfect Photo Suite fits seamlessly with my workflow. Because of this, when I encounter a very detailed subject that's just too much work for the Focus brush to mask and focus, I use Photoshop. For this image of Delicate Arch in Moab National Park I wanted to give the arch more depth, but it also involved much more precise masking than I could do with FocalPoint. So instead, I first used Photoshop to create my selection, and then brought it in to FocalPoint to give it the look of having shallow depth of field.

Step 1

This time, I started with my image in
Photoshop. I wanted to keep the arches and
people in focus, but take the foreground
out of focus in FocalPoint. To prepare,
I made a rough selection around the rocks
and people using Photoshop's Quick
Selection tool.

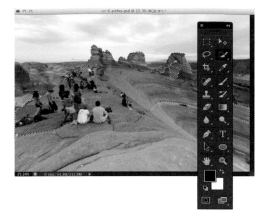

Step 2

Now that I had a decent selection around
the main portion of the photograph, I also
wanted to be sure to keep part of the
foreground out of the selection so I could
blur it in FocalPoint. I didn't want the harsh
selection edge, so I jumped into the Quick
Mask mode by pressing the Q key. This
mode temporarily gave me a mask overlay
view of my selection. (In the figure, note that
the red areas are the unselected areas of
the scene.)

NOTE

You can create selections in many ways within
Photoshop, and I'll barely be scratching the sur-
face in this example. In other words, use whatever
selection method you prefer for your images in
Photoshop.

Step 3

Next, I selected a brush with a very soft edge, and painted with white in the middle of the image so that there was a soft transition between the foreground and middle portion of the image. This also gave me the chance to do any touch-up work to other areas of the scene, like to some of the people in the background. Once I finished painting I pressed Q again to bring the marching ants of my selection back in view.

Step 4

With my selection finished, I chose File > Automate > FocalPoint 2 within Photoshop to launch FocalPoint in a new window.

Step 5

Again, my first move was to choose Edit >
Reset All to reset the Focus Bug settings so
I could start from scratch. Because I needed
to inverse the selection, I clicked the Invert
Selection box in the Focus Brush settings.

HOT TIP

By default, FocalPoint wants to add blur to the selected areas, so if you as soon as you bring an image into
FocalPoint with an existing selection it will automatically blur that area. To reverse the blur make sure that the
Invert Selection box is checked in the Focus Brush settings.

Step 6

Next was the easy part: editing the
Focus Bug. Because I wanted this to be
a "natural" blur, I changed the shape to
Planar and reduced the Blur Amount to
8. I also tilted the Focus Bug by **Option-
dragging** (**Alt-dragging**, PC) the bug's
body. I then moved and resized the bug
until everything looked good and flowed
well with the photograph.

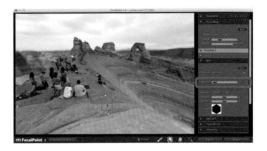

NOTE

It's usually a good idea to zoom in to 100% (1:1
ratio) or closer when doing detailed masking in
window.

Step 7

After all of my changes were made, I clicked
the Apply button to send the image back
into Photoshop. The software automatically
save the adjustments to a new layer on the
Layers pane.

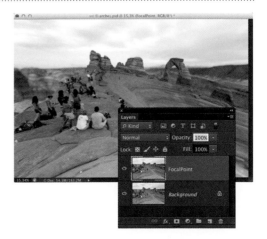

Hot Air Balloon in Provo, Utah, 2011.

Canon 5D Mark III, 14mm lens, 1/40 sec at f/5.6, ISO 100

PERFECT RESIZE

When you want to enlarge or print your images, Perfect Resize is your best friend. Formerly known as Genuine Fractals, this product is specifically designed to prepare your images for final output and is typically the very last step in your editing workflow. With Perfect Resize you can enlarge, crop, sharpen, and even create tiles or gallery wraps. It's a straightforward utility that will help you prep your masterpieces to print yourself or to send to an off-site printing lab.

The Perfect Resize Interface

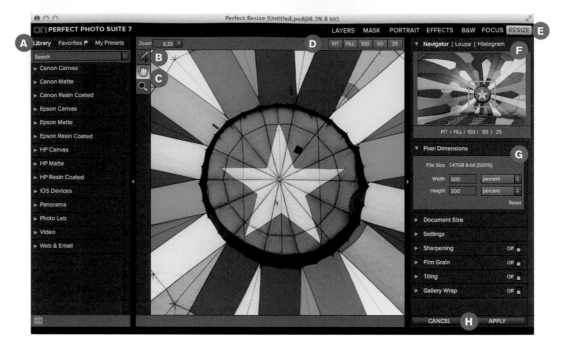

A Library, Favorites, and My Presets
B Crop tool
C Hand and Zoom tools
D Tool Options bar

E Module Selector
F Navigator, Loupe, and Histogram
G Adjustment panes
H Cancel and Apply buttons

When to Use Perfect Resize

Perfect Resize will be the last step in your workflow, especially if you plan on enlarging or printing your work. Here are some examples of why you may want to use Perfect Resize:

- **Image enlargement:** Perfect Resize can increase the size of an image over 1000% with very little to no loss in quality. The software is built with the Genuine Fractals algorithm, which makes it one of the very best resizing programs on the market.

- **Preparation for printing:** With Perfect Resize you can enlarge, sharpen, and crop your images easily with the settings in the software. It also includes special built-in effects specific for various printers and papers, as well as basic photo labs or unique output formats (such as video or mobile devices). Plus, just like in any other product in the Perfect Photo Suite, you can create your own custom presets to use for future images.

- **Enlarging images created with mobile devices:** One thing that Perfect Resize is great for is printing images you create with a tablet or smartphone. Because of the nature of the device used to make these images, the photo may already contain visible pixel artifacts. To keep these artifacts to a minimum, you'll get the best results by using the best product on the market: Perfect Resize can easily enlarge these images just as beautifully and precisely as any other photograph.

- **Creating tiled files or canvas wraps:** When you want to create a unique output, such as breaking up a photo into several different tiles, or print your image as a gallery wrap, Perfect Resize is a great choice. It takes all the guessing out of the equation and does the work for you.

NOTE

Perfect Resize comes in two editions: Professional (which ships with the entire Perfect Photo Suite 7) and Standard (sold separately). They both offer the same benefits of enlarging and preparing for print, but the Professional edition allows a few additional features, such as integration with host software like Adobe Lightroom and Photoshop. For more information on the specifics of each of these editions, please see www.ononesoftware.com/products/perfect-resize.

Understanding Resolution

The concept of resolution can be a tricky one to understand at first, but once you put a few key pieces of the puzzle together the picture becomes a little bit clearer. Before I discuss how to use Perfect Resize, therefore, I want to discuss the basics of pixels, resolution, and image size in relation to preparing your images for printing. All these settings are interconnected; you can't change one without affecting the other:

- **Pixels:** These are tiny squares that make up your digital image. When you work in the digital world you need to understand that you are working in pixels. To create a print you will translate those pixels into inches, centimeters, or other measurement.

- **Resolution:** Resolution is often referred to as pixels per inch (ppi) or dots per inch (dpi). A typical resolution for printing is between 240 and 300; however, this will vary depending on your printer. When publishing images to the Internet or for digital viewing, a typical resolution setting is 72 ppi.

- **Print Size:** The original pixel dimensions of your file determine the print size of a photo. Larger pixel sizes will equal a larger print size.

When you create a photograph from your camera, you probably already know how many megapixels your camera is, which then, in turn, determines the pixel size of your photographs. **TABLE 8.1** is a handy reference to help you with camera megapixels, pixel dimensions, and their maximum print sizes in inches at 300 pixels per inch (ppi).

TABLE 8.1 Camera Megapixel Conversions

Megapixels	Pixel Dimensions	Maximum Print Size at 300 ppi
1	1224 x 816	4.08 x 2.72"
2	1736 x 1160	5.79 x 3.87"
4	2448 x 1632	8.16 x 5.44"
5	2736 x 1824	9.12 x 6.08"
8	3464 x 2312	11.55 x 7.71"
10	3872 x 2584	12.91 x 8.61"
12	4240 x 2824	14.13 x 9.41"
16	4896 x 3264	16.32 x 10.88"
18	5200 x 3464	17.33 x 11.55"
22	5744 x 3832	19.15 x 12.77"
36	7352 x 4904	24.51 x 16.35"

The table shows the maximum print size you can get with the native file size of each image. As you can see, even with a very high megapixel count you can create only a 24 x 16 inch print without any enlargement of your images, but not everyone will have that many megapixels to work with. Very likely, however, you will want to print images much larger than their native file sizes, and to do so you will need to enlarge the files. So, doesn't it just make sense to do so with one of the best products on the market?

Ultimately, when you resize an image the software doing the enlargement creates new pixels to fill in the gaps. The main job of Perfect Resize is to fill

in those gaps to look as realistic as possible without removing sharpness or quality, and also without introducing an abundance of artifacts in the process. Of course, you also need to take into consideration the viewing distance of your final print, as you're more likely to look at a 4 x 6-inch print up close while holding it, and then view a 40 x 60-inch print while standing several feet away from the wall where it hangs. The point is that your images resized with this software will not just be stretched out and "blown up"; rather, they can be enlarged to as much as 1000% over their original size while retaining as much clarity and sharpness in the areas that need to remain sharp and clear.

Pixel Dimension and Document Size

When you open an image in Perfect Resize, the top two panes on the right, Pixel Dimensions and Document Size, are going to be your first stop (**FIGURE 8.1**). These two panes are "connected," meaning when you change the settings in one of the panes, you'll see those changes reflected in the other pane. Take a closer look.

Pixel Dimensions

The Pixel Dimensions pane shows you the size of the file in megabytes, as well as the width and height of your image in pixels. You can also view and change the size in percentage, which is helpful when you're making enlargements and want to know just how large the image has become after inputting your changes.

To resize the pixel dimensions click either the Width or Height box and type a new value. You can select either pixels or percent by using the drop-down next to each of the number boxes. As you change the file's pixel or percentage numbers, you'll notice the information changing next to the File Size readout, which lists the size of your file in megabytes, the bit value of the file (8 or 16), as well as the percentage of the document size in pixels when compared to the original file.

FIGURE 8.1 The Pixel Dimensions and Document Size panes allow you to change the physical size of your photograph.

HOT TIP

If you want to go back to your original image size (100%) you can do so by clicking the Reset button in the bottom right of the pane.

Document Size

When you want to get a bit more specific with your image size, then the Document Size pane is a good place to turn. In this pane, you can set the width and height in pixels, percent, inches, centimeters, millimeters, points, or picas. You can also set the resolution (pixels per inch or pixels per centimeter), which is a number typically determined by your printer or photo lab.

A few other settings you need to be aware of are:

- **Preset:** If you know the specific size you want to print or have a specific type of paper you want your image to fill, then this is a good place to start. Click the drop-down, and choose the preset you want to use. If you need to crop your image, then adjust the cropping box that appears over your image.

- **Rotate Crop:** When using a preset to crop your photo, by default it starts off with the same orientation as your original image. If you want to reverse the orientation (from horizontal to vertical, for example), then check the Rotate Crop box (**FIGURES 8.2** and **8.3**).

FIGURE 8.2 When the Rotate Crop box is checked, Perfect Resize will rotate the crop to match the orientation of your image.

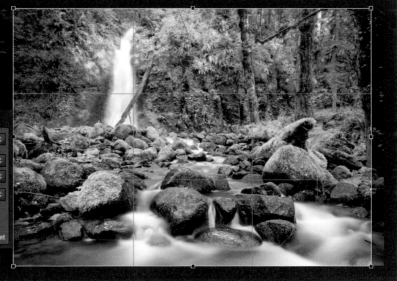

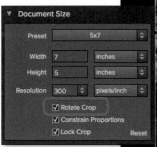

FIGURE 8.3 By deselecting the Rotate Crop box you can flip the orientation of the crop in your image.

- **Constrain Proportions:** When checked, this box constrains the original proportions of your image. This setting affects the width and height in both the Document Size and Pixel Dimensions pane. Constrain Proportions is checked by default, and deselecting it may cause distortion when you resize your image.

- **Lock Crop:** When checked, this setting "locks" the crop to the exact dimensions of the preset. This means that if you size the crop down or up, the resulting image will always remain at the same exact pixel size. Deselect this box before resizing to create a custom crop size.

HOT TIP

When cropping your image, be careful you don't press the Return or Enter key, which may feel natural to do if you're already a Photoshop user. If you do, you will apply all of the changes and exit Perfect Resize. If you do this and end up back in Perfect Layers, then you're in luck: Simply choose Edit > Undo to remove the changes from Perfect Resize and start over from scratch.

Presets and Cropping

On the far left of your window you'll notice a familiar pane, consisting of a Library, Favorites, and My Presets (**FIGURE 8.4**). The Library section has a large selection of built-in presets that are specific to printers, paper, devices, and output. These are a great starting point for many of your projects. You can also save your own Presets by choosing Preset > Save Preset or organize your favorites by clicking the flag icon next to the name of the preset. For more information on saving and organizing Presets in the Perfect Photo Suite, please turn to Chapter 1, "Getting Started."

There are very few tools associated with Perfect Resize, the main one being the Crop tool. To use the Crop tool, click the icon at the top of the tool-well and click and drag the cursor in your image to create a crop area (**FIGURE 8.5**). If you want to be precise with your crop you can select a preset from the Preset drop-down in the Tool Options bar or even enter values into the width and height in the boxes manually. Here you can also select the unit of measurement, as well as reverse the orientation with the circular icon between the Width and Height boxes. Also, to start over from scratch and bring everything back to its original sizes, click the Reset button on the far right of the Tool Options bar.

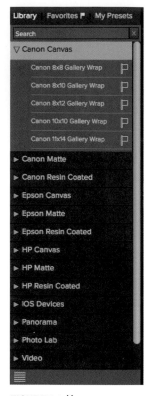

FIGURE 8.4 You can access the Library, Favorites, and My Presets from the far left side of your window.

HOT TIP

Presets in Perfect Resize are great tools to use for batch processing images. One thing to keep in mind is that if there's any cropping involved then you'll want to apply the preset to your images one at a time instead of batching a large group of files at once. This will allow you greater control over the crop of your images.

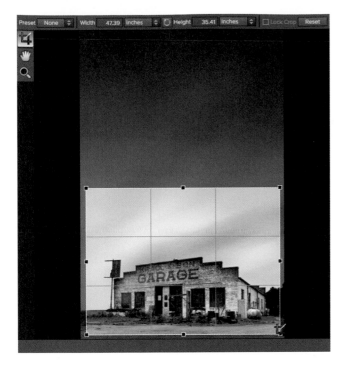

FIGURE 8.5 To crop your image, click on the Crop tool and drag the crop inside of the Preview window.

Settings

The Settings pane controls which resizing algorithm is used on your image; this is where the "magic" takes place in this product when enlarging your images (**FIGURE 8.6**). Here are each of the settings and how you can use them with your images:

- **Image Type:** This drop-down menu offers six types to choose from; select the one most appropriate to your image. For many images you'll be just fine with *General Purpose*, and if you have an image with a file size smaller than 10 megabytes, use the *Low-Res JPG* setting. These settings will determine the Texture, Threshold, and Smoothness settings.

- **Method:** The Method setting determines the algorithm used to process the enlarging of your images. Genuine Fractals is the original, classic method and is a good option for most images. If you're enlarging a portrait, however, then the Perfect Resize Portrait method is a good choice as it is a little softer on the edges, which may look better in portraits.

FIGURE 8.6 The Settings pane allows you to select the resizing algorithm for your image.

• **Texture:** The Texture setting affects the definition of the areas of your image that are not perfectly sharp, but are also not smooth—areas in the background such as grass, fur, or trees. Increasing this setting becomes more noticeable the more you enlarge your image (**FIGURES 8.7** and **8.8**).

FIGURE 8.7 This is an image enlarged by 800%, zoomed in at the pixel level (100% zoom) with a Texture setting of 2.

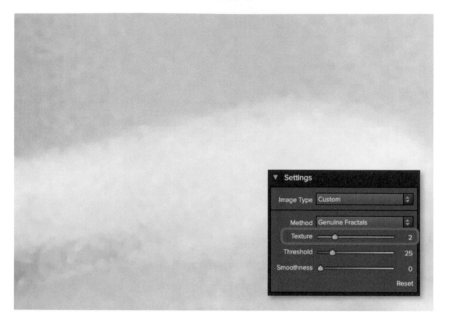

FIGURE 8.8 This is an image enlarged by 800%, zoomed in at the pixel level (100% zoom) with a Texture setting of 5.

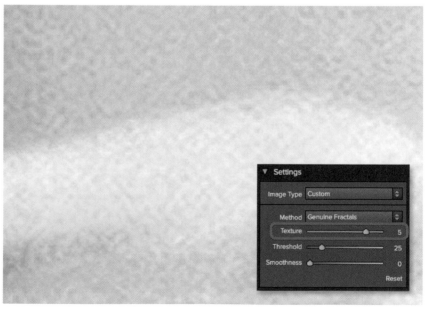

- **Threshold:** This setting, ranging from 0 to 100, controls the amount of hard-edge detail that is enhanced. Low numbers, such as 25 and below, focus the algorithm to affect only the hard-edge details. A higher number affects more of the image.

- **Smoothness:** The Smoothness setting smoothes out the artifacts around hard edges. Use the lowest possible setting required for your images.

HOT TIP

When making any custom changes with the Texture, Threshold, and Smoothness slider, be sure to zoom in to 100% in your image to preview the effects of each setting.

Sharpening and Film Grain

All photos, even perfectly in-focus images, can benefit from a little bit of sharpening. This is especially true when printing your images, so Perfect Resize offers a dedicated Sharpening pane (**FIGURE 8.9**). To add sharpening to your image, first toggle the switch on the right to On and expand the pane, if needed.

FIGURE 8.9 The Sharpening pane in Perfect Resize allows you to sharpen the image before printing.

NOTE

Sharpening an image does not add focus to your image; it accentuates the existing sharpness that is already in the photo. In other words, an out-of-focus image will still be out of focus after sharpening. If you want your photos to be tack-sharp, be sure to focus them as well as possible in your camera.

To get started with sharpening you first need to determine which sharpening type you want to use. The Type drop-down at the top of the pane offers three choices: Progressive, Unsharp Mask, and High Pass. The default is *Unsharp Mask*, and is a good choice for most images as it is only applied to the luminance of your images (in other words, it won't create color artifacts). *Progressive* is also a good choice for general use, as it will sharpen in different amounts, depending on the size of the details in your image. If you have an image that is somewhat soft in focus, however, then you may want to use *High Pass*. The High Pass option is a little bit more "harsh" in terms of sharpening, so try to use one of the other two for a well-focused image. Here is a breakdown of the other settings in this pane:

- **Amount:** Ranging from 0 to 200, the Amount slider is pretty straightforward. Move it to the right to increase the overall sharpening amount in your image, and move it to the right to decrease it.

- **Radius:** This setting, only available when you choose Unsharp Mask for the Type setting, determines the size of the details (edges) you want to apply sharpening to and ranges from 1 to 4. Be careful not to set this number too high, or you'll start to see halos around the edges of your image.

- **Protect Highlights and Shadows:** When you sharpen a photograph, you may not want to sharpen certain areas, such as the highlights and shadows. These sliders, both ranging from 0 to 100, are to protect those areas and prevent the sharpening from affecting them.

If you see any artifacts in your images, you may want to use the Film Grain pane to even it out. Unlike the Film Grain settings in other products, such as Perfect Effects and Perfect B&W, this pane is not for stylizing your image. In Perfect Resize, the purpose of adding simulated film grain is to help hide artifacts found in the image due to the enlargement process or alterations to the image, such as compression artifacts or banding (**FIGURES 8.10** and **8.11**). The resulting image will then appear sharper, and it's especially useful for black-and-white images, too.

Adding film grain is pretty straightforward: There is one setting ranging from 0 to 100. Move the slider to the right to increase the amount of film grain, or to the left to decrease. This setting is optional, because you may not have artifacts in your images you need to hide. This should be one of the very last settings you apply to your image just before printing.

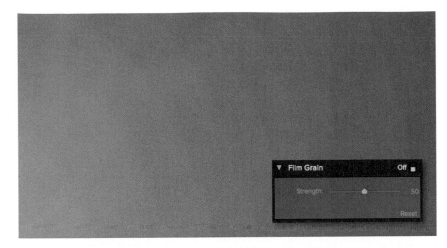

FIGURE 8.10 There is a considerable amount of banding in the sky portion of this photograph.

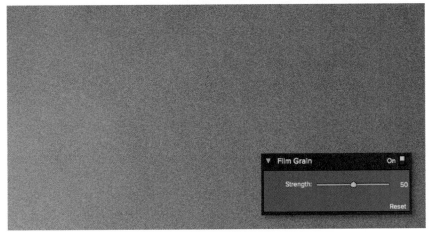

FIGURE 8.11 Adding film grain to the image helps mask some of the banding artifacts visible in Figure 8.10.

Gallery Wrap and Tiling

At times you may want to divide your images into several pieces to print separately and then piece together afterwards, or maybe you want to print on canvas and then it wrap around wooden stretcher bars without losing part of the image around the edges of the frame. This is when the Tiling and Gallery Wrap panes will come in handy.

Tiling

To get started with tiling, first toggle the switch on the right to On (**FIGURE 8.12**). Immediately you'll notice cyan-colored guides in your image. These guides indicate the sections where the image will be "cut." You can change the size of each section in the Tile Size area of the Tiling pane.

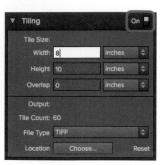

FIGURE 8.12 To separate your image into tiles toggle the switch to On and enter your settings.

When setting your tile sizes, if you know the specific dimensions of tiles you need then you can enter them using pixels, percent, inches, or centimeters. If your math is not precise, however, and it doesn't add up to the document size, then you'll see the grid flow over the edges of your image (**FIGURE 8.13**). For most projects I recommend using columns (for width) and rows (for height). This will ensure that you can maintain your current document size and also fit your tiles perfectly within your image without going off of the canvas (**FIGURE 8.14**).

One additional setting in this section is the Overlap setting, which is for printing a little bit of extra image information around each tile (**FIGURE 8.15**). This is helpful when you need to correct for printer margins or want to connect the pieces together afterwards without losing any of the image. For example, if someone wanted to print tiles of their photo on cloth and then sew it into a quilt, having some overlap on the edges of their tiles will allow them to sew the pieces together without losing the main part of the image tile.

When you're ready to save the tiles, you can do so from within the Output section of the pane. This section shows you the individual size of each tile, as well as allows you to select a file type and location to save the images. Once you have all of your tile settings ready to go, click the Apply button to apply the changes and export the image files; each tile will save as a separate file so you can print them individually (**FIGURES 8.16** and **8.17**).

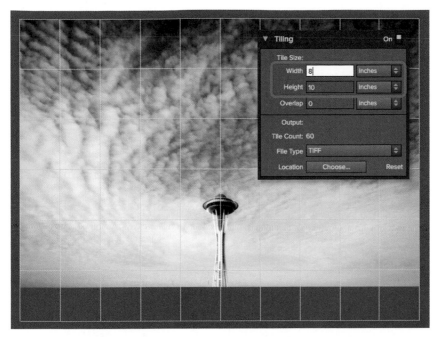

FIGURE 8.13 The settings in the Width and Height don't match up with the document size because they are set to specific dimensions in inches.

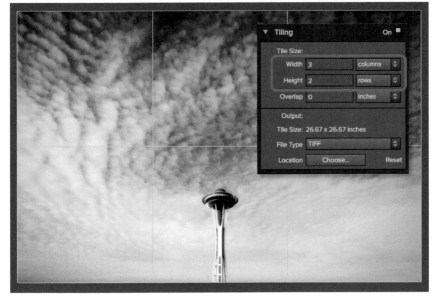

FIGURE 8.14 By changing the Width and Height units to columns and rows I was able to fit the tiles into the image proportionally.

FIGURE 8.15 The Overlap setting adds an overlap to each tile.

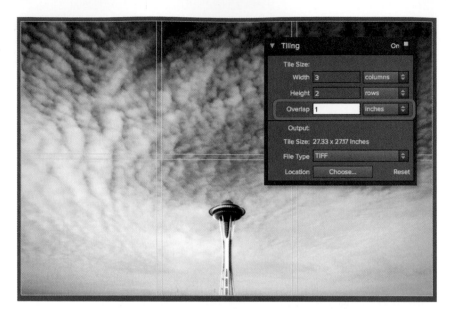

FIGURE 8.16 I selected to save my tiles as JPEG images in six different tiles.

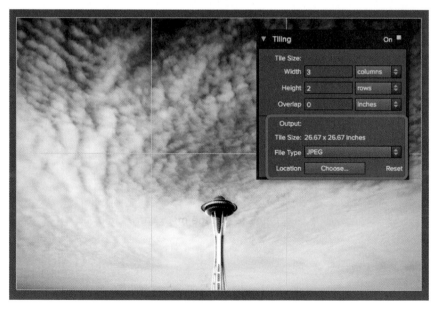

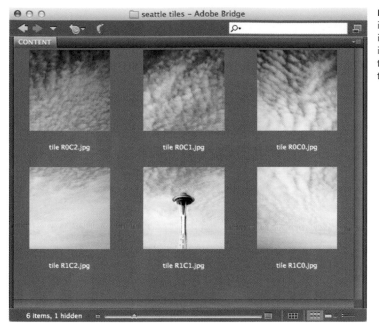

FIGURE 8.17 After clicking the Apply button my images were saved as individual JPEG files to the location I specified in the Tiling pane.

Gallery Wrap

The Gallery Wrap setting was designed specifically to print images with a border around the edges to wrap around a wooden stretcher frame. If you try printing your image at a photo lab as a wrapped canvas the lab will usually give you a warning that part of your image will be wrapped around the frame and not visible from the front. For most images this is not ideal, as you will lose some of the important parts of your photograph; with the Gallery Wrap pane you can solve this problem by adding additional images around the outside edges of your document to prevent the main image from being wrapped (**FIGURES 8.18** and **8.19**).

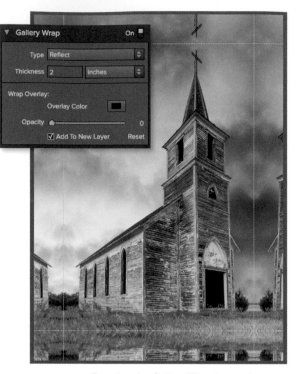

FIGURE 8.18 This image has elements that sit very close to the edge of the frame. With 2 inches of wrap much of the main subject disappears around the edges.

FIGURE 8.19 By using the Gallery Wrap feature in Perfect Resize, I was able to keep the main elements on the front part of the print and use a reflection to wrap around the wooden frame.

The Gallery Wrap pane consists of three main settings: Type, Thickness, and Wrap Overlay. These settings affect the added wrapped portions of the image only, which are the edges of your gallery wrap (the front portion of your print will remain unchanged). Here are each of these settings and how to use them to prepare your images for printing as a gallery wrap:

- **Type:** There are two main types of wrap: Reflect and Stretch. *Reflect* reflects the specified amount of wrap from the edge of the frame. This is a very popular setting, as it gives the gallery wrap a seamless look around the edges. *Stretch*, on the other hand, stretches the image from the edge outward. For each of these you can also select the option to have a *soft* reflection or stretch. This adds a subtle blur to the wrapped portion of your image (**FIGURES 8.20** through **8.23**).

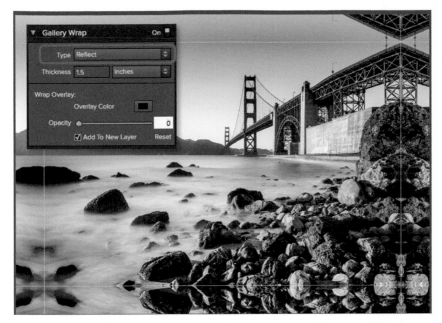

FIGURE 8.20 The Reflect setting reflects the inside portion of your image on the wrapped area of your image.

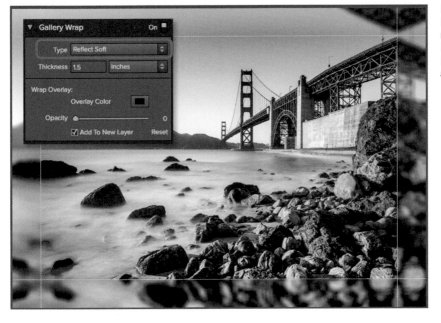

FIGURE 8.21 The Reflect Soft setting reflects and blurs the inside portion of your image on the wrapped area of your image.

FIGURE 8.22 The Stretch setting stretches the photo on the wrapped area of your image.

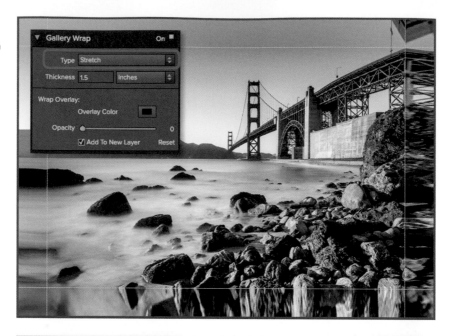

FIGURE 8.23 The Stretch Soft setting stretches and blurs the photo on the wrapped area of your image.

- **Thickness:** The Thickness setting determines how much excess wrap is created on the outside of your image. This number will be determined by the wooden frame's thickness and is typically around 1 to 2 inches. If you're printing at a photo lab be sure to ask about frame thickness to determine what to enter into the Thickness setting.

- **Wrap Overlay:** This section's settings add additional styling to the wrap. If you wanted to darken or lighten the wrapped area, or even give it a solid color, you can do this by selecting an *Overlay Color* and then moving the *Opacity* slider to the right. To change the color of the overlay, just click the color icon to the right of the Overlay Color setting (**FIGURE 8.24**).

FIGURE 8.24 You can add color and different levels of opacity of that color to the wrapped portion of your image; in this example I changed the color to white and set the opacity to 74 percent.

- **Add To New Layer:** When selected, this setting adds the wrapped portion to a new layer in your PSD file. When you deselect this check box, your entire PSD document will be flattened and the wrapped portion will be applied to the flattened layer; but don't worry, you'll get a warning before you attempt to do this in case you unintentionally left it unchecked (**FIGURE 8.25**).

FIGURE 8.25 If you deselect the Add To New Layer box, a warning dialog pops up letting you know your image will be flattened.

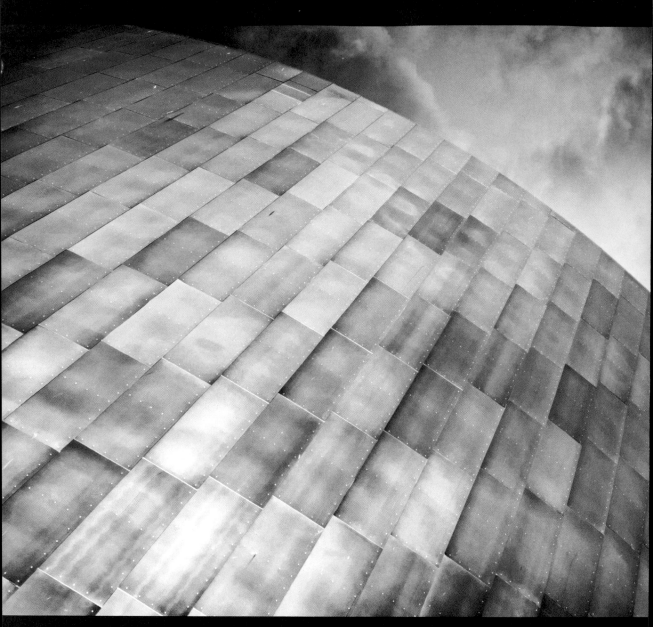

Space Needle Reflection; 2012. I added a new sky to this image in
Perfect Layers, and converted it to black and white using Perfect B&W.

Fuji x100, 23mm lens, 1/70 sec at f/11, ISO 200

PERFECT INTEGRATION

When processing images, we very rarely will use only one application or product. In fact, that's what's so great about Perfect Layers: It allows us to seamlessly work in and out of all of the Perfect Photo Suite products without having to exit the software. In this chapter I will walk through the steps I take when processing my images from more than one product in the Perfect Photo Suite 7.

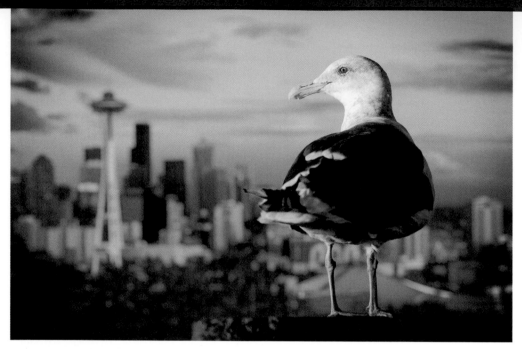

Creating Blurry Backgrounds for Composites

One way to create more realistic composites is to effectively blur the background similarly to how your image would look if photographed on location. Here I'll take you through the steps I used to place a seagull in a brand-new city using Perfect Layers, Perfect Mask, and FocalPoint.

Step 1

I started in Perfect Layers, opening two images as separate layers in the Layers pane. Because I wanted to replace the background of the seagull image with the Seattle skyline, I made sure that the seagull was arranged as the top layer. Next, I selected the seagull in the Layers pane and clicked Mask in the Module Selector to open the image in Perfect Mask.

Step 2

Inside of Perfect Mask, I selected the Drop brush in the tool-well and drew a short line in the sky portion of the image. From this action Perfect Mask removed most of the background, but the result still needed some refinement.

Step 3

To remove the remaining sky from the seagull image, I first selected the Brush tool and set the Mode to Paint Out. To easily view the areas which needed to be removed, I pressed **Ctrl+M** to change the mask view mode to Grayscale. Then I painted over the white specks in the background with the Brush tool to remove them.

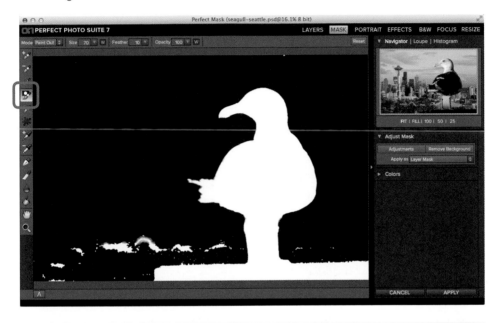

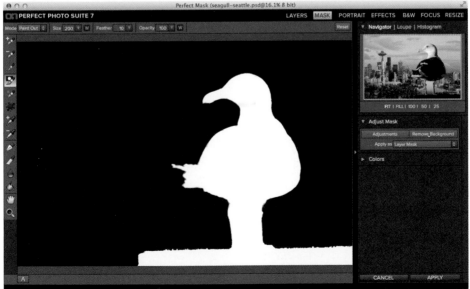

Step 4

Next, I toggled the back to All Layers view mode and zoomed in close to the legs to fill the gap where some of the background still remained. I selected the Drop brush, just as I did in Step 1, and drew a line down through the area I wanted to remove. When I let go of the brush, the background area disappeared.

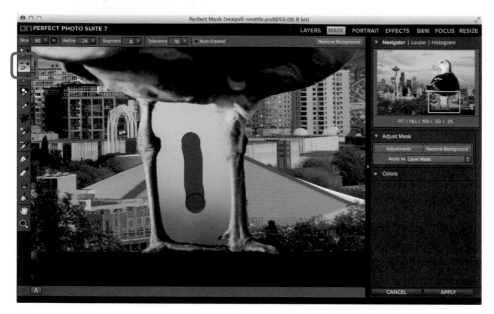

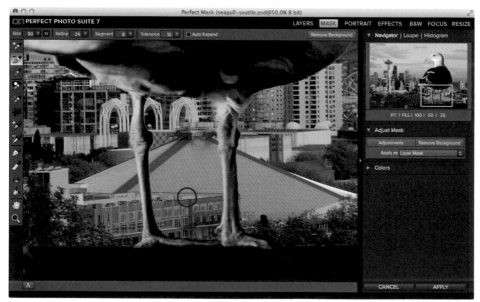

Step 5

The background was stubbornly still showing along some of the edges in the photo. To remove this, I selected the Magic brush from the tool-well, made sure it was set to Paint Out mode, and painted along the edges to remove the remaining bits of background.

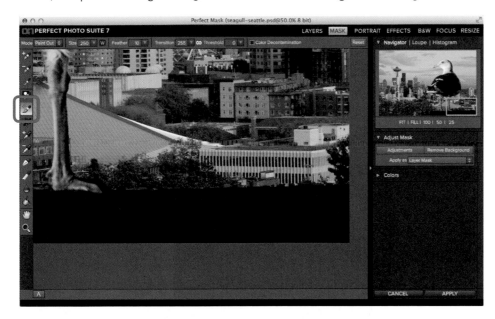

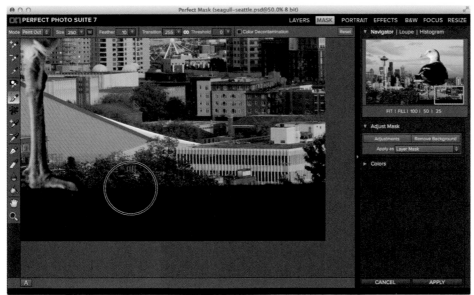

Step 6

I noticed a little bit of a halo effect around part of the bird, so I selected the Chisel tool from the tool-well and set it to Remove mode in the Tool Options bar. Then, I painted along the edges wherever there was a halo to chisel away the edge one pixel at a time.

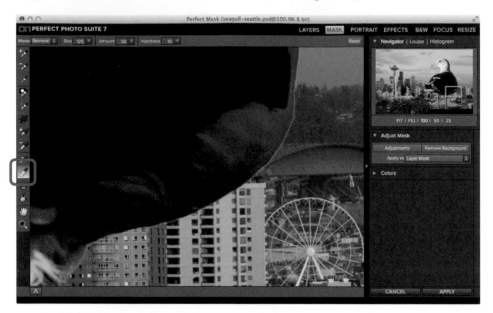

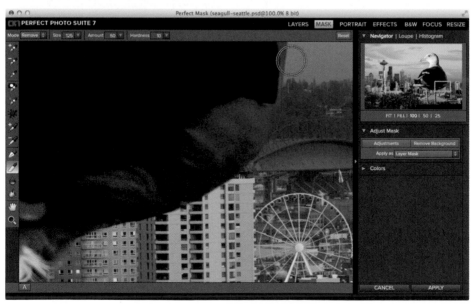

Step 7

My mask was ready to go, so I applied it as a Layer mask from the Adjust Mask pane and clicked the Apply button to bring the image back into Perfect Layers.

Step 8

Once inside Perfect Layers again, the very first thing I did was to choose File > Save to save my progress. The background looked good, but it had way too much depth of field. For the background to blend better with the foreground it needed to be much more blurred, and to do this I needed FocalPoint. So, I highlighted the Seattle layer and clicked the Focus button in the Module Selector to launch FocalPoint.

Step 9

Because FocalPoint always retains the settings from your previous edit, the first thing I almost always do before starting on a new image is reset all of my settings. I did just that for the Seattle image, choosing Edit > Reset All.

Step 10

Because I wanted to blur the *entire* background, I needed to remove the in-focus part of the FocusBug. To ensure that the entire image would be out of focus, I set the Opacity to 0 in the FocusBug pane.

Step 11

The default blur in the Blur pane was a bit too intense, so I dropped the Amount setting down to 15.

Step 12

In the Options pane, I changed the Highlight Bloom setting to 372 to make some of the lights in the distance glow just a little bit, and I also decreased Brightness to −17 and increased Contrast to 13. I selected the Film Grain box, and lowered the Amount slider to 16 to add a small amount of film grain.

Step 13

For a final touch, I used the Vignette pane to add a subtle vignette. I set the Lightness to 15 and the Midpoint to 58. Then, I clicked Apply to apply the blur settings and bring the image back into Perfect Layers.

Step 14

My FocalPoint edits were saved as a new layer in Perfect Layers, so I toggled the visibility of the FocalPoint layer to view before and after images of the changes.

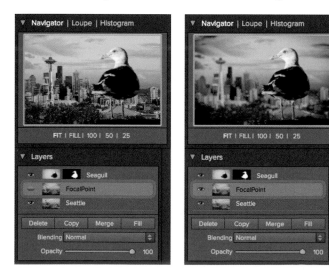

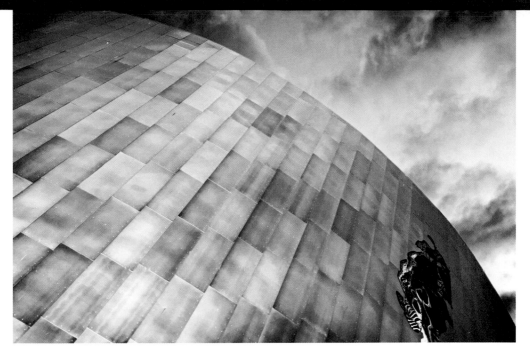

Replacing a Sky and Converting to Black and White

Some days the weather won't cooperate, leaving your subject backed by a less-than-perfect sky. Don't worry; the Perfect Photo Suite is the perfect solution to quickly swap out a boring sky with something that has a little more depth. Here I'll walk you through the steps I took to add a much more interesting sky to this image in Perfect Layers, as well as creatively convert it to black and white in Perfect B&W.

Step 1

I started with one image opened up inside of Perfect Layers. I wanted to remove the blank blue sky, and because it was a fairly simple masking job I decided to use the Brush tool in Perfect Layers. I clicked the Brush tool in the tool-well, set it to Paint Out mode, and also made sure that the Perfect Brush was checked in the Tool Options bar. Then I painted over the sky along the edges of the building, being careful to keep the crosshairs inside of the blue sky.

Step 2

After all of the sky area was removed, I chose a cloud image to place in the background. Using the Browser on the left of the window, I double-clicked a cloud image from my own collection. A window popped up asking if I wanted to add the image as a new layer or as a new image. I clicked Add to add the image as a new layer in the Layers pane, and the cloud layer was added to my document. To make a little more space, I hid the Browser pane by clicking on the vertical bar to the left of the tool-well.

Step 3

Perfect Layers placed the new layer at the top of the Layers pane, but I needed it on the bottom. To rearrange the order, I clicked the layer in the Layers pane and dragged it underneath the image of the building.

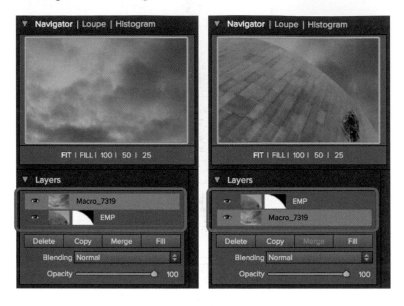

Step 4

Now that I had the cloud layer in position, I wanted to transform it to select a different portion of the image to fill in as the new sky. I confirmed that the cloud layer was selected in the Layers pane, and then I chose the Transform tool from the tool-well. I first clicked the Fill button on the top right in the Tool Options bar to fit the layer to the canvas, and then used the rotate and flip buttons until I found a section of cloud I liked. Clicking the Apply button in the Tool Options bar applied my transform changes.

Step 5

My image was ready to go, but before I could launch Perfect B&W I needed to create a merged composite of my entire image. To do this, I clicked the top layer of the Layers pane and chose Layer > New Stamped Layer in the menu bar. Perfect Layers created a merged copy of all of my layers and placed it on the top of the Layers pane. Then, I saved my progress by clicking the Save button on the bottom right of the application window.

Step 6

After checking that the top layer was selected, I clicked B&W in the Module Selector to launch Perfect B&W. Once inside Perfect B&W I wanted to add an effect, so I selected Ansel In The Valley from the Effects pane on the left. Then I hid the pane by clicking on the vertical bar to the left of the tool-well.

Step 7

I noticed that some of the areas became overexposed, so to view those spots I pressed the J key. The red areas in the image indicated the clipped whites. Because the original image was not overexposed in those areas, I suspected it was from a color conversion with the Color Response pane with the effect I used. So I expanded the Color Response pane and moved the Magenta and Red sliders to the left to correct the overexposure.

Step 8

This left the image somewhat flat, so next I expanded the Tone Curve pane and shaped the straight line into an S-curve to add brightness and contrast to the photo.

Step 9

Lastly I wanted to add a subtle amount of color to the photo, so I expanded the Toner pane and selected the Selenium 1 preset. Then I made some custom adjustments to the tones until I had a color combination I was happy with. I also adjusted the vignette in the Vignette pane, making it a bit stronger. Then I clicked the Apply button on the bottom of the screen to open the image back into Perfect Layers.

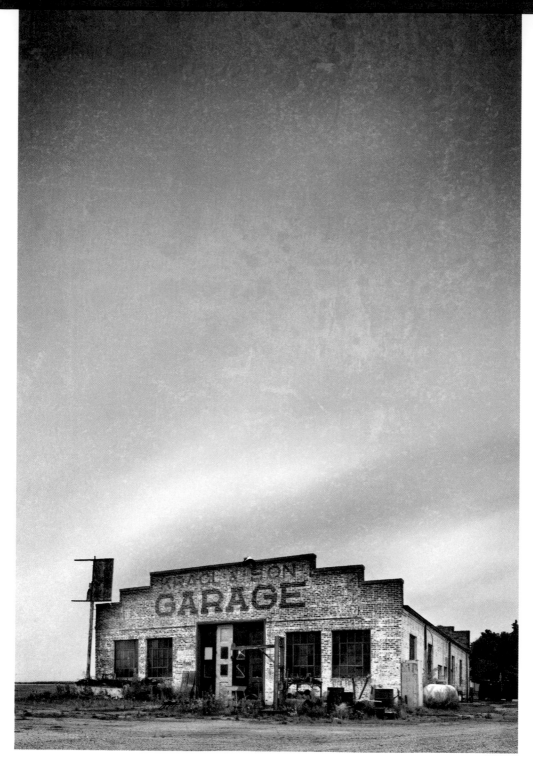

Adding Texture and Grunge

I enjoy playing with textures in my images, and although Perfect Effects offers a good selection to choose from, sometimes I just want to use one of my own. In fact, I'll go on photo walks with the sole purpose of finding textures to store in my image library. For this photo, I added a bit of grunge and drama to the scene using Perfect Effects, and then I went into Perfect Layers to add my texture.

Step 1

I started with my image open in Perfect Layers, but clicked the Effects button in the Module Selector to launch Perfect Effects.

Step 2

In Perfect Effects, I made sure the Effects pane was visible on the left and collapsed the All folder so I could scroll through all of the effects at once. Then I clicked the Blue Dawn effect to add it to my image, giving it an almost black-and-white look. Because I wanted to add some color punch and contrast I needed to change this, so I clicked the Options button in the Effects Stack pane to bring up the blending options. I chose the Soft Light blending mode with an Amount setting of 55.

Step 3

Next I clicked the Add button to add a new effect, scrolled to the Warm Polarizer effect, and reduced its Amount setting to 40. I added another new layer, but this time entered Tonal Contrast into the search box in the Effects pane. When the effect appeared, I clicked it to select it.

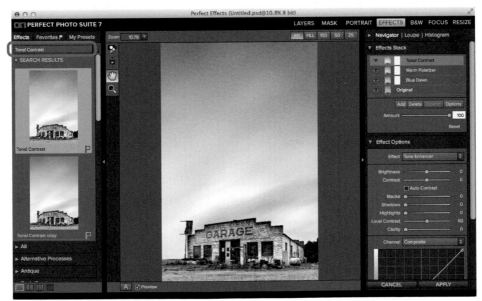

Step 4

Unfortunately, I didn't like what the effect was doing to the sky, so I decided to mask it out. To do this I selected the Masking Bug in the tool-well and clicked in the top-third portion of the image. I used the handlebars to resize the bug so it masked out the sky and pressed **Ctrl+M** to preview the mask.

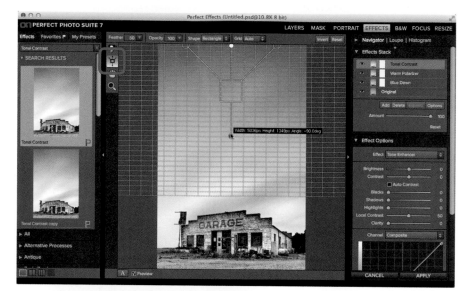

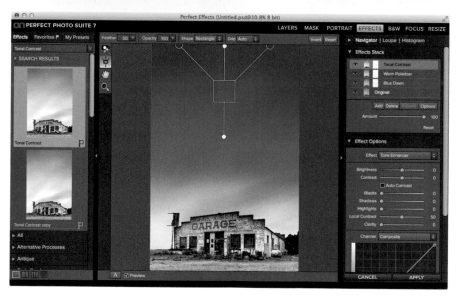

Step 5

Although I was finished editing my photo inside of Perfect Effects, I took a moment to save my edits as a preset. I chose Preset > New Preset, entered a name and other details, and then clicked Create. With my edits saved in case I needed to re-create them, I was ready to move on and clicked the Apply button to bring the image back into Perfect Layers.

Step 6

Back inside of Perfect Layers I saved my progress (File > Save), and then was ready to add my texture. I previously compiled a folder of a few textures I wanted to try on this image, so I used File > Browse to locate my Textures folder.

Step 7

To add one of the textures to my image, I double-clicked it in the Browser and a window popped up asking if I wanted to create a new file or add this image as a layer. I clicked the Add button to add the texture image as a layer in the Layers pane. Then I hid the Browser pane by clicking on the vertical bar to the left of the tool-well.

Step 8

The texture layer was a horizontal image, so I needed to rotate it and resize it to fit my photo. I clicked on the Transform tool in the tool-well, and then used the rotate button on the far-right side of the Tool Options bar to rotate the image to vertical. I also stretched the left side out a bit to hide a portion of the texture I didn't want to show. When I was finished transforming I clicked the Apply button on the top and then activated the Hand tool to hide the transform border on the image.

Step 9

The texture image was hiding the layer below, which was not my plan. To blend it in with the rest of the photo, I clicked on the Blending drop-down and scrolled through the settings until I found one I liked. I selected the Soft Light blending mode, and then reduced the Opacity setting to 45.

Step 10

I wanted the texture to affect the sky only, so I selected the Brush tool from tool-well and set it to Paint Out mode. Clicking **Ctrl+M** to preview the mask, I started painting over the building and ground to hide the texture from this part of my image. When I was finished I exited the mask preview by once again clicking **Ctrl+M**.

Step 11

Next, I warmed up the photo very subtly by adding a Color Fill Layer. I clicked the Fill button in the Layers pane and then selected the Warming preset in the Color Fill Layer window. I also set the Opacity down to 6 and clicked OK.

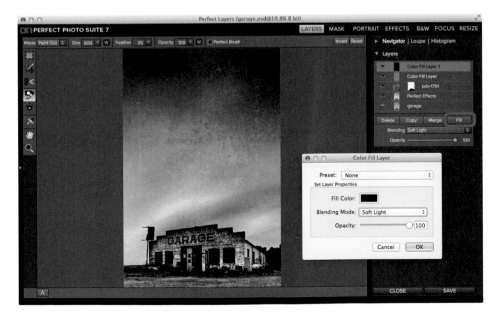

Step 12

I thought a vignette would darken the corners a bit, so I first clicked the Fill button in the Layers pane. I set black for the fill color, chose the Soft Light blending mode, set Opacity to 100, and clicked OK.

Step 13

The last step was to add a Masking Bug. I clicked the Masking Bug icon and clicked once in the center of the image. In the Tool Options bar I changed the shape to Round and the Feather setting to 100, and then I resized and repositioned the bug to darken up the corners. The result of my work was a gritty, dramatic, and colorful image. To view the before and after, I toggled the eyeball icons in the Layers pane.

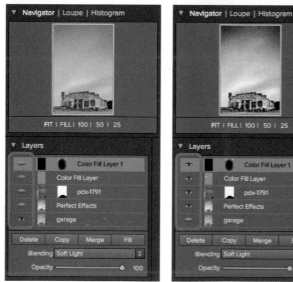

Batch Processing for Time-Lapse Photography

One of my passions is creating time-lapse videos from still photography. Basically, I photo-graph several images from a tripod of the same scene over a period of time, collect all the images, then batch edit them in Lightroom. Sometimes, however, I'm in the mood to stylize the photos a bit more. Although I typically have hundreds of still images to process, the batch editing features inside of the Perfect Photo Suite 7 make it so darn easy. Here's how I created a stylized time-lapse video using Lightroom, Perfect Effects, and Photoshop CS6.

Step 1

I started off with my group of still images inside of Lightroom; for this time-lapse I had a folder of over 400 photos. First I cropped one photo to make it match up with the 16:9 aspect ratio of HD and also made a few adjustments in the Basic panel to correct the white balance and tones. I wasn't too concerned with my stylizing inside of Lightroom because I planned to do most of it in Perfect Effects. Then, I exported one image to my desktop in the intended size and resolution of my video files. From this image, I would create my presets.

Step 2

Next, I opened the file into Perfect Layers and launched Perfect Effects by clicking the Effects icon in the Module Selector. Now came the fun part—creating a preset to use for my time-lapse video. In order and adding new layers after each application, I added these four effects (from the Effects pane on the left): Tonal Contrast (at 50% opacity), Daily Vitamin, Dreamland (at 20% opacity), and Magic Forest. Then, I hid the Effects pane by clicking on the vertical bar to the left of the tool-well.

Step 3

I also wanted to add a cross-processed effect, so I added a new layer to the Effects Stack and selected the Duotone Effect from the Effect Options pane. I selected the Sunburn preset, and then reduced the Opacity setting in the Effects Stack pane to 25%.

Step 4

As an interesting addition to the video, I added a new layer to the Effects Stack and then added a border by selecting the Film Type 55 1 Borders effect from the Effect Options pane. I set the blending mode to Multiply to blend the effect with the image.

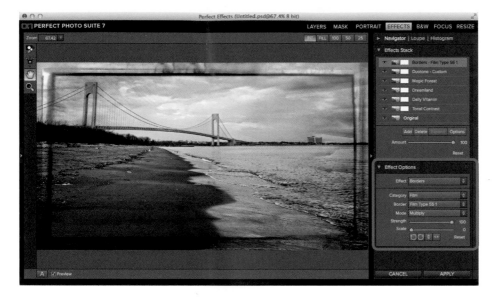

Step 5

After I was finished adding effects, I chose Preset > Save Preset so I could easily apply the same effect combination to all of my other time-lapse photographs. I named the preset, selected a category, and also added my own name and a description. Then I closed the file without saving and deleted the image, because it was just a temporary file used to create the preset.

Step 6

Back in Lightroom, I selected the time-lapse images I wanted to process with this brand-new preset and chose File > Export. In the resulting window, I selected Perfect Effects 4 from the Export To drop-down list, chose my newly created preset from the top section, and set the export location, file settings, and image sizing to fit my desired video size. Finally, I clicked the Export button.

NOTE

The Perfect Photo Suite can take a while to batch process a large number of files, so factor that into your schedule when working on a large project, such as processing still images for a time-lapse video.

Step 7

Next I used Photoshop CS6 to piece my still images together. In Photoshop, I chose File > Open, located my folder, selected one of the images, clicked the Image Sequence check box, and clicked Open. After selecting my frame rate (24 or 30 works well for smooth videos), I clicked OK to open the files as a video inside Photoshop.

Step 8

Still in Photoshop, I chose File > Export > Render Video to export my video. The result was a uniquely stylized time-lapse video—thanks to Perfect Effects.

Conclusion

I'm a photographer, and I understand the value of being out with my camera. Creating the images is the first step, and in order to get them on my website, uploaded to social media, or printed to hang on my wall I need to process them. I'm sure that I'm not the only photographer who dreads staring at the computer all day long. Many of us would much rather be out actually *creating* the photographs. Which is why I love this software: It's fast, efficient, and easy to use, giving me that time I so desperately desire to use my camera.

I've found so much excitement when editing with Perfect Photo Suite 7, and even more so while writing this book. This software has the ability to help me realize the possibilities that exist and gives me the tools I need to quickly process my photographs. Over time, editing my images has become less of a burden and more of an enjoyable experience, and the Perfect Photo Suite has been a big part of that process.

I hope that in reading this book you have learned not only how to use the software but have also had a few "light bulb" moments of inspiration. If I had my way—along with endless resources—this book would be a bit longer than it is, which is why you'll find an appendix on Keyboard Shortcuts over on Peachpit.com. Just register your book to get the free download. And, if you're in the mood for video training, I highly encourage you to go to onOneSoftware.com and click either the University or Inspiration link at the top. The educational department at onOne Software is superb. They have an entire library of training videos to show you how to use their products with step-by-step tutorials, along with inspirational posts and videos by the very talented Brian Matiash. These video tutorials, along with this book, will guarantee you have the resources you need to not only learn the software but also to understand it.

Like many photographers, I have several different tools I use to realize my vision with my images, from camera gear to post-processing software, but the thing to remember is that it's not the tool we use that creates beauty—it's the *photographer*. An expensive camera doesn't automatically mean you'll create spectacular images, just as a fancy plug-in effect can't save a crappy photo. Quick fixes are nice, but true dedication to your craft will give your images depth and your passion will shine through. Chances are if you've made it to the end of the book then you're on the right path to learning your tools and getting that much closer to mastering the art of photography. And whatever your method of processing images, I hope you find something that motivates you and works seamlessly to keep the creative juices flowing.

Index